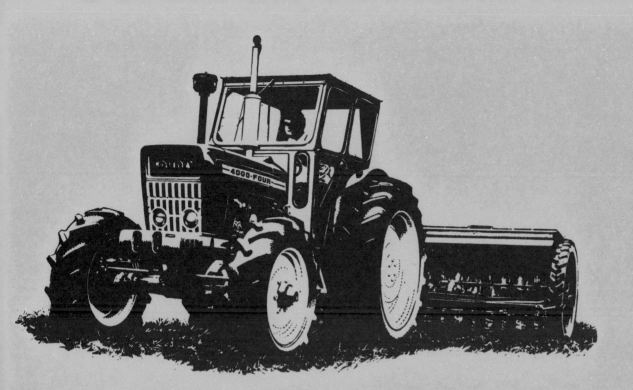

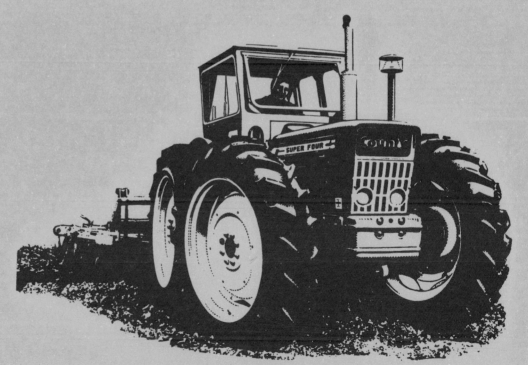

'The County ship, well built, long in service and with a crew of unequalled experience, sails resolutely through the storm, confident that when the wind lessens and the waves die down, a long life of service lies ahead.'

From *County News* 1980

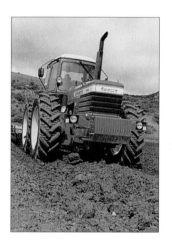 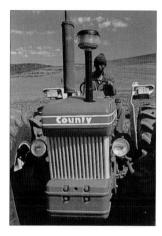

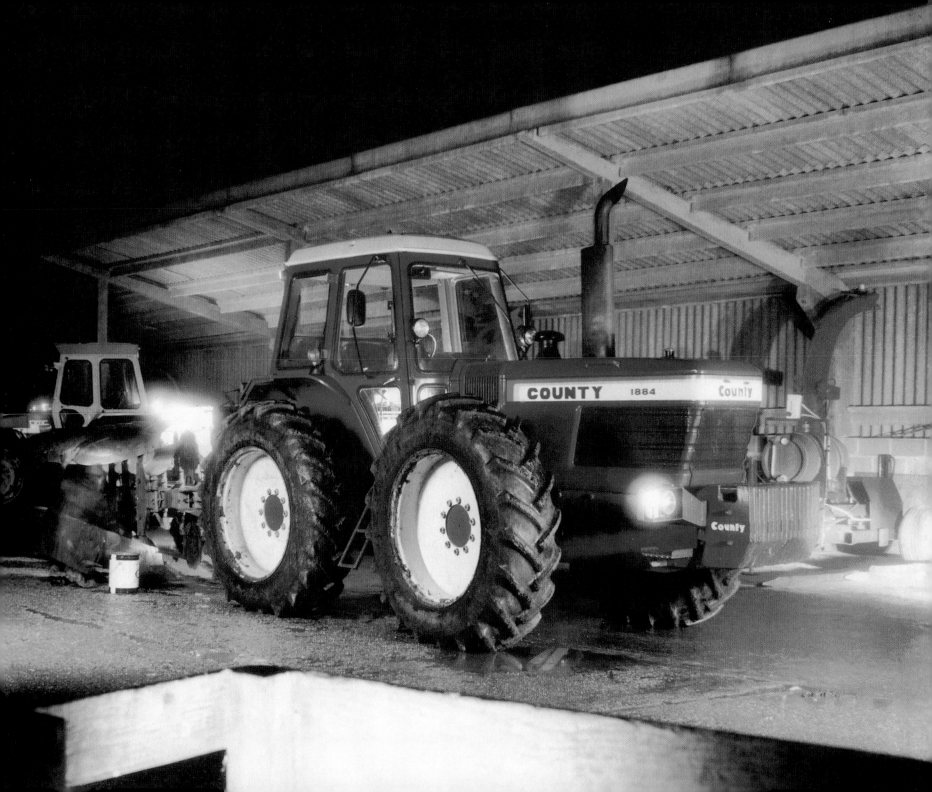

County

a pictorial review

Stuart Gibbard

Old Pond Publishing

ISBN 978-1-905523-70-2

A catalogue record for this book is
available from the British Library

Published by

Old Pond Publishing
Dencora Business Centre
36 White House Road
Ipswich IP1 5LT
United Kingdom
www.oldpond.com

Distributed in North America by
Diamond Farm Book Publishers
RR3 16385 Telephone Rd S
Brighton, ON KOK 1H0
Canada

www.diamondfarm.com

Cover design by Mark Ruggles
Printed and bound in China by 1010 printing International Ltd

Foreword

In his research for this commendably concise illustrated history of County Commercial Cars, Stuart Gibbard has consulted the memories of many 'County people'. I am sure that others will have shared my experience in recalling with pleasure so many almost forgotten facts and incidents about the products and the life we shared together, feeling the old fascination once again for all that made County special.

That Stuart believes there is still a strong readership is a tribute to all who were part of that achievement in those years between 1929 and 1983. County, no doubt, meant many things to those who were part of it, but two stand out: belonging and confidence. Belonging to an imaginative team and confidence in its ability to design, make and sell. People mattered.

I can still remember as an 18 year old waiting to 'join up', being taken in 1943 to the tank testing ground at Chobham and there saw two tanks undergoing 24-hour testing in gruelling conditions. One was a Churchill heavy infantry tank, the other, only half the height of the Churchill's hull, was the 'Praying Mantis' developed by County. It impressed me then as it does now that County was ready to tackle anything: the 'can do' spirit that characterised the company.

In these pages we read of the Ford County Sussex which was to form the backbone of the anti-aircraft balloon barrage. In 1944 more than 2,000 of these trucks were brought from all over the country to form a defensive shield around the south-eastern approaches to London against the V1 flying bombs. Many V1s were downed by the balloon cables.

The first County crawler is well illustrated too, production of which could hardly meet the pent-up demand for a British tractor that had real pulling power, as severe restrictions on imports from the USA led to American crawlers being unavailable.

Most will recollect the County range of equal-wheel four-wheel-drive tractors that were sold all over the world, setting new standards in performance and stability, and achieving impressive volumes both at home and overseas.

In reading this history, one may wonder at the nature of County's relationship with the Ford Motor Company, which spanned 50 years and 63,000 products, all without written undertakings, and yet a cornerstone of the company. That this fruitful relationship came to an abrupt end in 1983 was a tragedy, as the County team was never reformed.

Sadly, many companies suffered in this way, due in great measure to the political, economic and financing policies of the time, to which Stuart makes reference. These were to cause serious instability in industry and lead to companies giving overriding priority to their own market share sometimes to the detriment of long-established relationships.

Despite the ending, however, I believe that all who had any involvement with County Commercial Cars, be they staff, distributors or suppliers, will welcome, as I do, the care that has been taken to portray this unique British company.

Raymond P J Tapp
Hartley Wintney
3 June 1997

Author's Note

As County was a British company founded in 1929, all weights and measures are given in imperial figures, which was the system in common usage when most of the machines were built. All horsepower figures are approximate. British standard brake horsepower (bhp) figures are used where possible.

Preface

What is a County tractor? There is no simple answer. Basically, it could be whatever you wanted it to be.

An overstatement? Perhaps. But, with the exception of the mighty Ford organisation, no other manufacturer's tractors have been used as the basis for so many different types of machines — machines that were developed for use in nearly 150 countries of the world; from lifeboat-launching tractors in the Outer Hebrides to drilling rigs in the Middle East; from tractors that could cross the English Channel to machines that could clear snow up to 8 ft deep in Canada. All this from a small British family-run company that at its zenith was only employing just over 400 people.

However, tractors are only part of the story. During the 50 or so years that it was in existence, County Commercial Cars also built a variety of lorries, vehicles, tanks, specialist spraying machines as well as a host of ancillary equipment and attachments for tractors.

This book is not intended to be a full history of County, but rather a review of the fascinating variety of machines produced by the company, and the range of applications that those products were used for.

For most of the former company employees I have spoken to in the course of my research, the County story finished in 1983. Partly for this reason, and partly because of the constraints of space, I have restricted the book to cover the story of the original company, County Commercial Cars Ltd, from 1929 to 1983. Although only passing reference is made to the later developments, this is not meant in any way to detract from the equally important work carried on after 1983 under the name of County Tractors Ltd.

Very many people have helped in the preparation of this book. Most of them were County men whose veins still run blue with County blood. I realise that for them it has been a labour of love — a love for a company that recognised their loyalty and became part of their lives. Without their help, freely given, this book could not have been written.

Firstly, I would like to thank Raymond, Geoffrey and David Tapp who have provided important background information and family history, and have all read my manuscript and corrected me where necessary. I am especially grateful to David. Not only did he inspire me to write the book, he has also tirelessly tracked down former company employees and spent a lot of time tracing information and photographs.

Many former County personnel have assisted me with their invaluable help, information and photographs. In particular I would like to thank Stan Anderson, Bruce Coles, Geoffrey Eggleton, Mike Gormley, John Heathers, John Hull, Gordon Lewington, Graham Poole, Roger Philips, Brian Taylor, Roger Thomas, Percy Vickery, Dennis Whiting and Gordon Williamson — a veritable 'Who's Who' of County people.

The vast majority of County company photographs were taken by Terry and Martin Chapman who first worked for C & E Roe and then set up their own business, Benmuir Photographic Services. I am especially grateful for their kind assistance and time, and for allowing me to sort through their several thousand County negatives which has made a great deal of difference to the content of the book. Most of the overseas photographs and many of the working shots were taken on location by County's sales representatives, and I would especially like to acknowledge Mike Gormley for loaning me so many of his superb transparencies taken in South Africa, New Zealand, Scandinavia and elsewhere. Thanks are also due to Jim Russell for the excellent shots of his own tractors.

Finally, I would also like to thank Colin Bennett, Mike Bigland (M A Bigland Preparations), Jim Christie (Forestry Commission), County-York Ltd, Mark Farmer, Martin Gardner, Richard Martin and Johnny Weal. I must not forget to thank my wife, Sue, once again for keeping the coffee coming, the kids quiet and the dog walked.

It is easy to see why County was such a marvellous company, and where its strengths lay; without exception, every person I have spoken to connected with County has been helpful and friendly in the extreme, and all gave me a great deal of encouragement. Working with them and writing this book has been an absolute pleasure.

Stuart Gibbard
June 1997

County Commercial Cars — a brief history

County Commercial Cars Ltd was formed in 1929 by two brothers, Ernest and Percy Tapp, for the small-scale manufacture of six-wheel conversions on early Ford trucks. A humble beginning for a remarkable company that was to flourish and grow beyond all expectations — a company that by 1973 had built over 16,000 trucks and 30,000 tractors and was exporting to 143 countries of the world. Yet this expansion of business was never allowed to compromise the individual character of the company which remained a family-run concern inspiring great loyalty in its customers and employees alike.

Ernest and Percy Tapp were a unique partnership — each complementing the other with their own separate skills and fields of experience. Ernest's background was in engineering. He served his apprenticeship with Colonel Rookes Evelyn Bell Crompton, founder of the famous Crompton electrical company. At the time, Crompton was consulting engineer to the British Roads Board and he and Ernest jointly designed a three-axle tandem road roller which was patented in 1912 as the Crompton & Tapp Roller.

The elder of the two brothers, Percy, was a business-man with an aptitude for management. From 1907, he worked for a London confirming house with wide interests in East Africa and gained valuable knowledge of the world of imports and exports.

Both brothers served in France during the First World War where they experienced firsthand the many advantages of the motor vehicle over horse-drawn wagons. They returned to England keen to become involved in motor transport.

Ernest's father-in-law was a butcher, and the brothers seized on the opportunity to replace the horse-drawn wagons used to deliver meat to and from Smithfield Market with more efficient and faster motor vehicles. To this end, in 1919, they set up the Market Transport Company, which operated from Weir Road, Balham in south-west London.

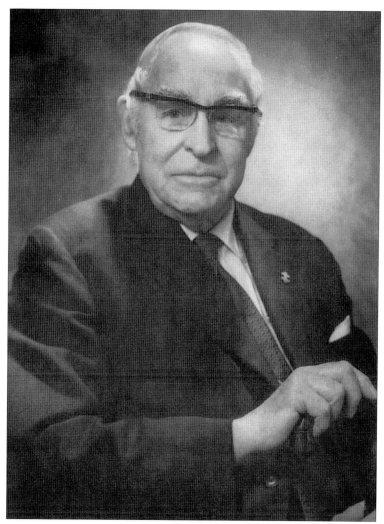

Ernest Tapp, co-founder of County and chairman from 1964 to 1974.

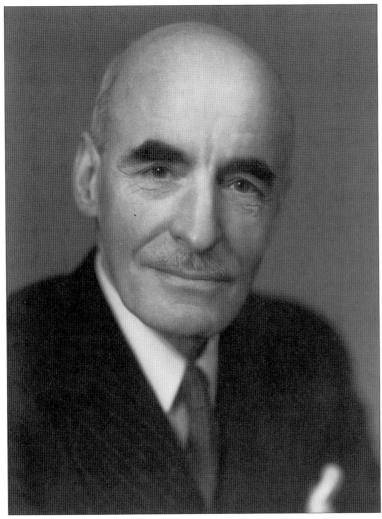

Percy Tapp, Ernest's brother and fellow co-founder, was chairman of County until his death in 1964.

Business prospered and the brothers soon built up a fleet of vehicles handling meat and general foodstuffs. However, by the late 1920s, the company was becoming concerned about proposed road traffic legislation which was to limit vehicles of two and a half tons unladen weight and above to a maximum speed of 20 mph. Lighter vehicles, such as the Ford AA truck introduced in 1928, were available but could carry no more than 30 cwt. Ernest solved the problem by using his engineering skills to turn the Ford truck into a six-wheeler capable of handling three tons at 30 mph by extending the chassis members and adding a third axle. The conversion proved so successful that the Tapp brothers decided to market it commercially. This lead to the formation of County Commercial Cars Ltd, a separate company from the Market Transport Company, to handle the manufacture and sales of the six-wheel trucks.

Two versions of the trucks were built. The 6x4 Sussex had a powered third axle, while the Surrey was a 6x2 with a trailing rear axle. Initially, the trucks were built at the Market Transport Company's premises in Weir Road, but as demand increased, production was moved to a factory belonging to Percy's brother-in-law, Richard Pool, in Fleet, Hampshire. Manufacture at Fleet was supervised by Ernest's brother-in-law, Ted Bright, who became works manager. In 1931, the designs were submitted to the Ford Motor Company in Detroit and were approved for UK line assembly — a major feat for a small British company and testimony both to Ernest's engineering and Percy's negotiating skills. Production of the trucks began at Ford's new Dagenham plant in 1933, with County supplying the chassis extensions and rear bogie components.

In 1937, a 6x4 Sussex on a Ford E817T chassis was successfully demonstrated to the Air Ministry at Studland Bay in Dorset and was chosen for use by the RAF. The same year, County expanded into new offices, taking over the old Fleet council buildings in Albert Street, which included a garage, fire station, mortuary and stabling for horses. The stable became the development shop and was always referred to as 'Sam's stable' after the council's horse.

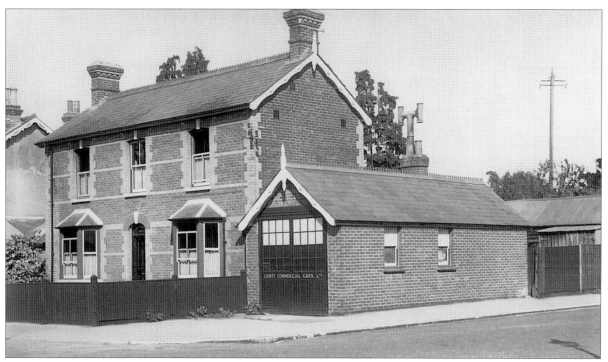

During the Second World War, some 14,400 military versions of the Sussex truck were produced. Although County had its hands full meeting demand, it still found time for some other developments including the 'Praying Mantis' two-man tank. Ernest Tapp was later involved in the design of an anti-aircraft gunnery training simulator, known as the Dome Gunnery Trainer, which was made by a sister firm, Radio Electronics of South Norwood.

The post-war period was a time of change and opportunity which affected many companies.

Above
County's original offices in Albert Street, formerly occupied by Fleet council.

County's immediate concern was to find new products to fill the gap left when the massive wartime production run for the Sussex finally came to an end. A chance order for several high-clearance spraying machines for Pest Control Ltd of Cambridge was followed by a request for a small number of narrow-gauge crawler tractors for spraying in hop fields. County also developed a standard-gauge version of the lightweight crawler, based on the Fordson E27N Major, which was put into production in 1948 and became known as the County Full Track. This model met with instant acclaim and sales were greater than ever expected; it launched the company in a new direction and heralded the start of a long line of County tractors.

Left
Chief engineer, Joe Davey, with the prototype County Full Track crawler in 1948.

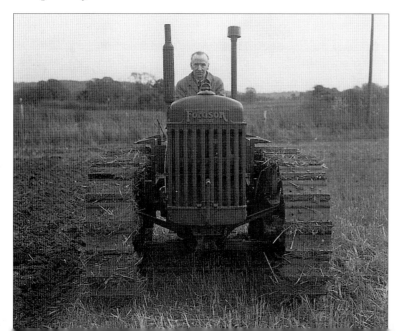

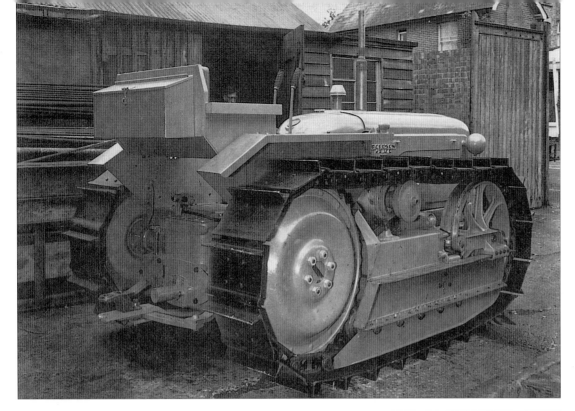

County Model Z crawler, based on the new Fordson Major, outside the development shop behind the Albert Street offices.

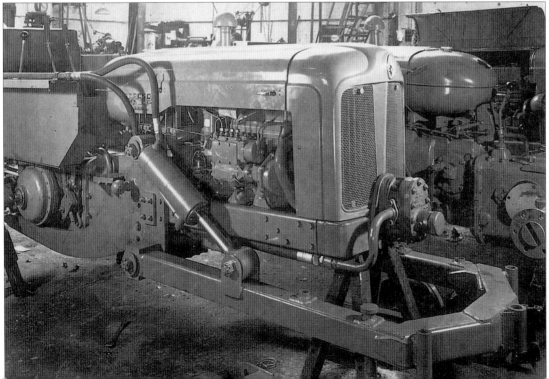

County crawler with Bray dozer equipment being assembled inside the development shop.

It is important to recognise the part played by the Market Transport Company in the development of County. Still run by the Tapp brothers as a separate entity, it became a limited company in 1947, and the business prospered and expanded. Not only did it provide County with the necessary financial stability, it also guaranteed the bank loan to get the crawler production started. The Market Transport Company remained under the control of the Tapp family and operated until 1984. Almost from the outset, it had built its own lorry bodies, and these were marketed after the war by a subsidiary of County's, Walker and County Cars Ltd.

Post-war production at Dagenham of the six-wheel truck conversions continued for a while on the 7V and ET6 trucks, ceasing with Ford's introduction of its Thames Trader range in 1957. However, County made the decision to continue to build six-wheel versions of the new Ford trucks themselves at Fleet, and market them as the County Thames Trader Tandems.

County had arrived at a watershed in its life and the character of the company was to undergo a subtle change. It could no longer afford to concentrate solely on developing new products which were marketed through a third party. With the crawler and its own trucks to sell, County had to divert its attentions to marketing and sales for the first time. The company managed to make the jump from being product driven to being market driven without too much difficulty. Home sales increased, and before long County was building up an enviable export trade.

The crawler was to prove to be the catalyst for County's future success. Although the company remained involved with commercial vehicles into the 1970s, truck production dwindled as tractor manufacture became the mainstay of County's business. New and improved models of agricultural and industrial County crawlers, including the acclaimed Ploughman and CD50 ranges, were introduced and made until 1965. The long production run for the crawler eventually came to an end because the company felt it could neither justify the cost

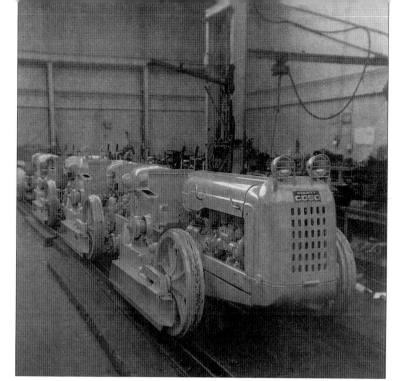

County CD50 crawlers under construction in the new works.

Two Super-4 tractors outside County's new offices in about 1960.

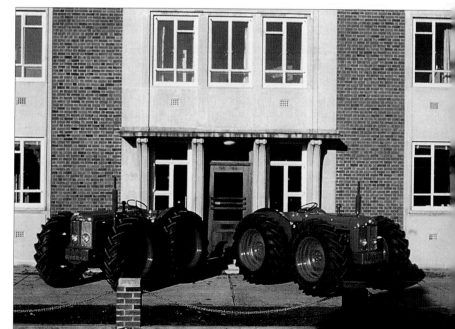

County's head office and No.1 works building at Fleet during the 1970s — part of a new complex of buildings opened in 1955.

nor the amount of time involved in adapting the design to fit the new Ford 6X skid unit introduced in 1964, and preferred to concentrate on developing its four-wheel drive production.

A request from the Puerto Rican sugar-cane industry for a wheeled tractor which had the performance of a crawler, launched County into the four-wheel drive market almost by accident in 1954, and resulted in the skid-steered Four-Drive. This was essentially a crawler on rubber tyres with the front wheels chain driven from sprockets on the rear axle, the Four-Drive sold well in the West Indies, but enjoyed only limited success on the home market.

In 1960, County produced its first equal-size four-wheel-drive tractor with conventional front-wheel steering. Designated the Super-4, it introduced a new drive system which was to feature in all future County tractors. Based on the Super Major, power to the front wheels was transmitted by twin propeller shafts driven by bevel gears off the Fordson bull-pinion shafts, the advantage being that the standard differential would work on all four wheels. A six-cylinder version, the Super-6, soon followed.

The Super-4 and Super-6 were the tractors that pushed the company into volume production. County had already moved into a new purpose-built factory, stores

and office complex, opened in 1955, just across the road from the old Fleet offices in Albert Street, and had the capacity to meet demand. Ernest's eldest son, Geoffrey, began to take over some of the responsibility for engineering, later becoming technical director and, from 1964, joint managing director with Percy's son, Raymond, who had been involved in the truck and production side of the company. In addition Raymond took over the chairmanship in 1974. Geoffrey's younger brother, David, became engineering liaison director. The sales and marketing director was Raymond's brother-in-law, Brian Taylor.

The County range was revised to embrace the new Ford models introduced in late 1964. The first to be released was the four-cylinder 654, based on the Ford 5000 skid unit. Unable to find the time to develop and test a new six-cylinder model, County bought up a year's supply of the old Super Major back-ends. These 1,000 units, bought at a cost of about £1 million, were kept on their wooden skids at a yard in Andover until needed. This allowed County to keep the old model Super-6 in production until its replacement, the 954, was ready at the end of 1965. Further new and more powerful models followed to match the demand for increased horsepower.

By 1975, County's annual turnover had reached nearly £13 million, and the company dominated the UK four-wheel drive market while still managing to export 70 per cent of its production. A range of seven basic models of four-wheel-drive tractors from 62 to 150 hp and two high-clearance machines were now in production. Subsidiary companies included County Power Drives Ltd, which marketed specialist

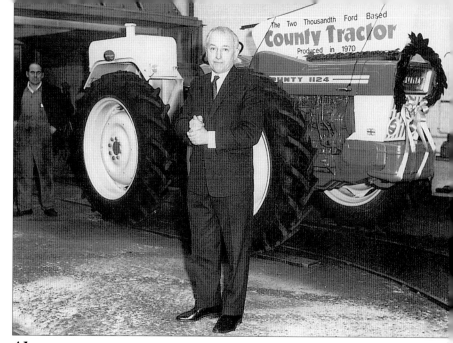

Above
The 2000th Ford-based County tractor produced during 1970 — an 1124 which rolled off the production lines on 31 December — with works manager, Bruce Coles.

Right
County 754 tractors on the main assembly line in the No.1 works building in 1974. Output was nine tractors per day.

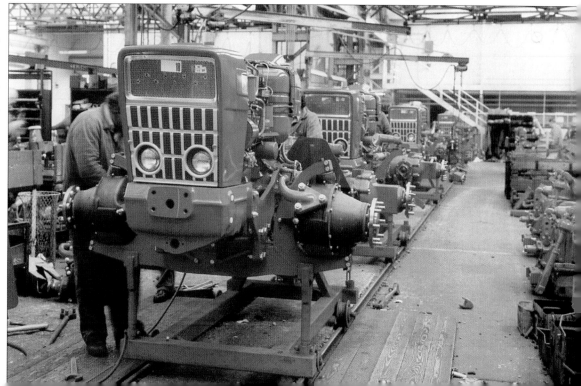

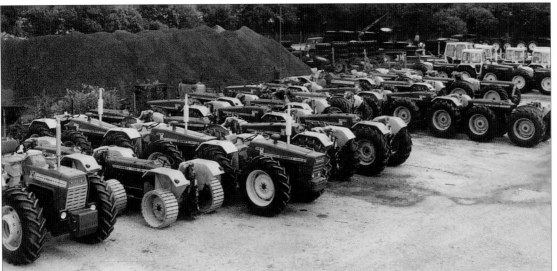

Above
*Completed tractors awaiting dispatch either for
the UK or export shipment in 1975. Note, some tractors
were shipped without tyres which would be fitted in the
country of its final destination.*

*A County Full Track crawler lined up with an 1184TW
for County's golden jubilee celebrations in 1979.*

and ancillary equipment for Ford and County tractors, and County Commercial Engineers Ltd, supplying precision-machined parts to the parent company from the premises of the old Radio Electronics firm in South Norwood, later moving to Andover. County now occupied a total area of around ten acres, including 150,000 sq. ft of buildings, and employed about 475 people.

County's turnover peaked at just over £18 million in 1977, but by 1980, the year the company's most powerful flagship model, the 188 hp 1884, was released, world recession was hitting County's important export trade and sales were falling.

Over the next two years, County was badly affected by the high strength of the pound against the dollar (approximately £1 to $2.6) which made it difficult for the company to compete overseas and decimated its important dollar markets, including the Caribbean and many of the sugar-growing areas. This, coupled with a recession on the home market, pushed County's sales down by 40 per cent. The final blow came when Ford announced that it was launching four-wheel drive versions of its own tractors.

County's long and fruitful association with the Ford Motor Company dated back to 1931, and was entered into without any form of written agreement or undertaking on either side. With very few exceptions, nearly all of the company's products were based on Ford units, including some 17,000 trucks, 10,000 crawlers and 35,000 four-wheel-drive tractors. It was ironic, therefore, that County should now face competition from its main collaborator.

The company managed to cut its overall costs by a

third, but it was not enough. Crippled by astronomical bank lending rates, County Commercial Cars went into receivership in February 1983. The company was bought by Shropshire County dealer, David Gittins, who formed County Tractors Ltd, which was in turn taken over in 1987 by the Benson Group, and relocated to Knighton in Powys.

A limited number of tractors were produced under Benson's ownership before production came to an end in 1990, although ten further machines were built for export in 1995, based on the Ford 40 Series skid units. In 2000, the County business was acquired by Benson's former chief engineer, Eric May, who operates as Countytrac.

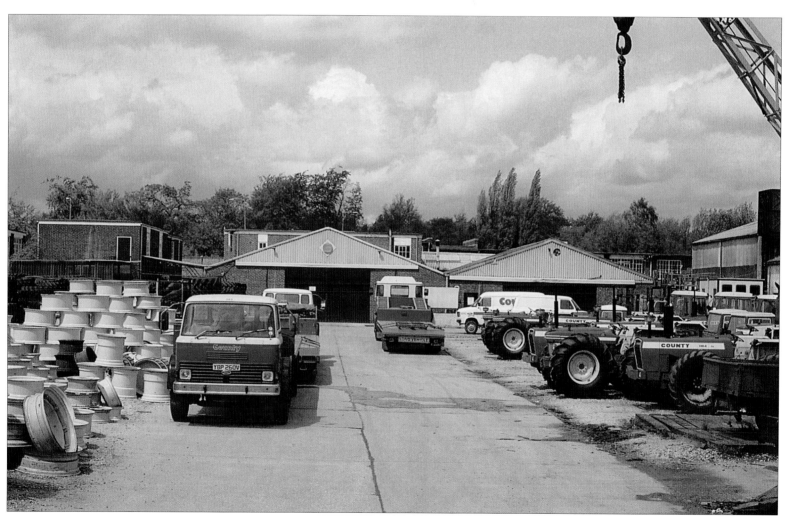

County's yard at Fleet in 1983 at the time when the company went into receivership.

Genesis

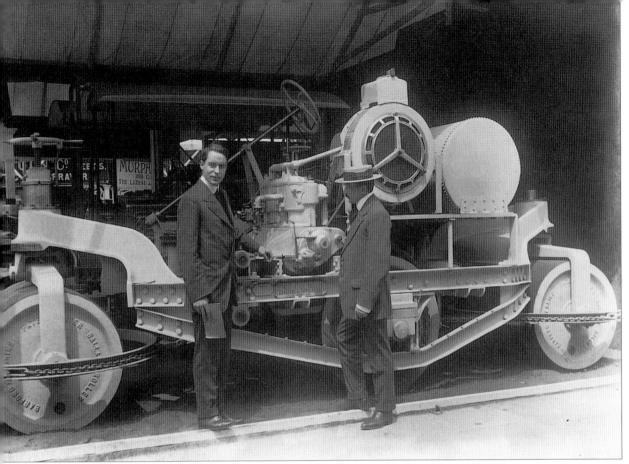

Left
1. Ernest Tapp (left) with one of his first engineering projects, the Crompton & Tapp three-axle road roller, which he designed jointly with Colonel R E B Crompton. Patented in June 1922, the machine had a centre-driven roller and two steering rollers. Weight distribution could be varied over the three rollers to prevent waves forming in the road surface. A prototype, powered by an Astor oil engine, was built later the same year by Barford & Perkins of Peterborough.

Right
2. The Market Transport Company was formed by Ernest and Percy Tapp in 1919. This early Karrier lorry on solid tyres, dating from around 1920, is typical of the type of vehicle used by the company prior to Ernest's introduction of his six-wheel conversions of the Ford AA trucks.

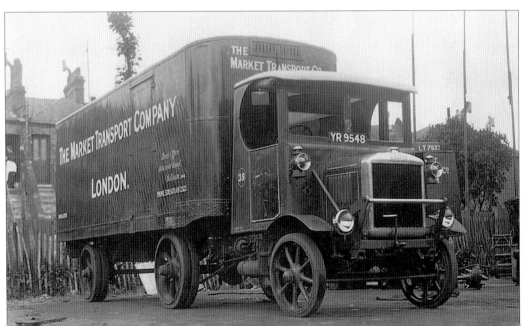

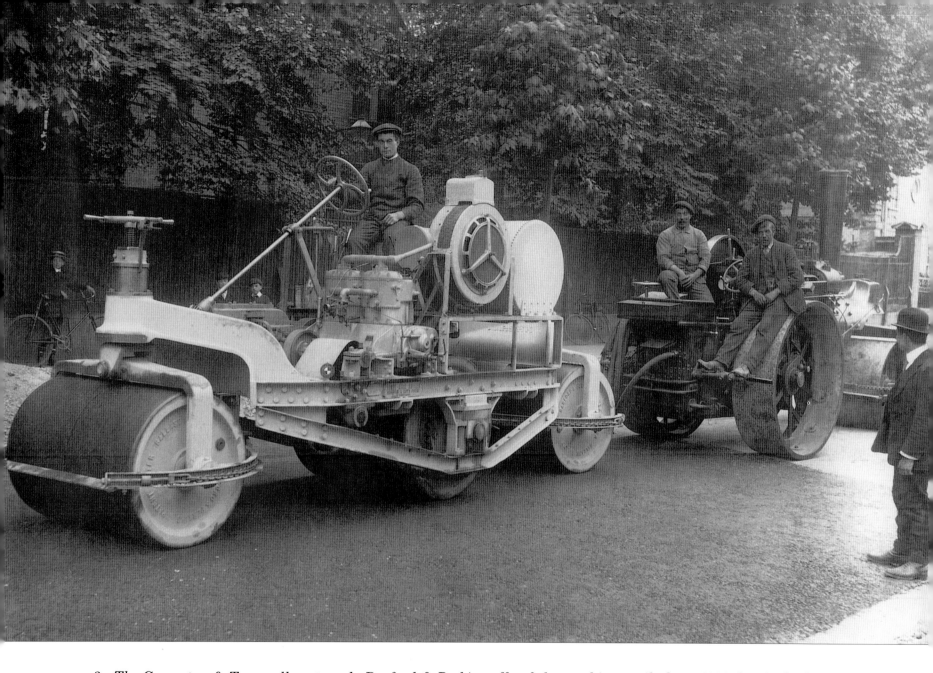

3. The Crompton & Tapp roller at work. Barford & Perkins offered the machine until about 1920, but its high cost deterred many customers.

Pre-war trucks

4. Ernest Tapp's first 6x4 conversion of the Ford AA truck demonstrating its excellent cross-country capabilities in 1928. The existing Ford worm-drive axle was inverted and mounted behind a new central axle unit, fitted with an output shaft to provide drive to the rear axle. The conversion was marketed by the newly formed County Commercial Cars Ltd from 1929.

Below

5. A 1929 Ford AA truck with the County six-wheel conversion. Adopted by the Ford Motor Company for production at Dagenham from 1933, the County Sussex conversion of the Ford AA now employed an improved double-drive centre axle embodying two spiral crown wheels and two bevel pinions.

6. A County Surrey 6x2 conversion of a 1929 Ford A chassis. The vehicle is fitted with a replica of its original country estate/shooting brake body.

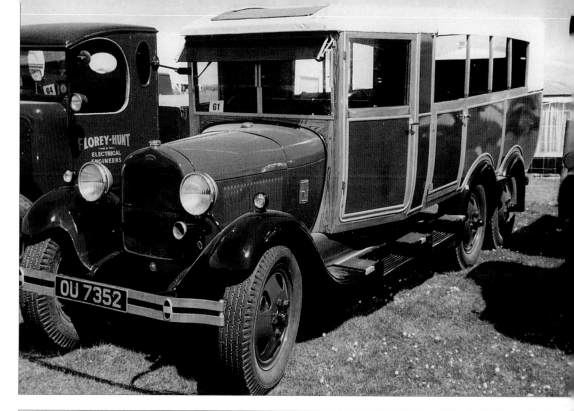

7. A County six-wheel version of a Ford BB truck dating from 1932. The complete Sussex double-drive attachment on single rear wheels added £120 to the basic cost of £227 of the 157 in. Ford two-ton chassis in March 1933.

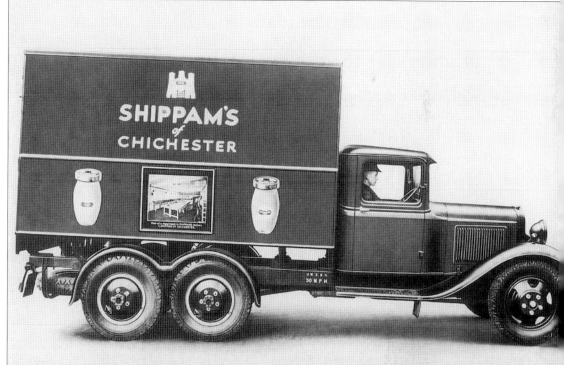

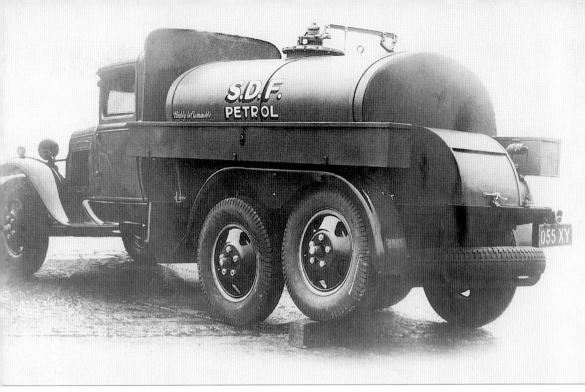

8. A County six-wheel version of a Ford AA petrol tanker. Although the vehicles were assembled at Dagenham, the necessary parts for conversion, including uprated rear springs and the centre axle and drive shafts were built up by County at Fleet. The extended chassis members, which were riveted, plated and braced, were supplied, to County's design, by Rubery Owen.

Below
9. A County 6x4 Sussex conversion of the forward control Fordson 7V truck introduced in 1937. Powered by a V8 engine, the 6x4 version in chassis form cost £335.

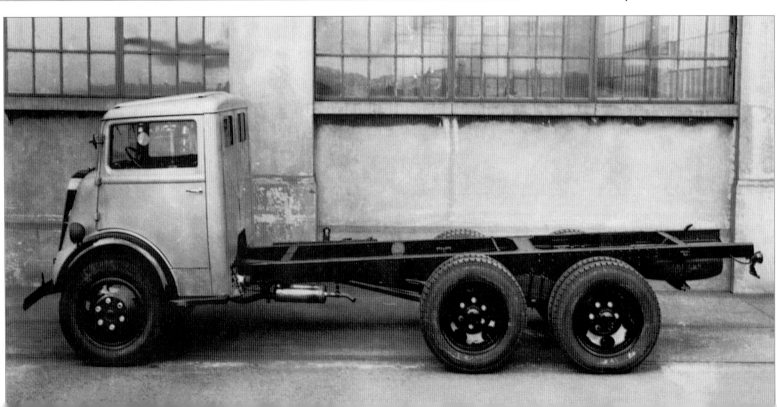

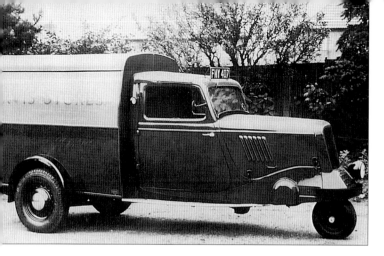

Above

10. In 1935, County introduced a new
concept of lightweight three-wheel
delivery vehicles based on the 8 hp Ford
Model Y car. The first of these was
designed to work as an articulated
tractor unit with special small semi-
trailers. The prototype was tested in 24-
hour running trials in the USA before
the vehicle went into production at
Dagenham as the Fordson Tug, priced
at £185. The van version shown was built
on an extended chassis from 1936 by
County at Fleet and was known as
the Devon Distributor.

Right

11. A larger version of the three-wheel
vehicle, with a 10 hp engine and twin
rear wheels, was fitted out as a fire
engine for trials with the Auxiliary Fire
Service during the period leading up to
the Second World War. However, the AFS
contract went to Scammel, and County's
two prototype fire engines were fitted
with meat bodies and pressed into service
with the Market Transport Company.

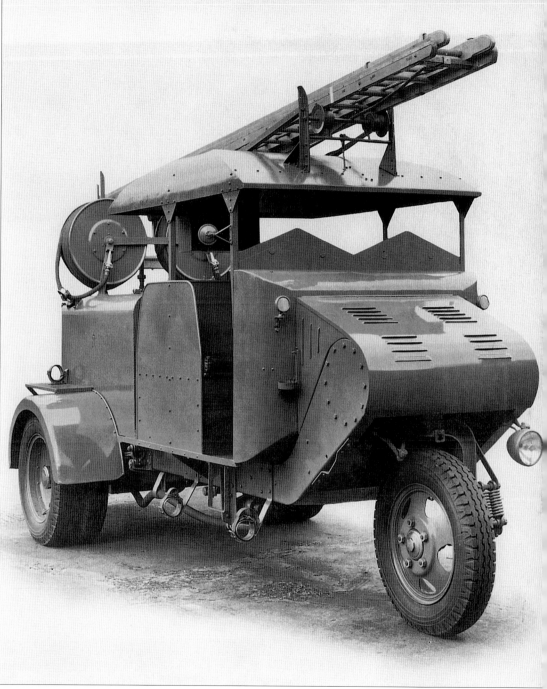

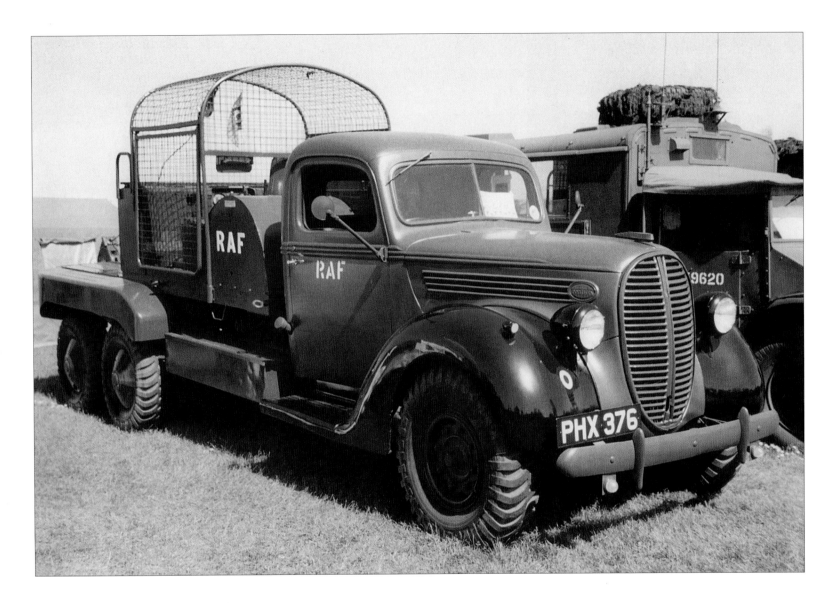

County at war

12. Following successful trials at Studland Bay in Dorset, County 6x4 Sussex versions of Ford trucks were chosen for use by the RAF. This 1938 V8 Ford E817T chassis was one of several fitted with winching equipment for launching barrage balloons. All the balloons used in the defence of London were flown from similar 6x4 Sussex trucks.

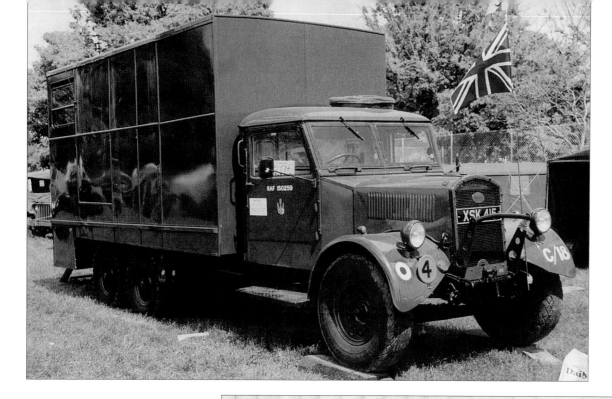

13. During the war, some 14,400 military versions of the Sussex trucks were produced. The axle and 14-leaf spring assemblies were built up by County at Fleet and shipped to Dagenham at the rate of 10 to 15 units per day. The Ford WOT trucks were also fitted with hubs and drums supplied by County. This WOT 1A Sussex saw service with the RAF and dates from about 1944.

14. Towards the end of the war, County became involved in the modification of a number of foam fire tenders built for the RAF on Ford WOT 1A Sussex chassis. Fitted with Merryweather equipment, the tenders were assembled in the Richmond film studios at Twickenham with County supplying gear-drive power-take-offs for the fire pumps.

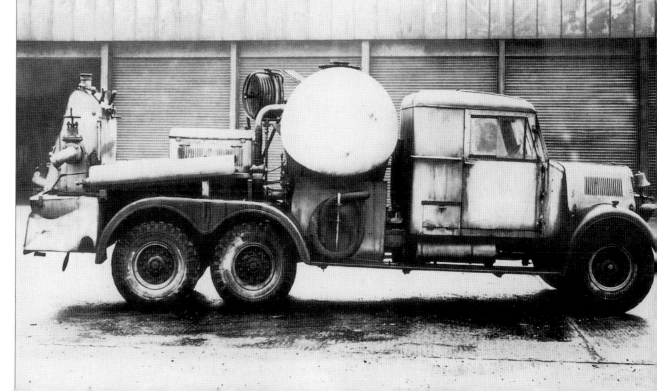

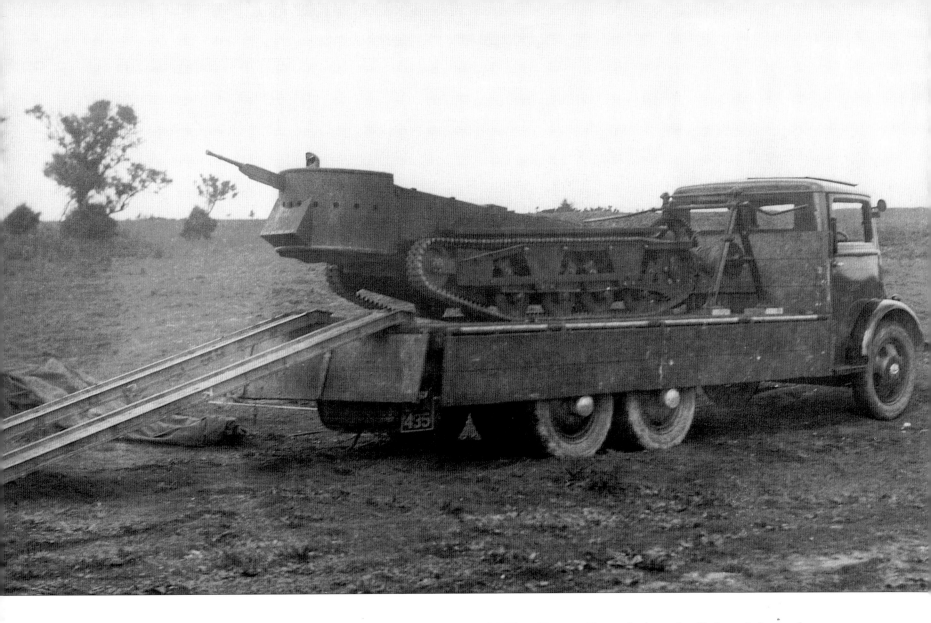

15. In 1939, drawing on experience gained during the First World War, Ernest Tapp designed a lightweight tank which would provide close armoured support to infantry fighting in villages. The prototype one-man tank, which he called the Mechanical Infantryman, is seen on County's own 1938 Ford BBE Surrey truck. The armoured compartment could be elevated by a vacuum system to allow the gunner to fire over walls or hedges, and the driver steered with his feet.

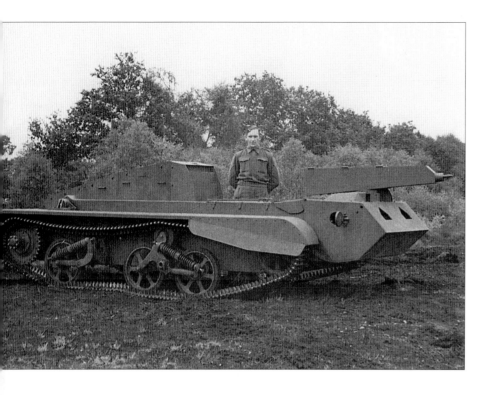

Above and right

16, 17. An improved two-man version of the tank, which became known as the Praying Mantis, was built in 1943 on a Ford V8-powered Bren gun carrier chassis from Ford's Leamington plant.

The armoured compartment, which was fitted with a periscope for the driver's vision, could be raised hydraulically to its full elevation in just over three seconds. It was armed with two Bren guns which could be fired by remote control.

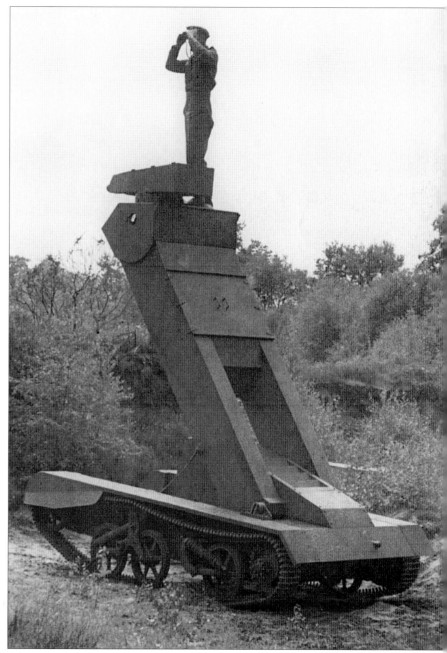

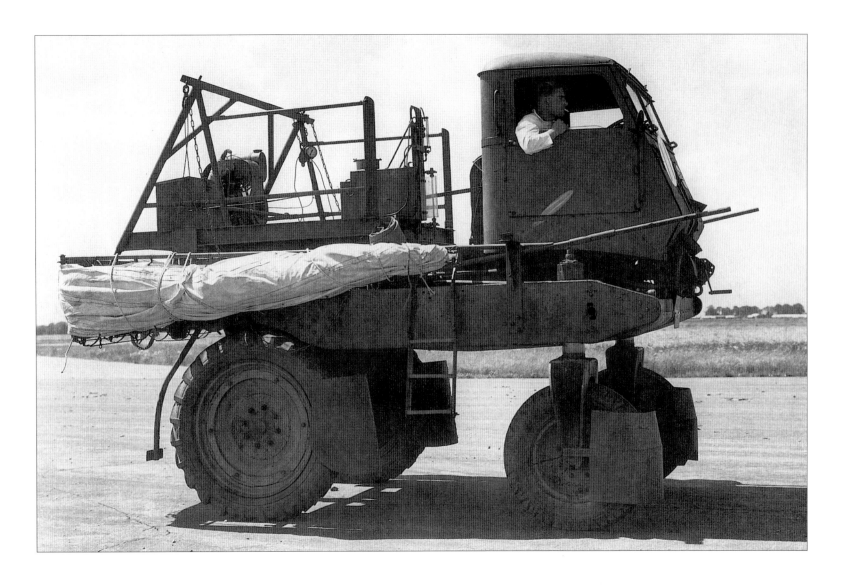

Pest Control sprayers

18. In 1946, County completed a batch of six high-clearance spraying tractors for Pest Control of Cambridge. Designed to have 4 ft ground clearance for spraying blackcurrant bushes and blackfly in beet seed crops, the machines were built mainly from Ford components, including a WOT6 truck cab and a V8 engine and gearbox. The track could be varied from 54 to 78 in. by turning a crank handle.

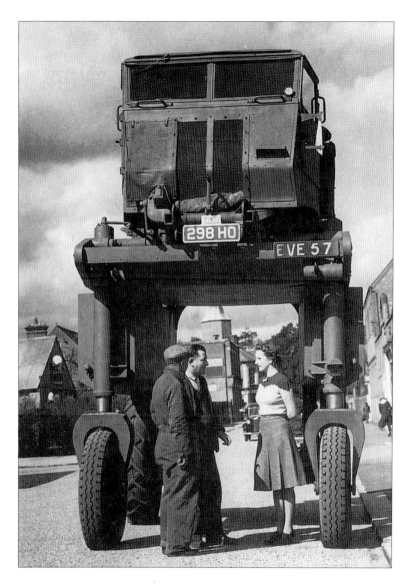

19. *A number of 7 ft clearance sprayers, with pannier spray tanks for stability, were also built for spraying cordon apple trees. Special tyres to suit the machine were supplied by Firestone.*

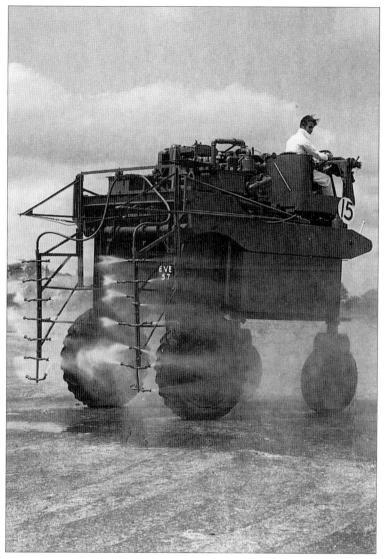

20. *One of the 7 ft sprayers in action. Although designed to travel at 25 mph on the road, they were capable of speeds of up to 40 mph and at least one machine overturned while travelling too fast round a corner, killing its driver.*

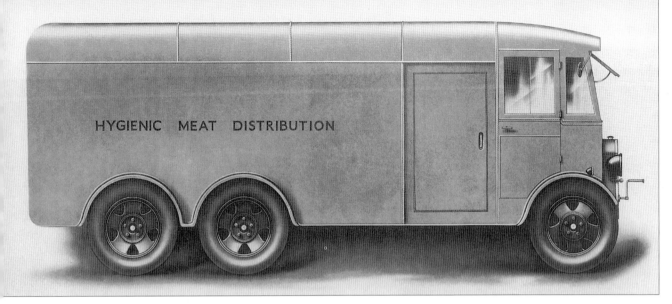

HYGIENIC MEAT DISTRIBUTION

Commercial vehicle bodies

Left

21. County was also involved in the design and manufacture of a number of lorry bodies, both for the Market Transport Company and other customers. This proposed design for a meat body dates back to the 1930s.

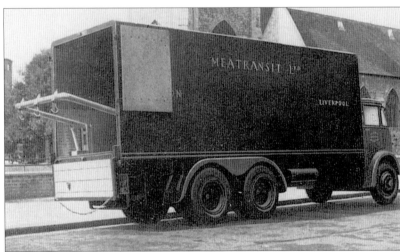

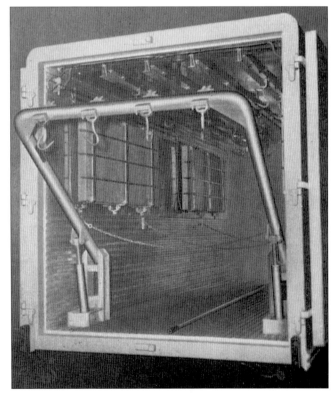

Above and right

22, 23. Built at Fleet, the Litex insulated meat body was designed for the bulk movements of fresh or frozen meat. Here a ten-ton body is seen fitted to a six-wheel Albion Chieftain. The Litex bodies could also incorporate the Market Loader, which was introduced in 1954. This hydraulically-operated lifting frame was designed for loading sides of meat and served four parallel meat rails.

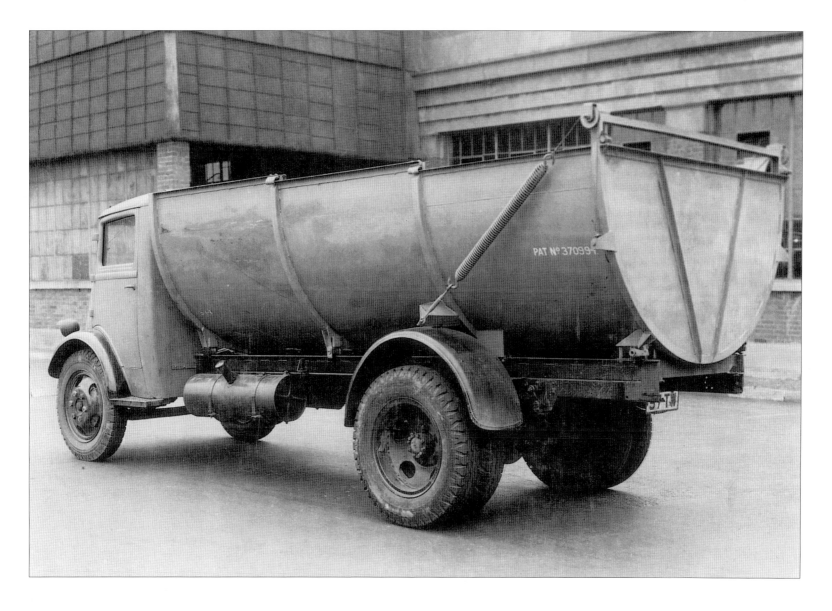

24. *County also designed the Jekta body, seen here on a Ford 7V chassis, consisting of three U-shaped scuppers which telescoped hydraulically to allow the easy discharge of bulk material — a concept originally devised by the company in the 1930s, and known as the Kleenaway system for refuse collection vehicles. The scupper bodies were made for County by subcontractors, Kennedy and Kempe of Andover.*

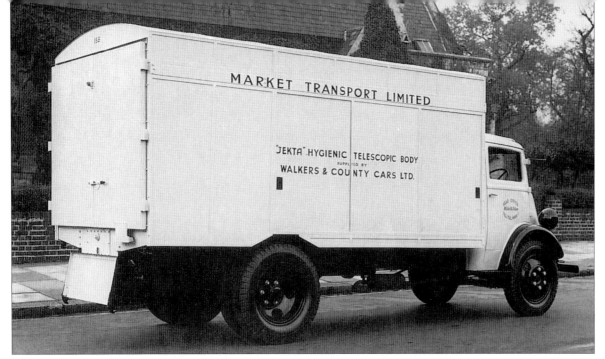

25. A 1946 Ford 7V with an enclosed Jekta telescopic body adapted for bulk meat deliveries. The lorry bodies were marketed from 1946 to 1960 by Walkers & County Cars Ltd. This subsidiary company, which operated from Fleet, was formed in partnership with Densmore Walker of Walker Brothers, who manufactured Pagefield lorries from 1907.

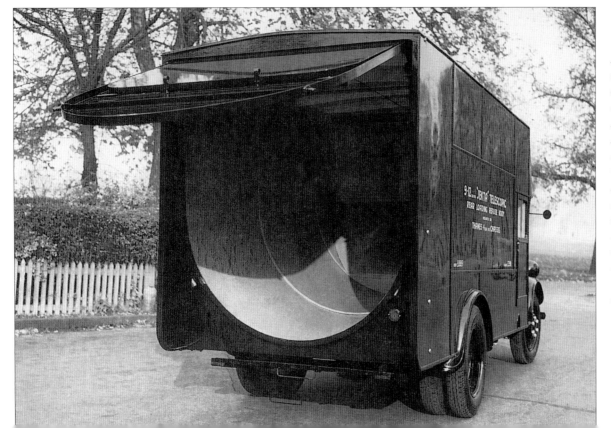

26. A four-ton Ford 7V chassis fitted with an enclosed Jekta body for handling refuse. Walker Brothers, based in Wigan, Lancashire, specialised in refuse collection vehicles. Consequently, with Densmore Walker's involvement, County aimed many of its lorry bodies at municipal authorities and, for a short while, also marketed the Paladin system which emptied dustbins by inverting them into the refuse collector.

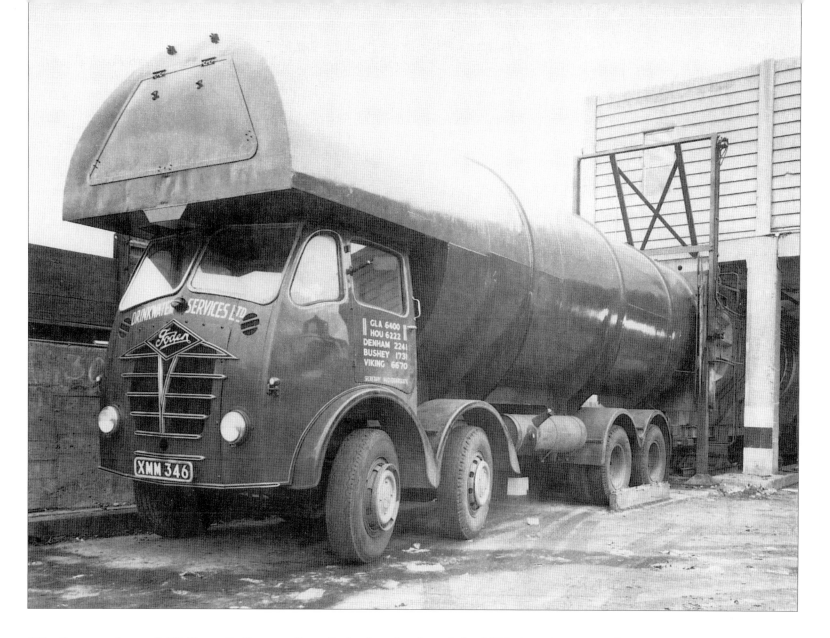

27. *County, through Walkers & County Cars Ltd, also developed the MPL (maximum payload) system of refuse handling. The refuse was delivered to a central processing plant, such as this one in Fulham, where it was hydraulically compressed into a slug and then forced by a giant ram into the back of a special cylindrical body seen here fitted to this 1952 Foden FG5 lorry.*

Post-war trucks

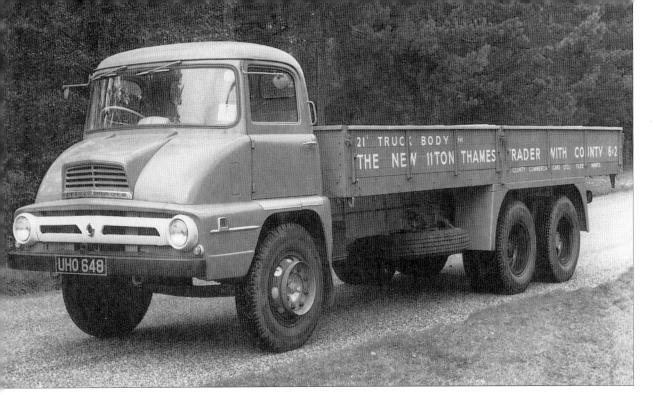

28. Six-wheel versions of the new Ford Thames Trader trucks, introduced in 1957, were produced in both 6x2 and 6x4 guise by County at Fleet. Registered in 1958, this 6x2 example has the standard long wheelbase chassis, designed to take a 21 ft body.

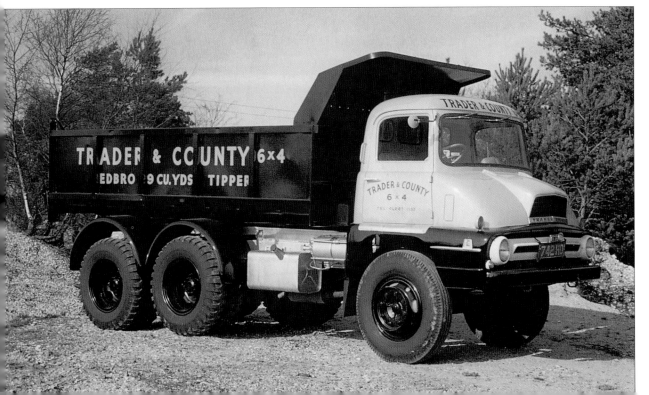

29. A County Thames Trader 6x4 Tandem tipper. The tippers were based on the 132 in. wheelbase models, and were fitted with either a Ford or David Brown five-speed gearbox.

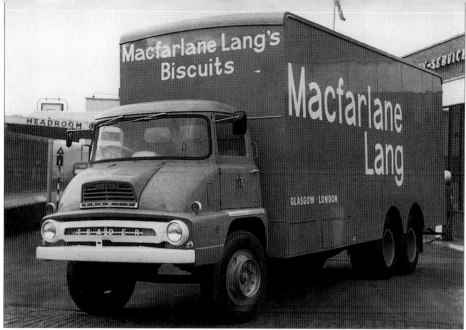

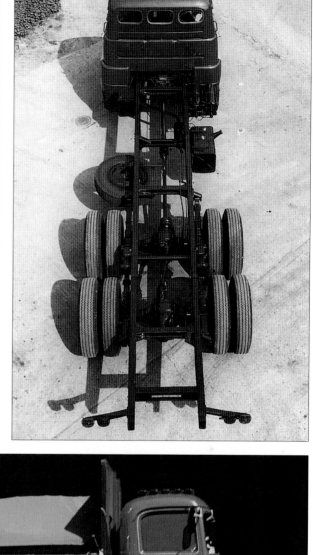

Above
30. A box van on a 1962/63 County Mark II Thames Trader Tandem chassis.

Right
31. Bird's eye view of a 1962 6x4 County conversion for the Mark II Thames Trader showing the double drive to the rear axle.

Below
32. A 1960 County Thames Trader dropside truck based on the 206 in. special long wheelbase 6x4 chassis.

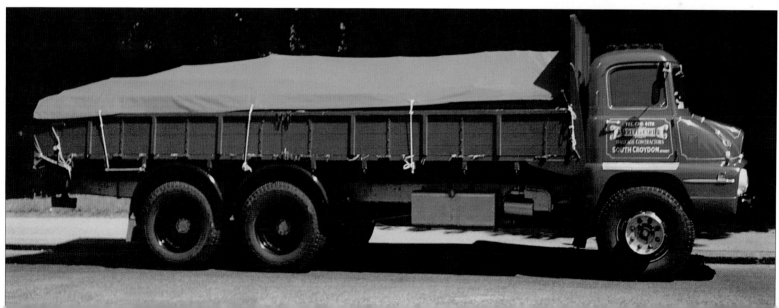

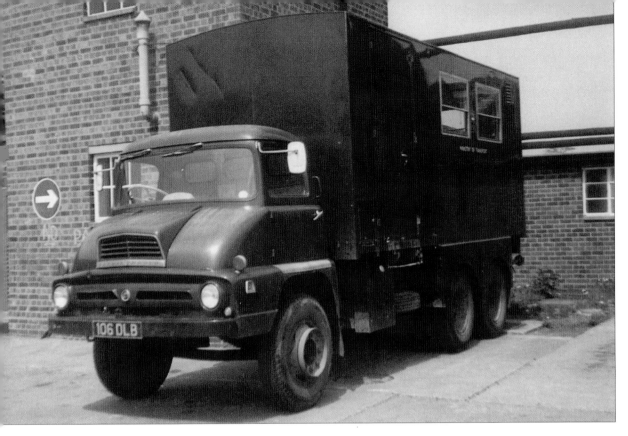

33. A Ministry of Transport soil testing unit mounted on a 1961 County Thames Trader Tandem.

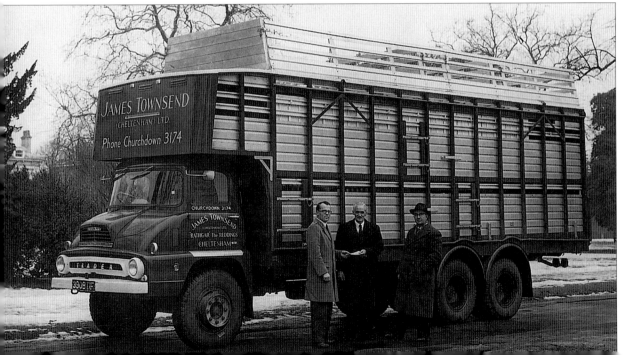

34. A Gloucester customer takes delivery of his new cattle truck based on a County Mark II Thames Trader Tandem in 1962. The six-wheel Thames Traders were available with a choice of Ford six-cylinder 112 bhp petrol or 108 bhp diesel engines. In 1963, the County 6x4 conversion added about £1,000 to the cost of the basic Ford truck.

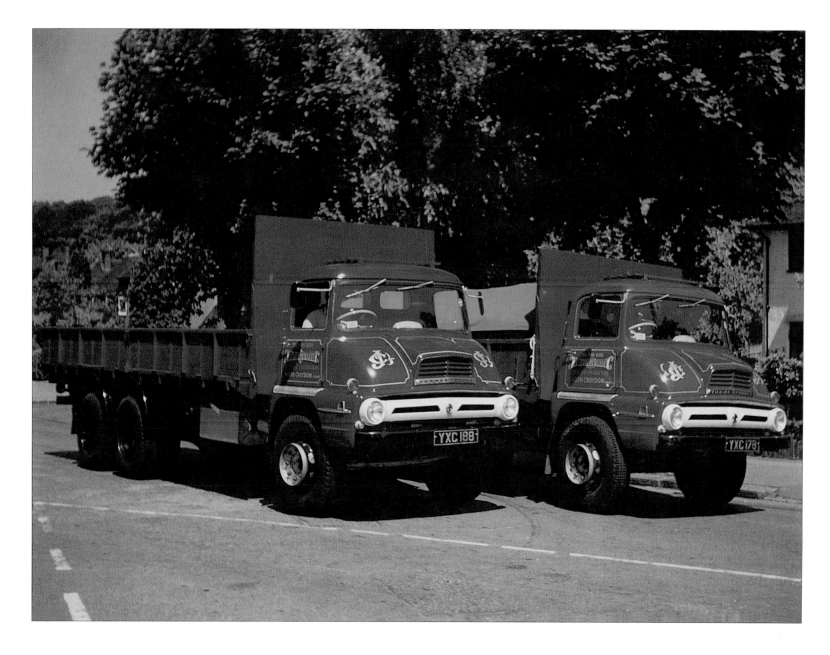

35. *A matched pair of 6x4 County Mark I Thames Trader Tandems delivered new to a Surrey haulage contractor in 1960.*

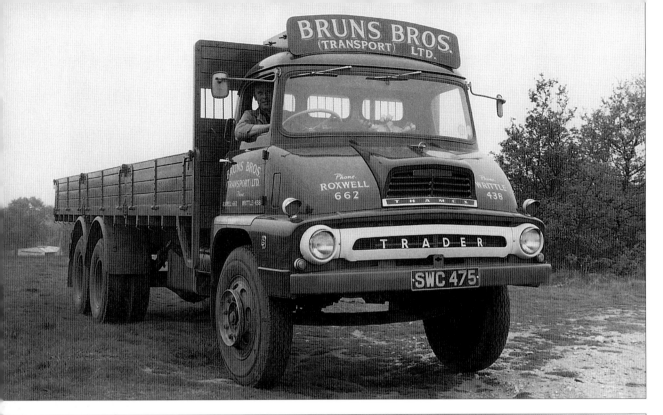

36. A 6x2 County conversion of a 1963 Mark II Thames Trader belonging to an Essex haulage contractor.

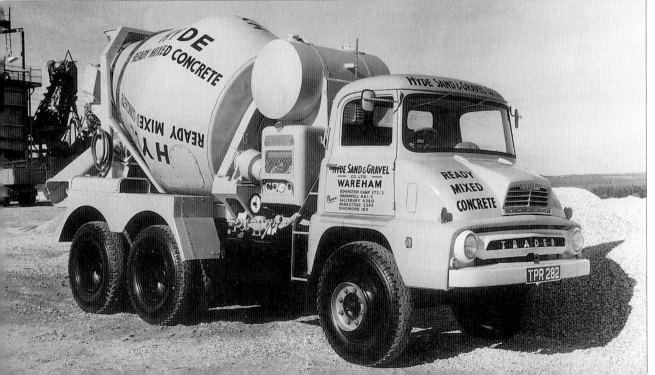

37. A concrete mixer based on a 1962 County 6x4 Thames Trader Tandem in Dorset. These concrete mixers used a special 137 in. chassis produced by County.

38. County also developed a six-wheel conversion for the new Ford D-Series trucks released in May 1965. A pre-production model of the short wheelbase 6x4 is seen here with a tipper body in 1964. The six-wheelers were assembled at Fleet on the D800 chassis, but were marketed by the Ford Motor Company.

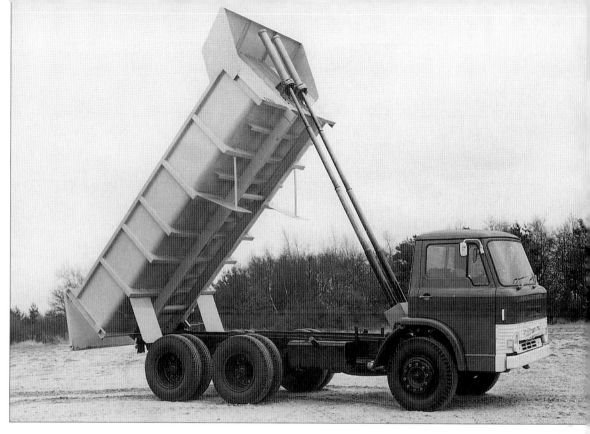

39. Ford D-Series trucks at Fleet. County also built a low-loader version of the six-wheel D-Series with a special body for the soft-drink industry. After the D1000 series model was introduced in the mid-1970s, Ford started to manufacture the six-wheelers 'in-house' at Langley and County's long association with Ford trucks came to an end.

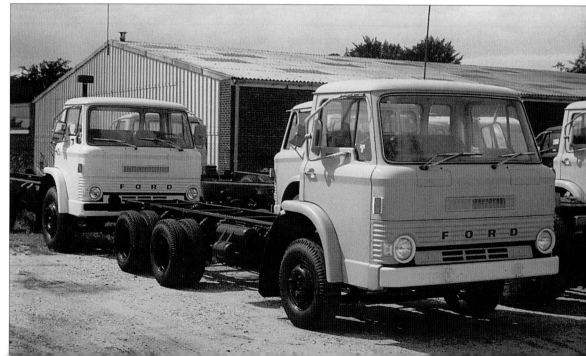

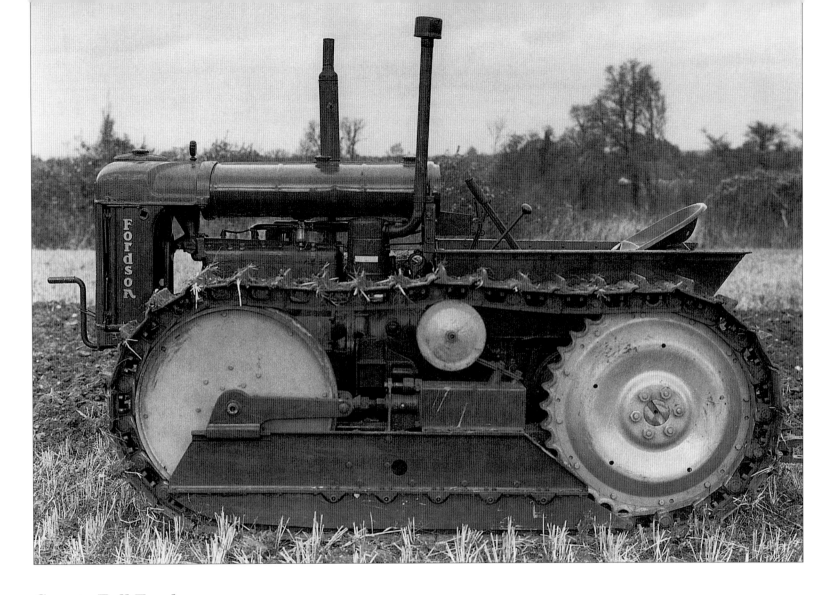

County Full Track

40. *County's first agricultural tractor, based on the petrol/TVO Fordson E27N Major, was built in 1948 following a request from Pest Control of Cambridge for a number of narrow-gauge crawlers for spraying hop fields. This prototype was made as a standard 52.5 in. gauge machine as the special castings for the shortened rear-axle housings had been delayed. International TD6 crawler tracks were used, and the front idler consisted of a fabricated assembly with two solid-steel discs.*

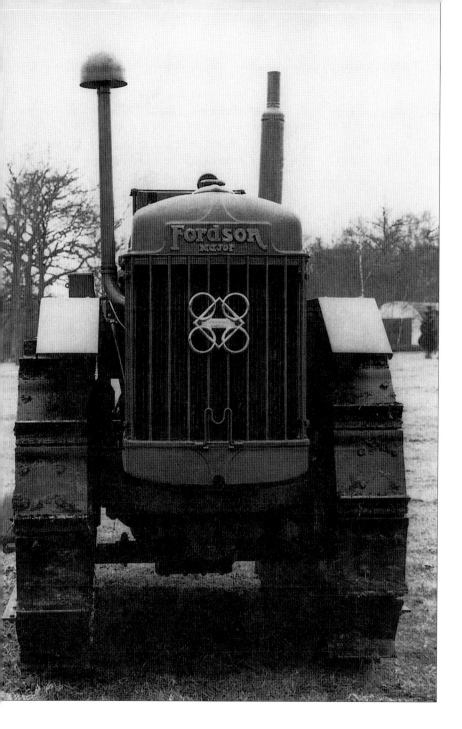

41, 42. *Five, narrow 34 in. gauge crawlers were delivered to Pest Control. The machine in the photographs is believed to be one of the original narrow-gauge machines which has been refurbished at a later date with improved tracks, cast front idlers and a Perkins P6 diesel engine.*

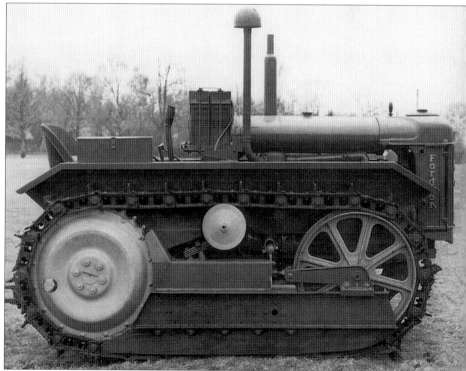

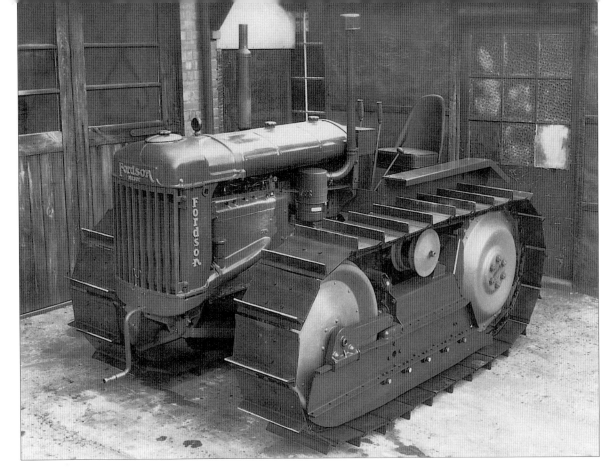

43. The standard-gauge machine, now with pressed-steel front idlers and County's own design of pin and bush tracks, went into production in 1949 at the rate of ten a week. There was some talk of calling the tractor the 'Kent' in keeping with the company policy of naming its products after English counties, but the crawler was eventually launched as the County Full Track, priced at £765. An early production model, fitted with 16 in. tracks, is seen outside the development shop.

44. Improved cast spoked front idlers were fitted to the crawler from 1950. The Full Track had a unique steering clutch mechanism, operated by internal expanding Girling shoes enclosed in a brake drum. Pulling on either steering lever released the internal shoes from the drum, disengaging drive to the appropriate track.

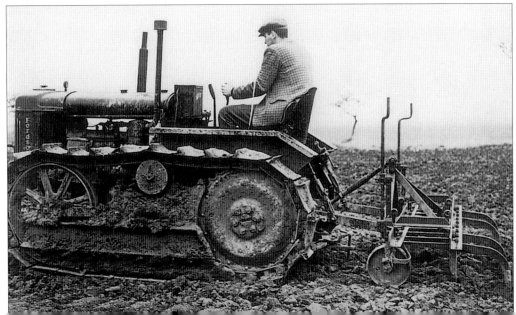

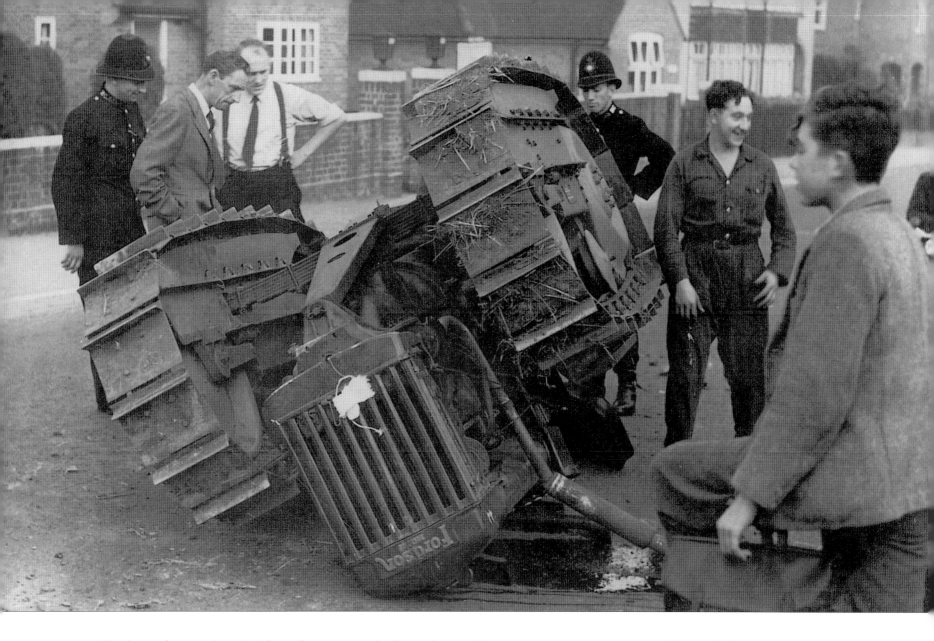

45. An embarrassing incident that occurred after a lorry driver attempted to move one of County's demonstration tractors from one part of the works to another, without strapping it down or ensuring it was in gear. The crawler fell off the lorry only 50 yds from Fleet police station and the driver was charged with having an unsecured load. Fortunately, no one was hurt, and County's service engineer, John Heathers (in overalls), seems greatly amused by the affair.

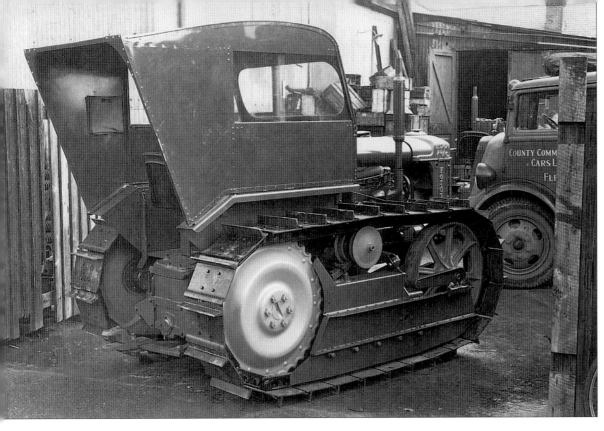

46. A County Full Track, fitted with a Scottish Aviation cab, in the old works yard at Fleet. As demand for the crawler increased, manufacture was shared between Fleet and the Harewood Forest Works belonging to Kennedy and Kempe at Longparish, near Andover, and production rose to 20 machines a week.

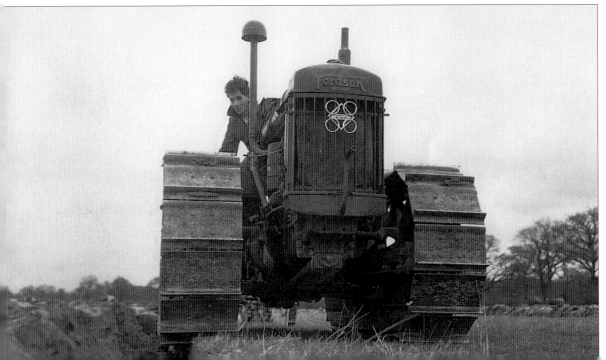

47. A County Full Track fitted with a Perkins P6 diesel engine. The old Fordson petrol/TVO engine had its drawbacks; at 29 hp, it lacked power and its out-dated gravity-fed lubrication system resulted in problems when working on slopes. Many farmers specified the optional 45 bhp Perkins engine which was more refined and more powerful, but more expensive.

48. *Fitted with a Perkins P6 diesel engine, this County Full Track was restored by the company for its golden jubilee celebrations in 1979. County was also approached to build crawlers for Massey Harris on the 744D skid unit with the same Perkins engine, but they declined rather than risk upsetting Ford.*

Below

49. *The Chubbock Dredger, based on a County Full Track. Designed by contractor, Mr F W Chubbock of Loddon in Norfolk, the machine was built up for him by J J Wright of Dereham. Fitted with a 6 ft 6 in. bucket, hoisted by a cable passing over the tractor to a rear-mounted winch, the machine was capable of clearing over 170 yds of ditch in a day. The fourth version of the machine is seen at work in 1951.*

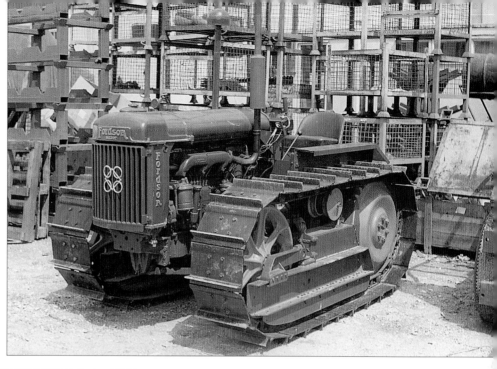

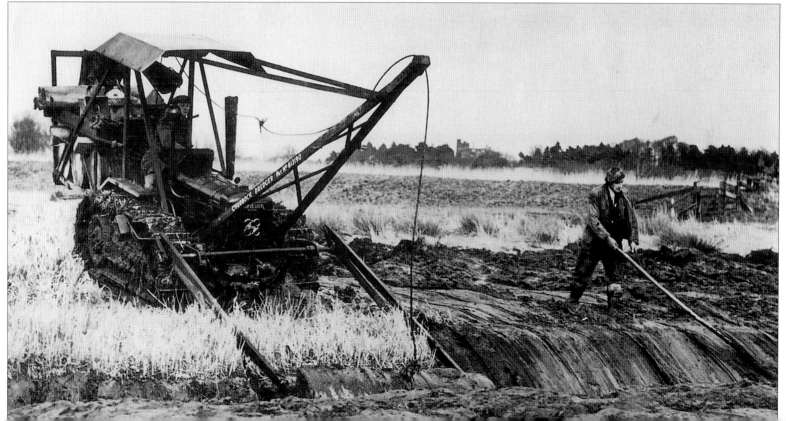

Agricultural crawlers

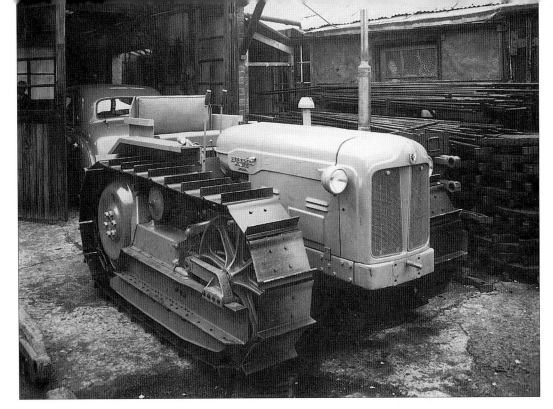

50. County was loaned a pre-production model of the new Fordson E1A Major tractor, due to be released in November 1951, and was able to secretly develop a crawler version in a shed at the bottom of the Fleet yard. The new crawler was ready for the Smithfield Show in December. It was designated the Model Z, as all the parts used which were not common to the old model Full Track were given the suffix 'Z'.

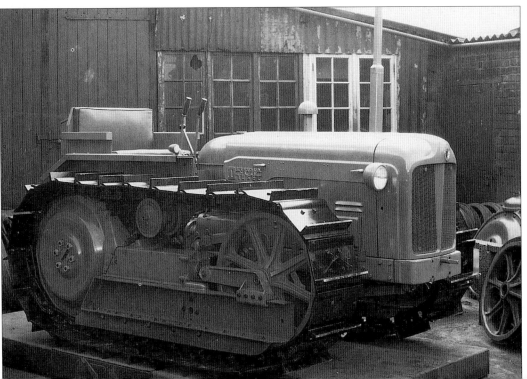

51. In 1954, the agricultural crawler (shown) became known as the Mark II to differentiate it from the Mark III industrial version launched at the same time. The crawlers used the excellent 40 hp four-cylinder Fordson Major diesel engine. Petrol and TVO options were available but were rarely specified.

Facing page

52. A County Mark II agricultural crawler in action. Many of the trials for the early crawlers were carried out on a farm in Kent belonging to Ernest and Percy Tapp's brother, Arthur.

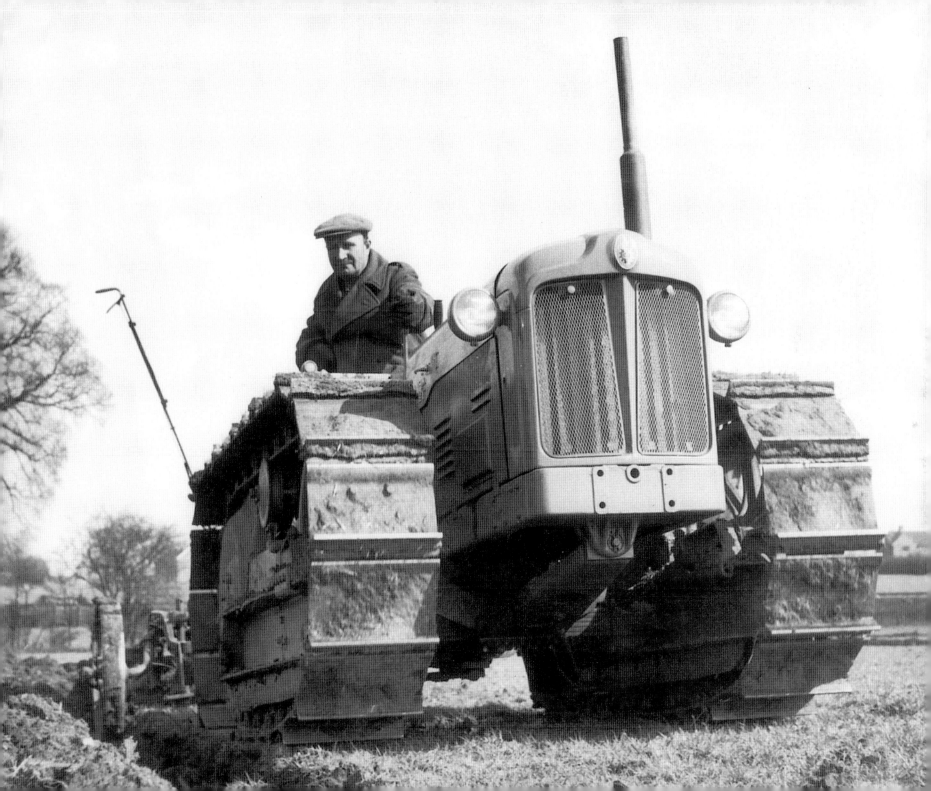

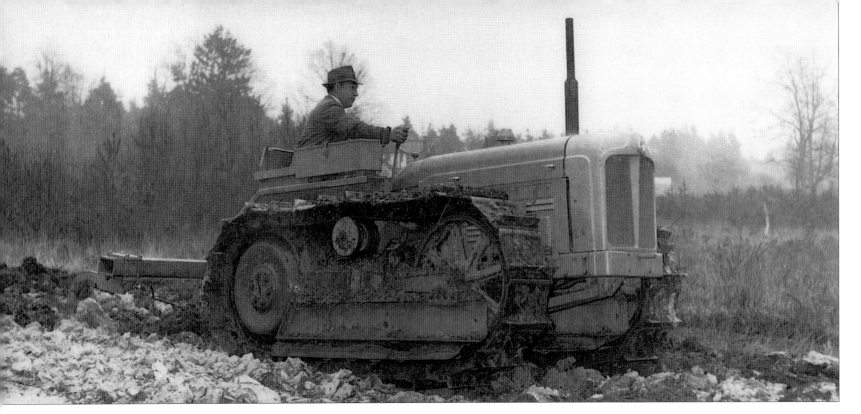

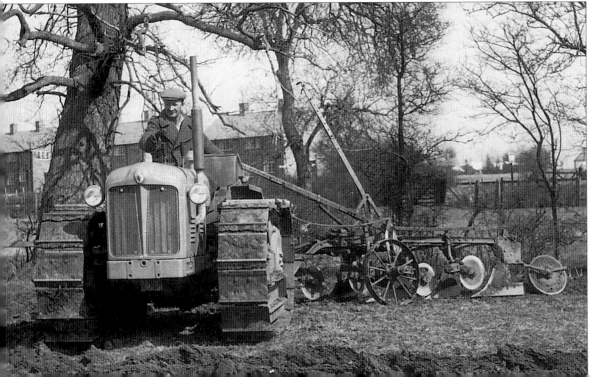

Above
53. John Heathers panbusting with a County crawler near Fleet. The heavy-duty toolbar was a County product designed to mount tools available for use with the Caterpillar D4 and other similar crawlers.

Left
54. County's high track profile provided good ground clearance and excellent traction. The Mark II crawler was claimed to be capable of a maximum sustained pull of 10,500 lb, and would handle four- or five-furrow ploughs with ease.

55. *The County Ploughman was introduced in 1957 to replace the Mark II. Fitted with improved roller-bush tracks, it also had the option of multi-plate steering clutches. After the launch of the new Fordson Power Major skid unit in 1958, it became known as the Ploughman P50, rated at 51.8 bhp.*

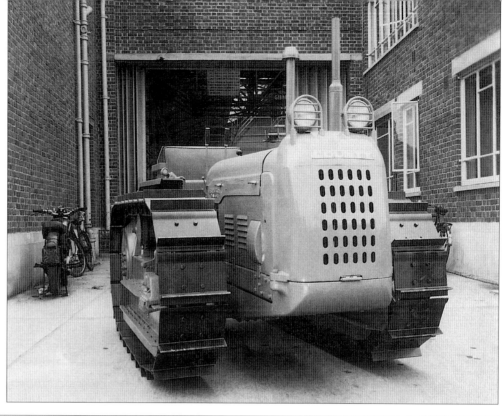

Below

56. *A Ploughman P50 on test with a dynamometer car recording drawbar pull at the National Institute of Agricultural Engineering at Silsoe.*

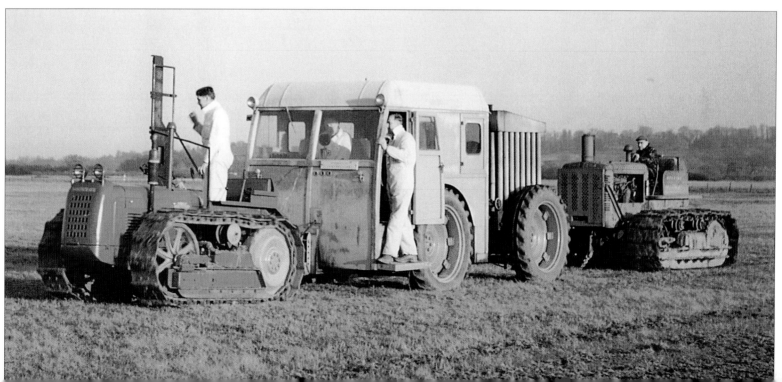

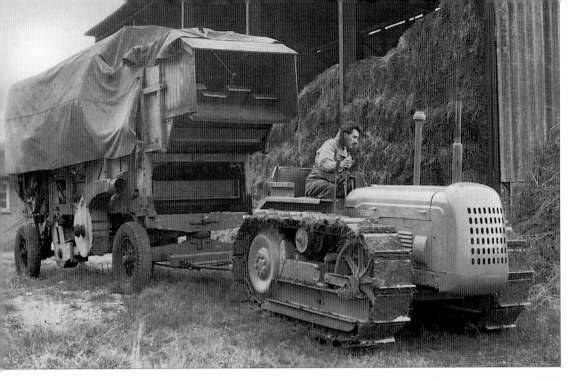

57. A County crawler is used to manoeuvre a threshing drum into position. Peter Jaggard, County's sales manager is at the controls.

58. Following the introduction of the Fordson Super Major skid units in 1960, the agricultural County crawler became known as the Ploughman P55 and was fitted with an uprated 55 hp version of the Ford engine. It was also finished in the same yellow colour scheme as the industrial crawlers. This example is still used on a Scottish farm for consolidating the silage clamp.

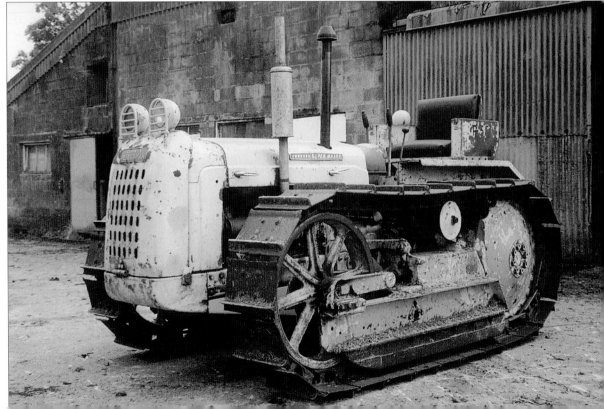

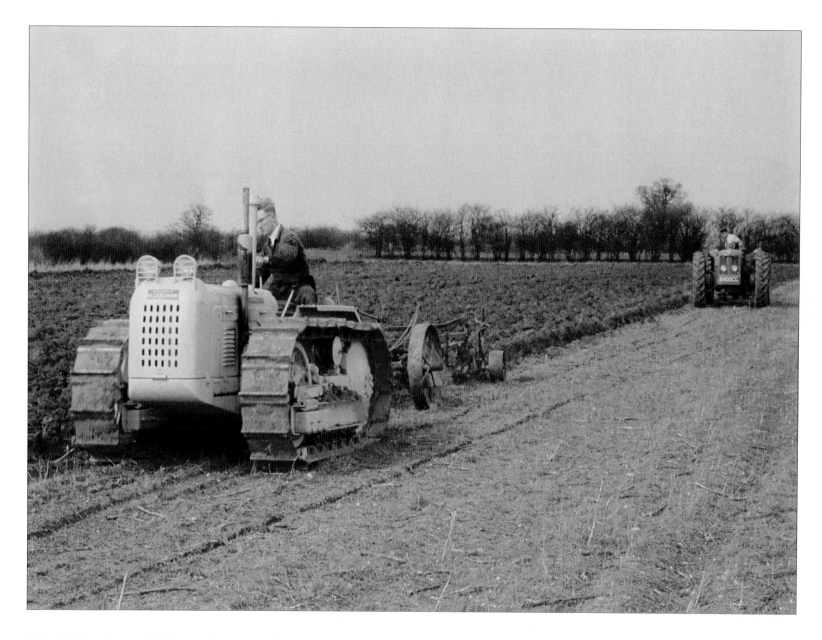

59. *A Ploughman P55 crawler at work. By this time, County was also heavily involved in four-wheel drive production, and in the background is one of the company's Super-4 tractors.*

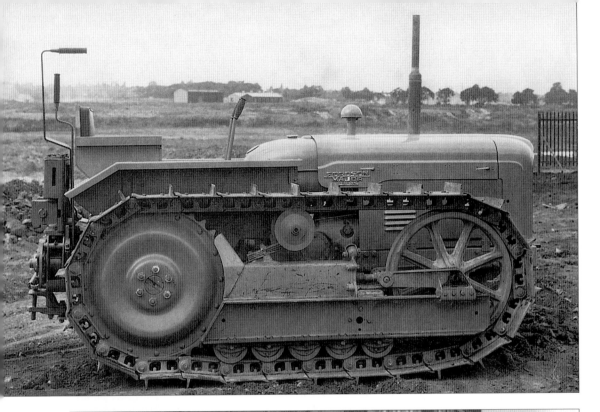

Industrial crawlers

60. A County industrial Mark III crawler fitted with an Onions cable control winch for use with a scraper. The industrial and export Mark III was introduced in 1954 at the same time as the agricultural Mark II. County experienced a number of problems with stress fractures with this model, when used with dozer equipment and had to brace the rear axle to the side frames.

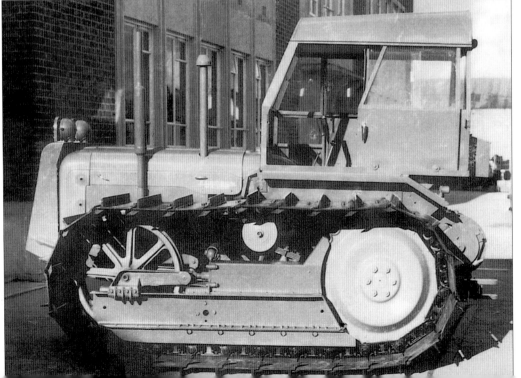

Left
61. An industrial Mark III County crawler fitted with a Boughton winch and a Winsam cab.

Facing page
62. An industrial Mark III crawler with a Bray angledozer used by McAlpines in the construction of the Marchwood power station near Southampton.

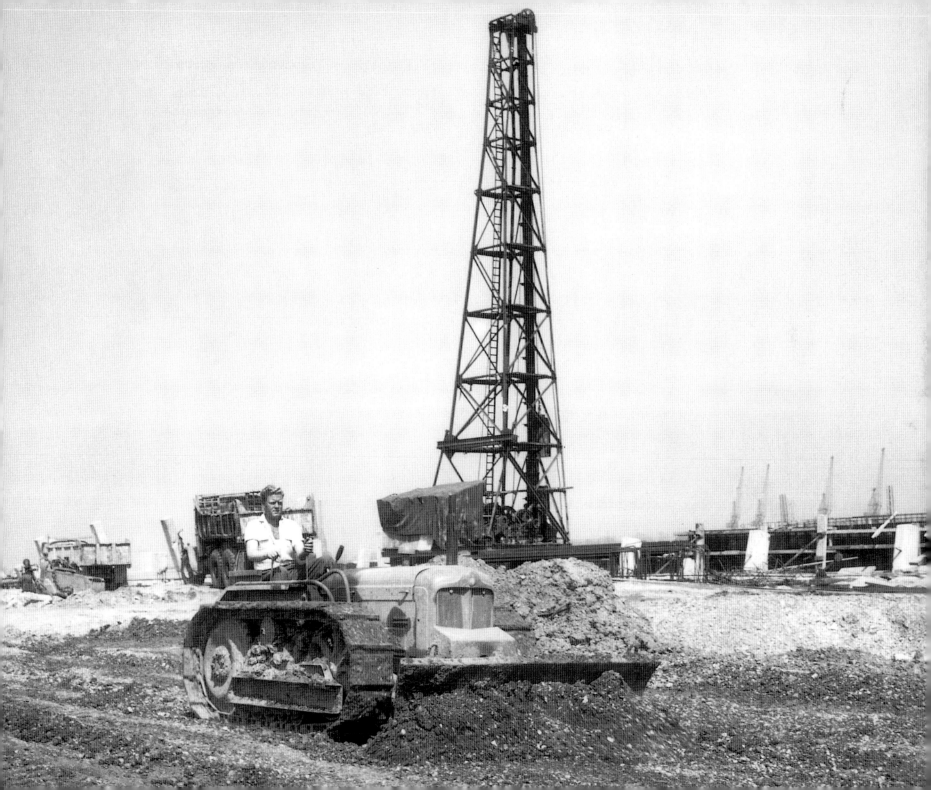

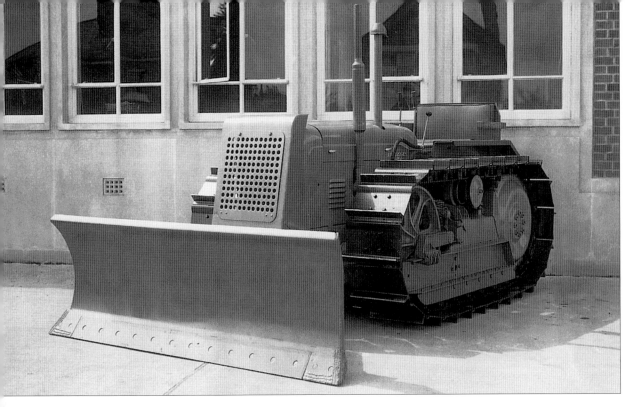

63. The industrial Mark IV County crawler, which replaced the Mark III in 1956, included several design improvements, including eight-stud rear axles in heavy-duty cast steel housings.

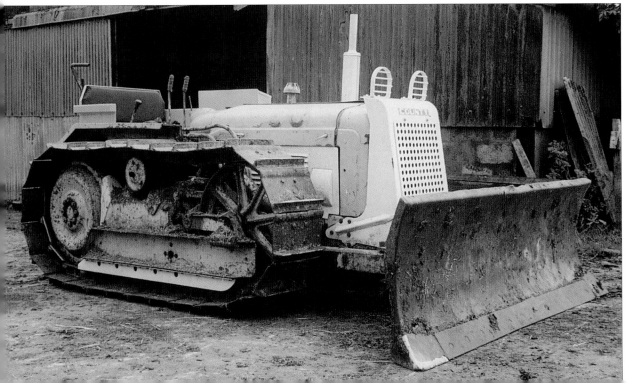

64. Photographed in 1995, this industrial Mark IV County crawler, fitted with Bray dozer equipment, is still in regular use.

65. *An industrial County CD50 fitted with a Boughton 4200 winch and a Bray angledozer blade. The CD50 was introduced in 1959 to replace the Mark IV A sister machine to the agricultural Ploughman crawler, it also featured roller-bush tracks and multi-plate steering clutches.*

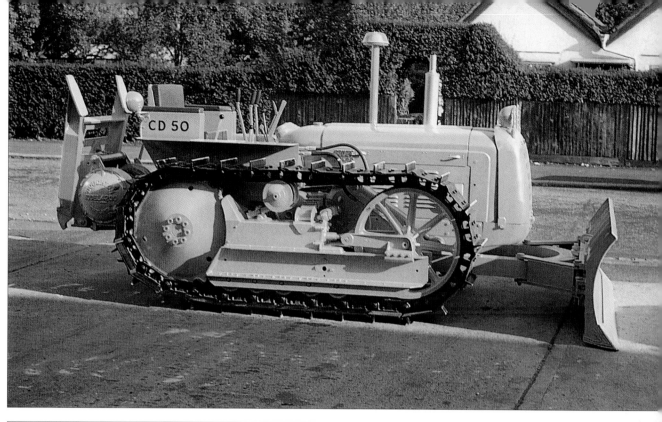

66. *Like the Mark IV, the CD50 was built with cast steel axle housings and was ideally suited to dozer work. This example working in Surrey is fitted with a Lambourn canvas cab.*

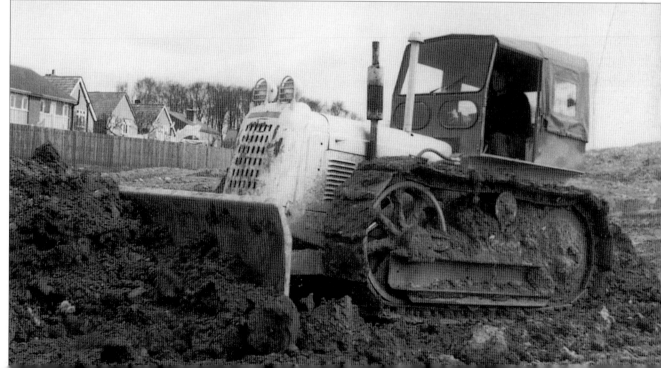

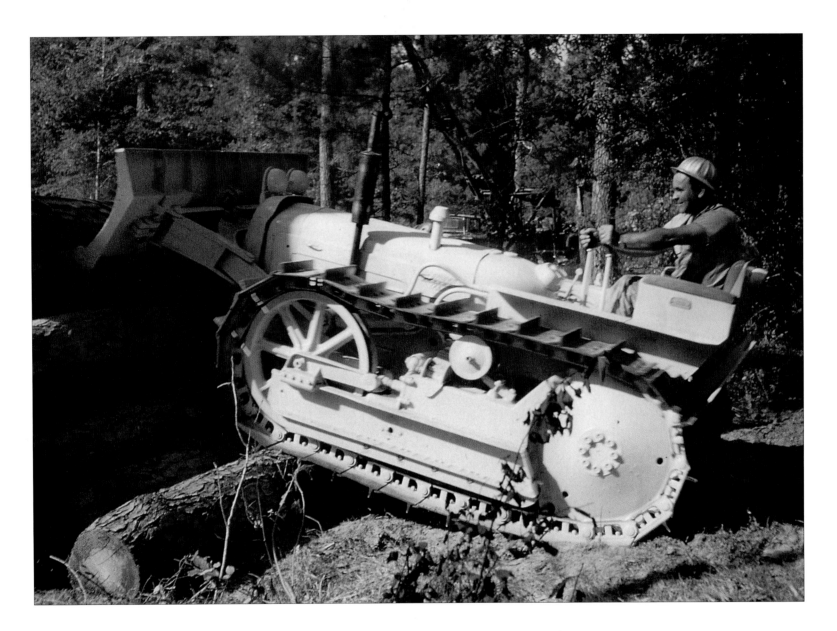

Above
67. A number of CD50s were exported, including this machine, which went to the USA, seen here logging in Texas.

Facing page
68. A County CD50 waiting to go into the Smithfield Show at Earls Court.

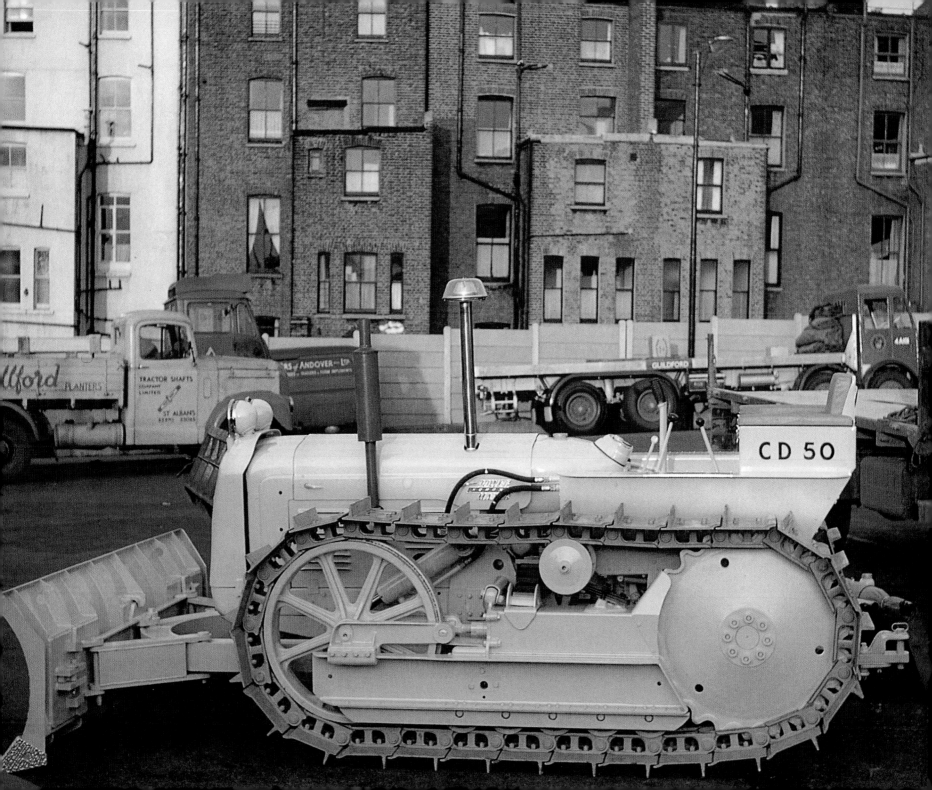

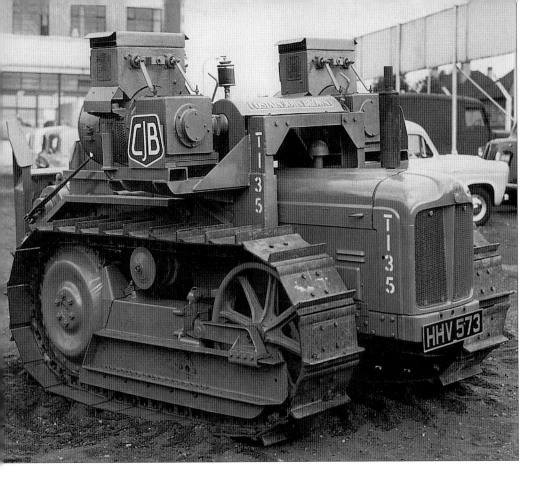

Industrial applications

69. *Designed for use in pipeline construction, this 1954 Mark III crawler was fitted with mobile welding equipment and a Boughton winch for Costain-John Brown.*

Right
70. *A Merton Overloader, built at Feltham, mounted on a Mark III County crawler. Designed for bulk loading, the machine would be fitted with a bucket at the front to lift materials, such as sand or gravel, on to the conveyor which discharged at the rear. The tractor was fitted with industrial tracks for working on loose conditions.*

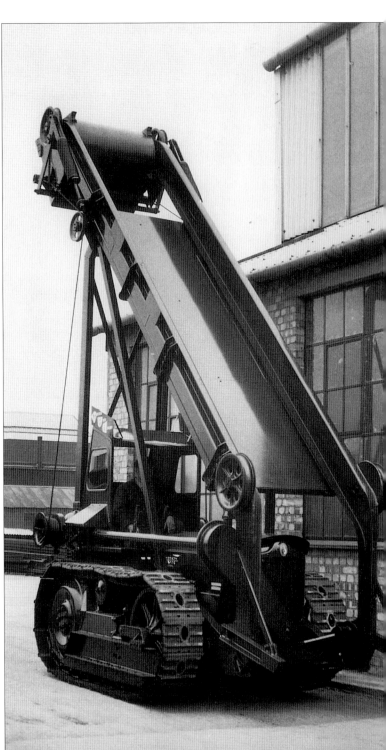

71. *TT Boughton & Sons Ltd, of Amersham Common, Buckinghamshire, made a range of winches and other specialist equipment to fit County tractors. One of the company's 4000 series winches is seen fitted to a County Mark III crawler.*

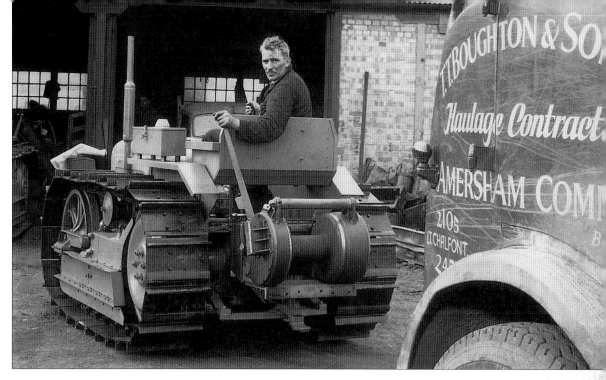

72. *Backhoe loader attachments for County crawlers were made by both Steelfab and JCB. A County Mark IV is shown fitted with a JCB Hydra-Digga backhoe in 1958.*

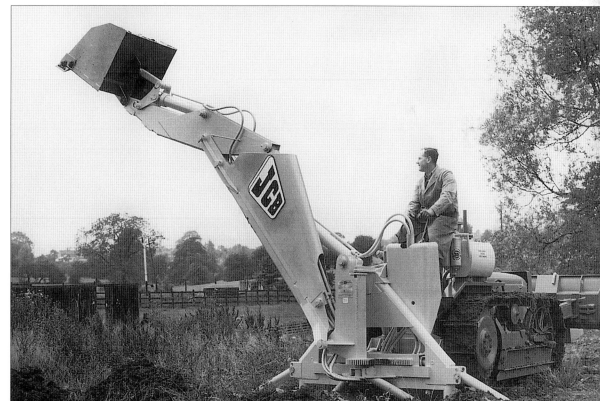

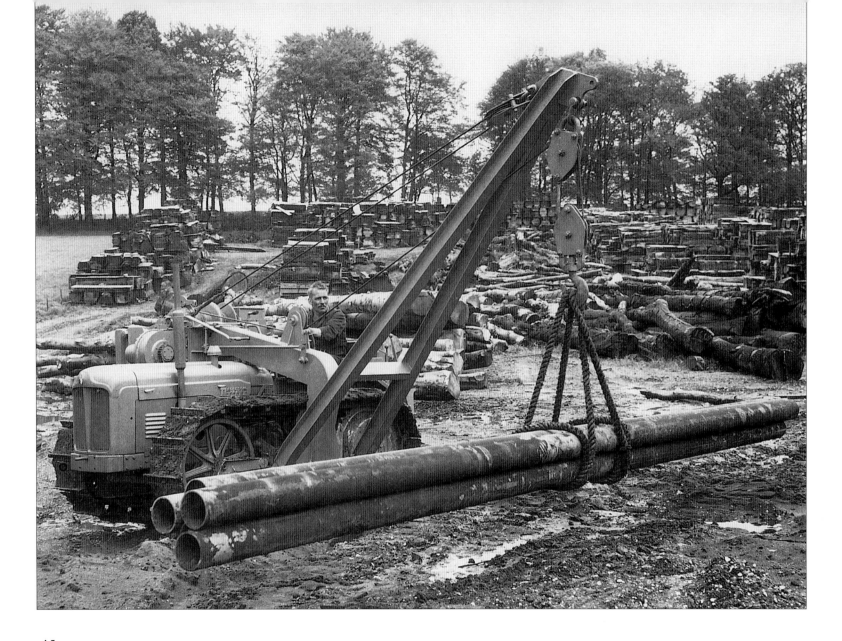

Above
73. A side-boom crane was jointly developed by County and TT Boughton. Primarily designed for pipeline construction, the crane was also suitable for use in timber yards and had a maximum lifting capacity of five tons at 4 ft jib reach.

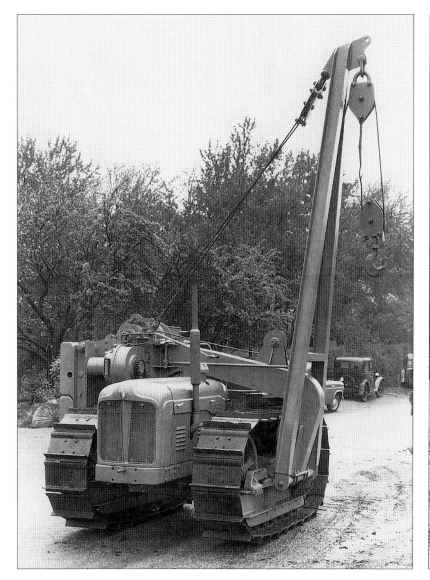

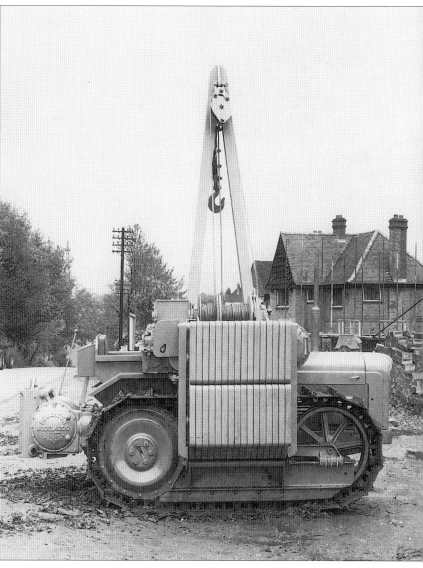

74. *The prototype Boughton side-boom crane fitted to a Mark III County crawler. Note the duplex chain drive to the hoisting and luffing winches.*

75. *Thirty-two 104 lb counterweights, weighing a total of 3,332 lb, balanced the crane in work. A Boughton 4200 winch was also fitted to move the pipes into position ready to be lifted.*

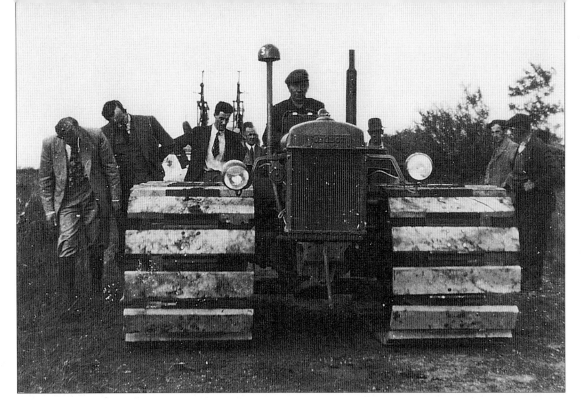

Swamp crawlers

76. *This early attempt to adapt the County Full Track for swamp work is believed to have been carried out in conjunction with the Irish Forestry Commission. The tractor has been fitted with wide-gauge running gear and 30 in. wooden track shoes.*

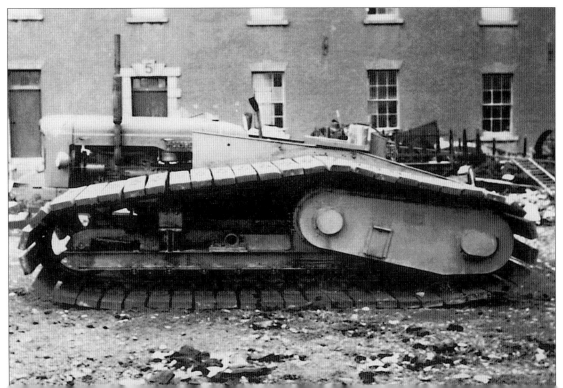

77. *Based on a County crawler skid unit, the Bord-na-mona tractor was developed for peat bog reclamation in Ireland. It had an enclosed chain drive to the rear sprockets, and the wide flotation tracks were made of oak.*

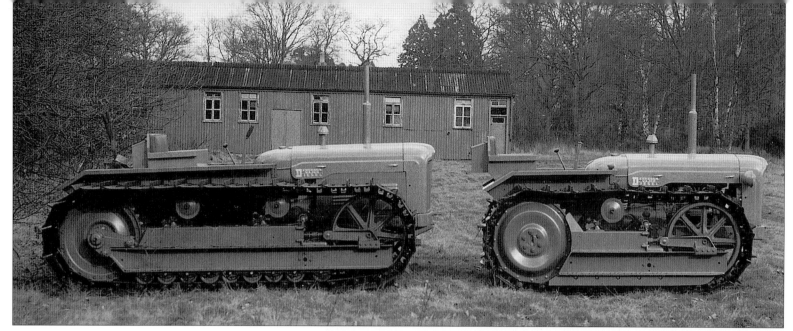

Above

78. County's own swamp tractor, based on the Mark III crawler, first appeared in 1954. The long swamp version, shown compared to a standard crawler, was designed for cross drainage work. County lengthened the tractor by fitting a dummy transmission housing between the gearbox and rear transmission. The extended track frames were mounted on a pivot on the rear-axle hubs.

Right

79. With 30 in. tracks and a clean underbelly, the County long swamp tractor was capable of working in conditions where it would even be impossible to walk and exerted a ground pressure of only 2.26 psi.

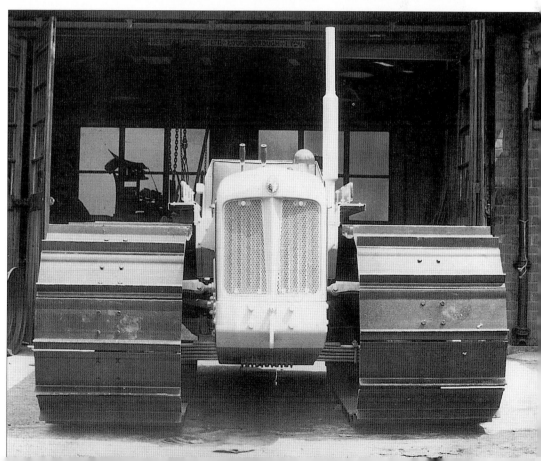

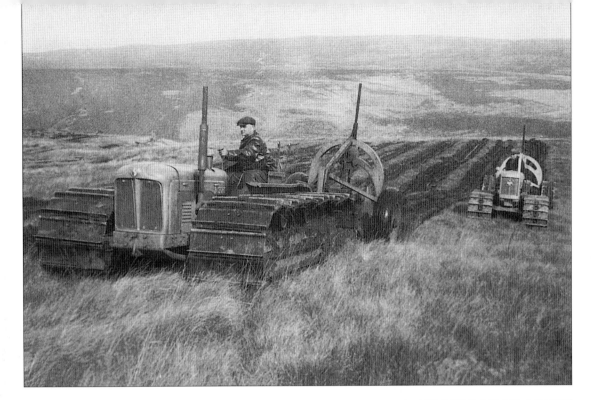

80. A County long swamp tractor working with a Cuthbertson plough in Scotland for the Forestry Commission. County swamp crawlers were used for land reclamation work, draining peat bogs and preparing wetlands for cultivation and afforestation. The second crawler in the photograph, a Howard Platypus Bogmaster, turned out to be no match for the County.

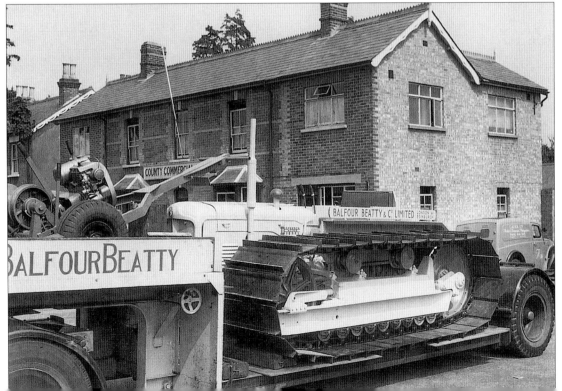

81. A County long swamp tractor sold to Balfour Beatty who used it for towing electric cables into position on pylon schemes. The tractor is seen being collected from County's premises in Albert Street, Fleet. In the background is a van belonging to County's photographers, C & E Roe, who had been sent to record the event.

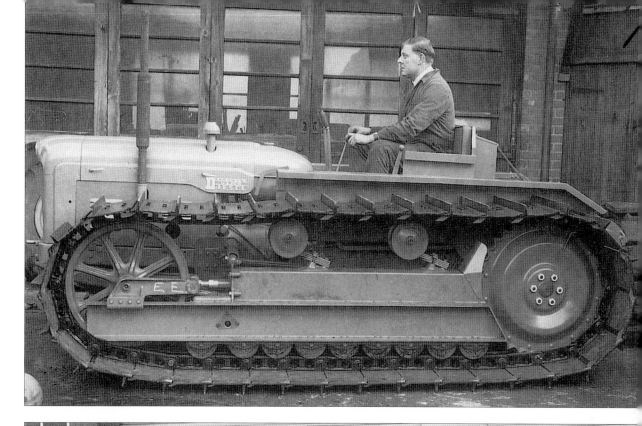

82. Later County long swamp tractors were fitted with longer cast steel axle housings and had the track frame supports mounted on the inside. Fitter, George Collier, is at the controls.

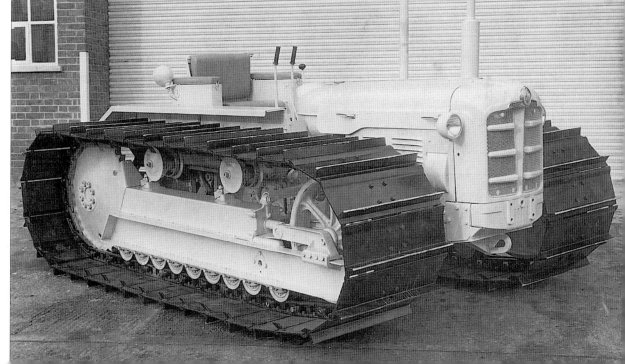

83. This long swamp tractor, based on a Super Major County CD50, is believed to have been the last County crawler built, and was one of three exported to Japan in November 1965.

County Four-Drive

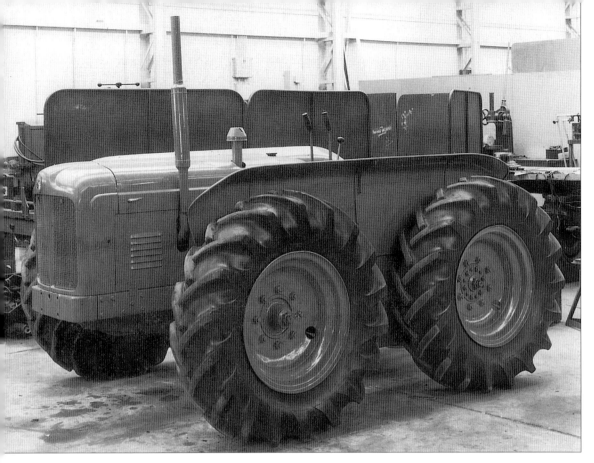

84. County's first four-wheel-drive tractor, the Four-Drive, was introduced in 1954. Based on the crawler skid unit, the front wheels were chain driven from sprockets on the rear axle. The crawler expanding-shoe steering clutches were retained and the tractor was 'skid steered', relying on the flex in the rubber tyres. 12x24 tyres were used on the prototype, but 14x30s were found to give better performance.

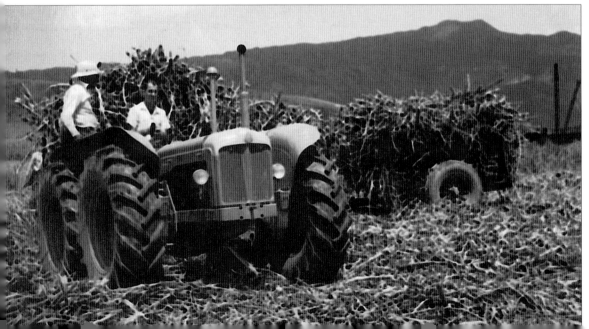

85. The Four-Drive was designed specifically at the request of the sugar-cane industry in Puerto Rico. County's brief was to supply a wheeled tractor that had the performance of a crawler in the field, yet could be used on the road to take the crop to the refinery. In the right conditions, the Four-Drive proved itself capable of handling up to 60 tons with ease.

86. In 1958, a small number of Four-Drive skid units were supplied to Manchester-based, E Boydell & Company, manufacturers of Muir-Hill dumpers and earthmoving equipment. The Four-Drives were adapted to form the basis of a new loading shovel which was sold as the Muir-Hill 4WL. It is believed that very few were produced.

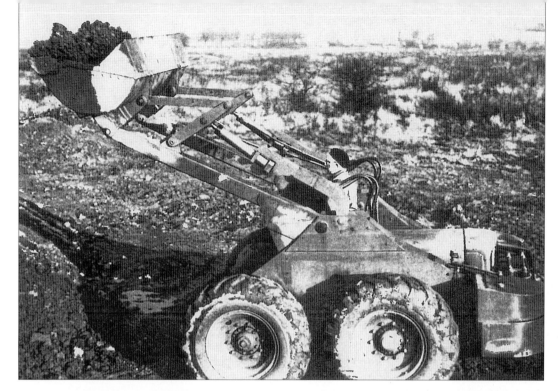

87. A County Four-Drive that was restored by the company, photographed in the yard at Fleet in 1983. The drive to the front wheels ran in an oil bath inside an enclosed articulated chain case that also housed the front wheel hubs. Although the Four-Drive was a success in the West Indies, few were sold in the UK.

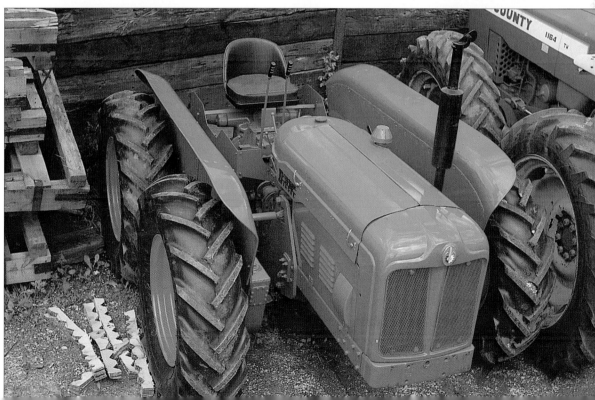

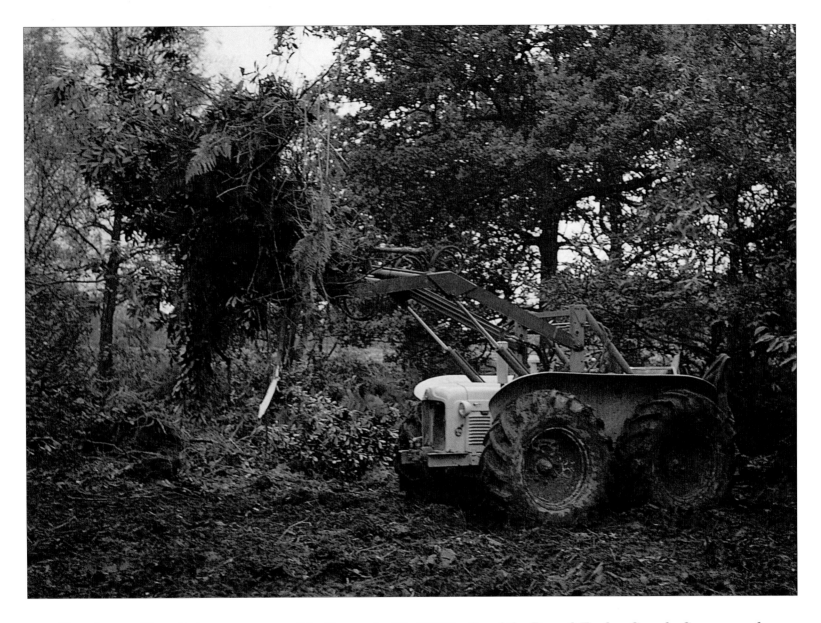

88. *This County Four-Drive was operated in Sussex by Mr F H Martin of the Round Timber Supply Company of Heathfield. Used for clearing scrub and woodland, the tractor was fitted with a Whitlock loader, a Bray Hydro clamp and a Boughton ten-ton winch, and was capable of lifting a tree trunk weighing up to two tons.*

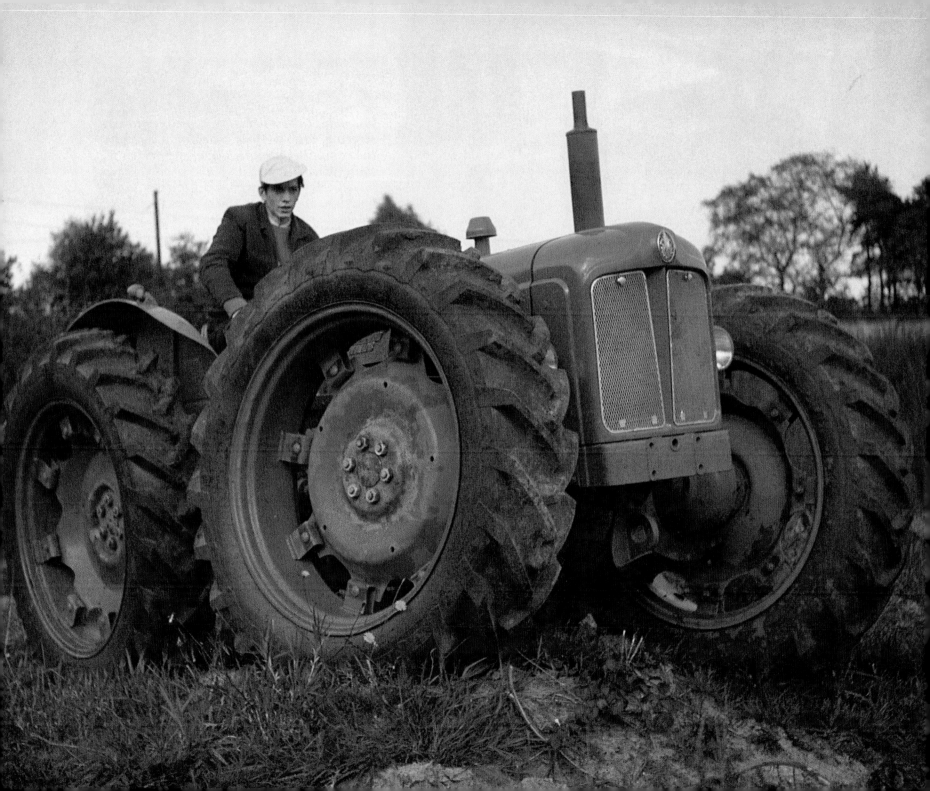

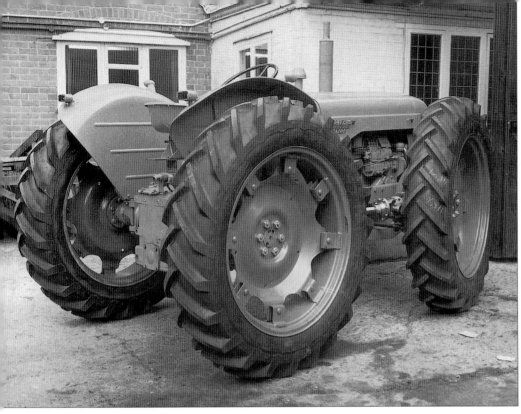

Super-4

Previous page and left
89, 90. The Super-4 was County's first four-wheel-drive tractor with conventional steering, and the first machine to embody the company's unique design principle of twin drive shafts. This 1960 prototype was based on a Fordson Power Major without hydraulics. After its trials were completed, it was dismantled and the four-wheel-drive parts sold off to a local farmer.

Below
91. A Super-4 being tested for drawbar pull, with a dynamometer car based on a Scammell tractor unit at the Motor Industry Research Association's test track at Lindley in Warwickshire.

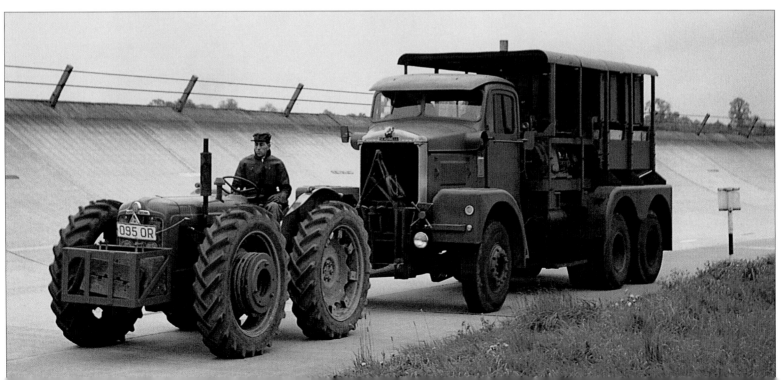

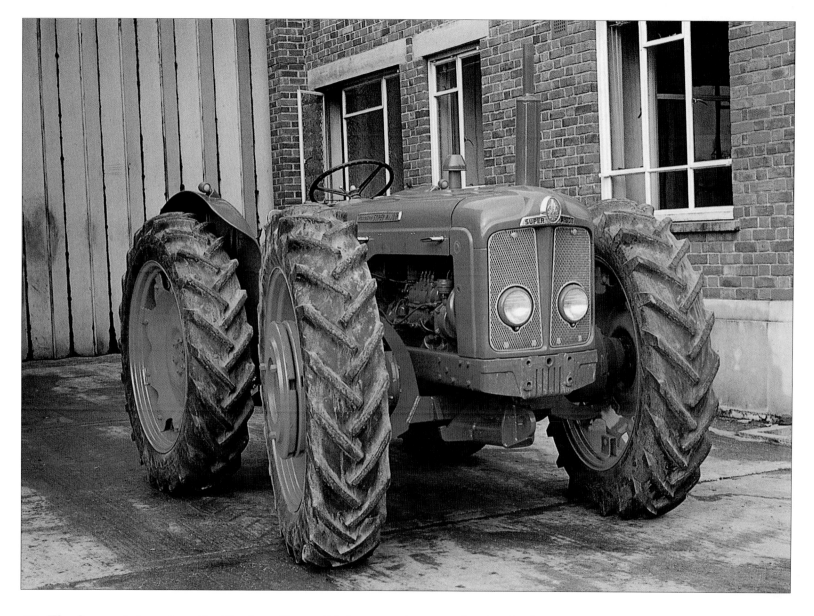

92. *The Super-4, based on the Fordson Super Major, went into production in August 1961, priced at £1,470. The four-wheel-drive transmission utilised many 'off-the-shelf' Ford parts, including Dexta crown wheels with modified pinions and Thames Trader universal joints.*

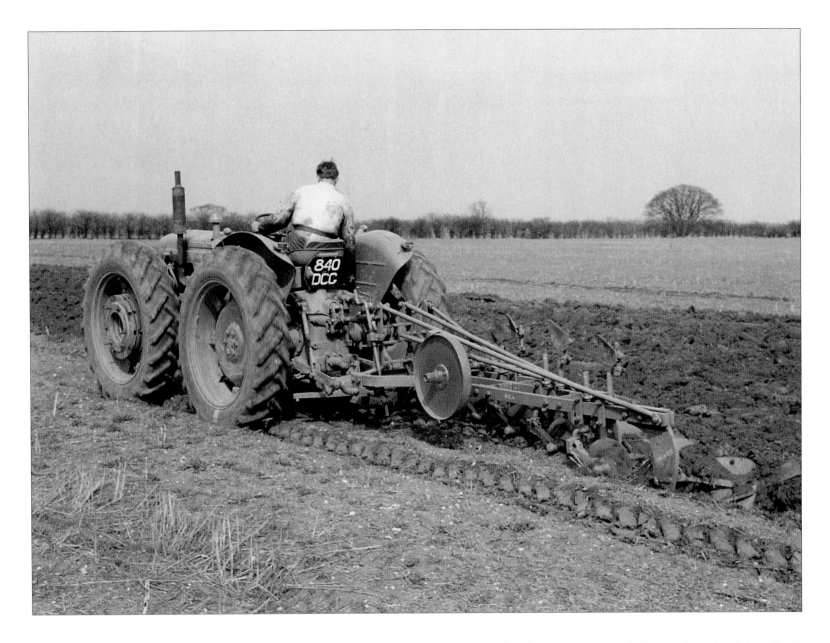

93. A 1961 County Super-4 working with a five-furrow Ransomes plough. The advantage of County's twin drive shaft design was that the standard differential and steering brakes acted on all four wheels.

94. *In response to the demand for increased horsepower, County introduced the Super-6, fitted with a six-cylinder Ford 590E engine developing 95 bhp. The gearbox was also modified and strengthened and a Borg & Beck 13 in. heavy-duty clutch was fitted. This prototype Super-6 is shown outside the Fleet works in 1962.*

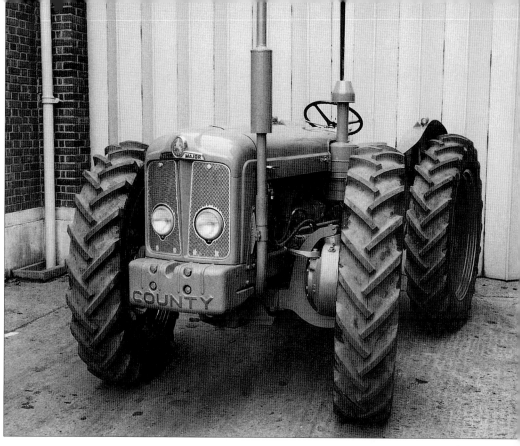

Below
95. *An early production model County Super-6 dating from late 1962.*

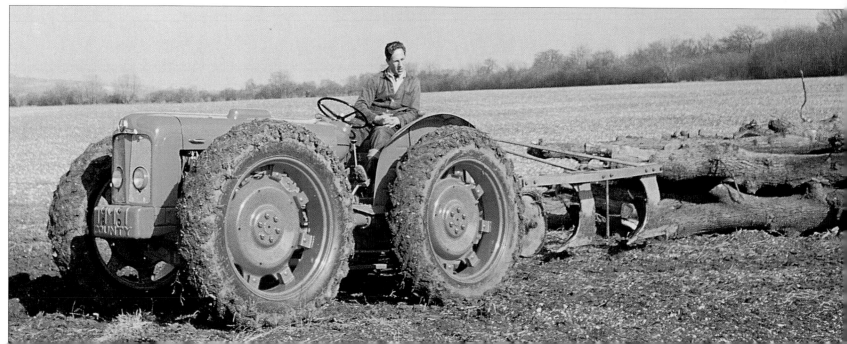

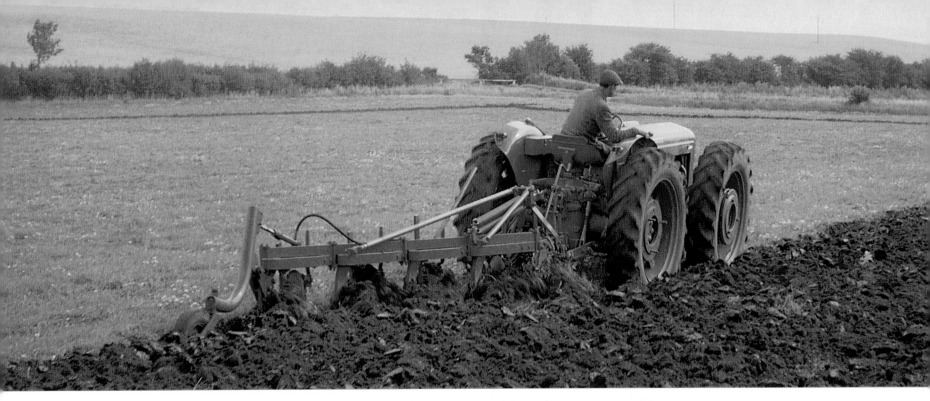

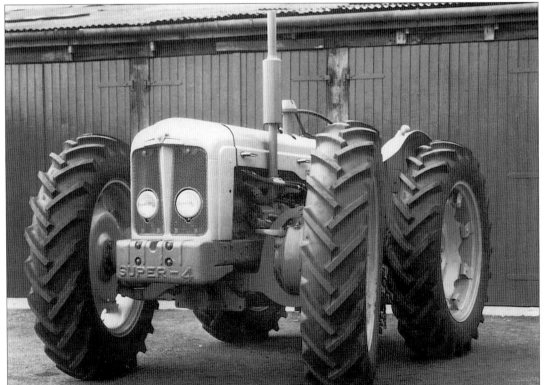

Above
96. A County Super-6 with a five-furrow Ransomes plough.

Left
97. A late model Super-4, based on the 'New Performance' Super Major introduced in June 1963. This tractor would be finished in the new Ford blue and grey colour scheme.

98. *From 1963, the Super-6 was also restyled and fitted with a fibreglass bonnet and a new distinctive radiator shroud.*

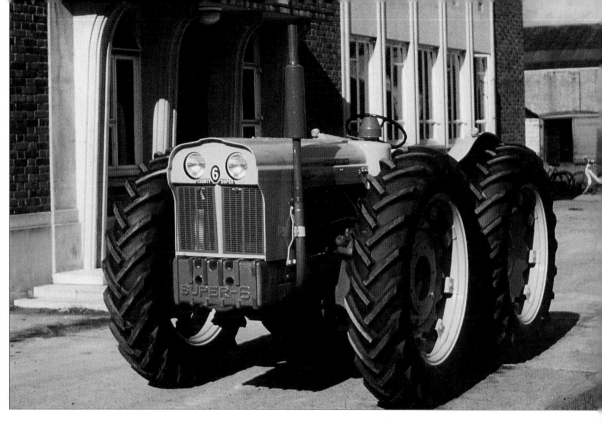

Below
99. *A County Super-6 pulling three Massey Harris 720A grain drills covering 27 ft in one pass. The Super-6 remained in production until late 1965.*

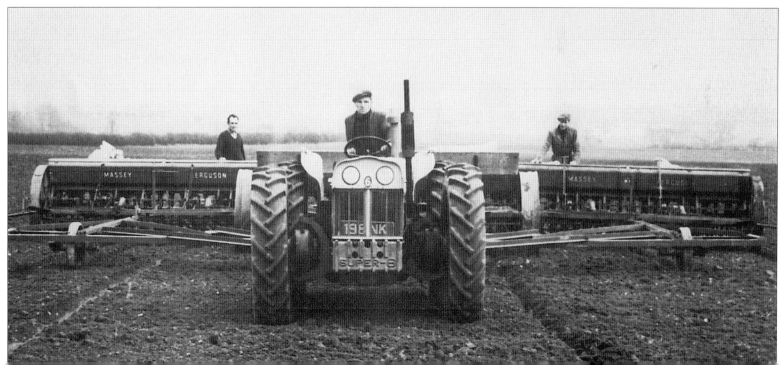

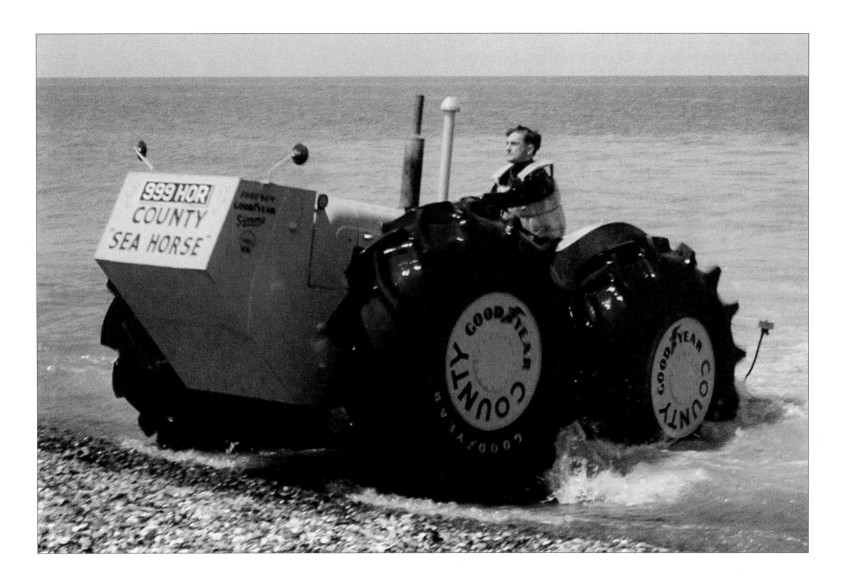

Sea Horse

100. The County Sea Horse, an amphibious version of the Super-4, was David Tapp's brainchild. Equipped with flotation compartments front and rear, it also had sealed watertight compartments in each wheel to provide extra buoyancy. Modified seals and extended breathers helped keep the tractor watertight. No electrics were fitted, and the tractor was started by a Simms inertia starter.

Right

101. In an unrivalled publicity stunt, David Tapp used the Sea Horse to cross the English Channel on 30 July 1963. The photograph also shows the pilot boat and County's support vessel which accompanied him on his trip. Note, the special 18x26 Goodyear cane and rice tyres have been fitted in reverse as initial trials carried out on Hawley Lake proved this to be the best method of achieving forward propulsion from the deep lugs.

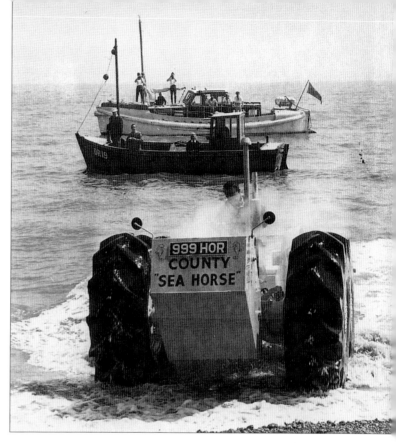

Below

102. The crossing of 28 nautical miles, from Cap Gris Nez on the French coast to Kingsdown near Dover, took 7 hours 50 minutes at an average speed of about 3.5 knots.

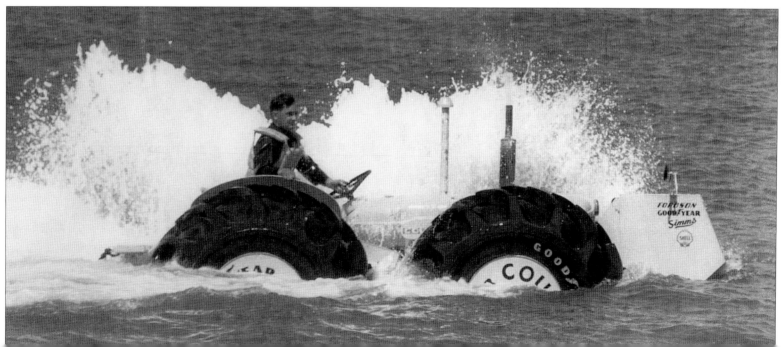

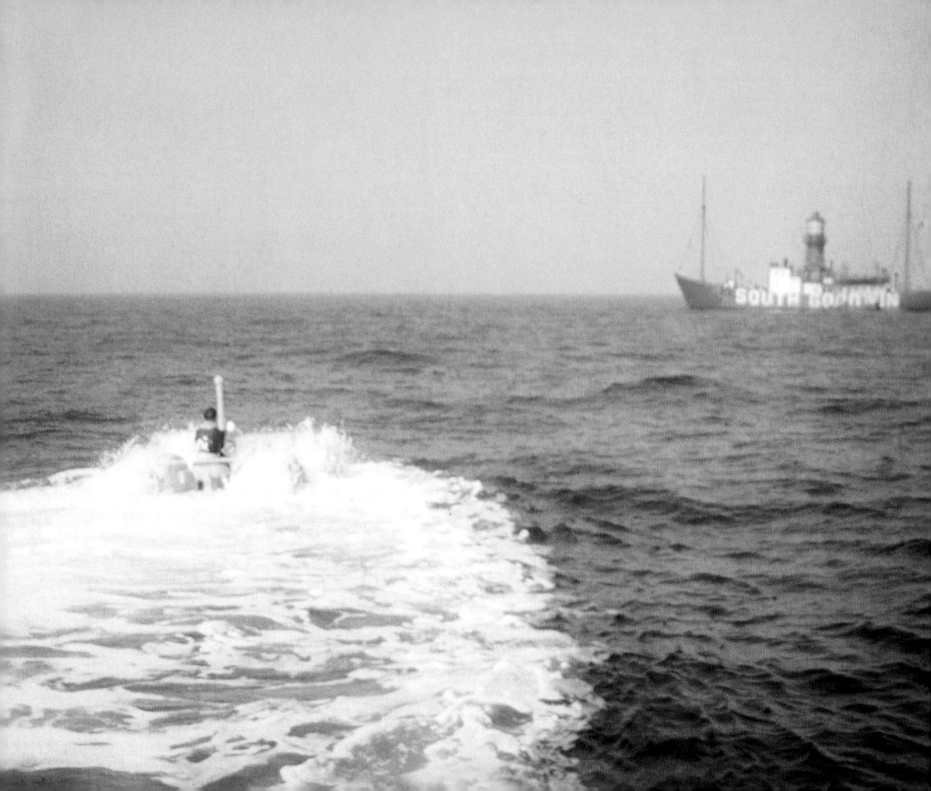

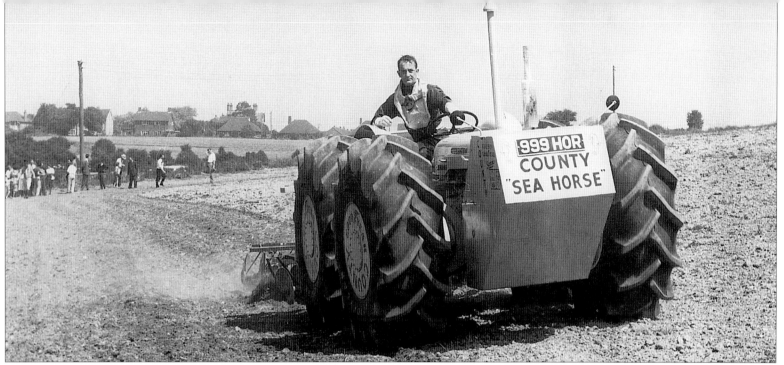

Previous page
103. The Sea Horse approaching the South Goodwin lightship. This was the only time the lightship ever had to log a passing tractor!

Top
104. On its arrival back in England, the Sea Horse was immediately put to work in a field with a set of disc harrows to show its versatility. Unfortunately, after a couple of minutes it ran out of diesel, demonstrating what a close run thing the crossing had been.

Right
105. The Sea Horse on trial in Scotland with a Cuthbertson drainage plough.

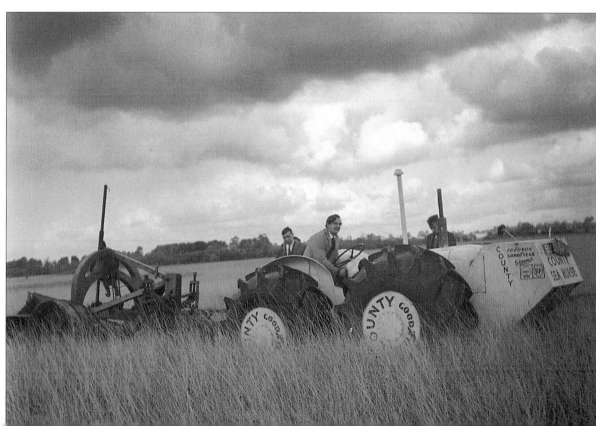

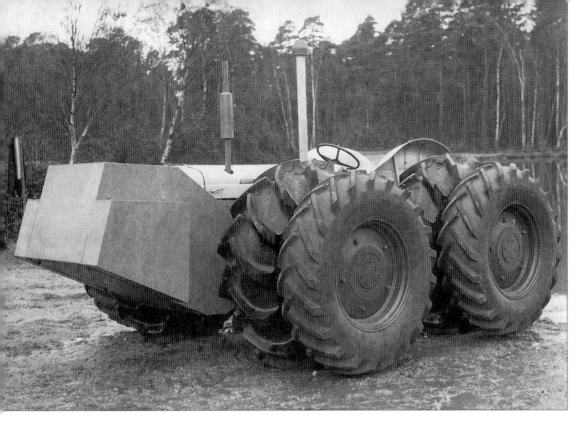

106. This six-cylinder version of the Sea Horse, based on the Super-6, was built for a demonstration tour of the USA. It was fitted with larger flotation tanks, to offset the weight of the engine, and dual wheels for extra propulsion.

107. Rising out of the depths – the Super-6 Sea Horse on test in Hawley Lake before it was sent out to the USA. County had hoped to gain publicity by taking the Sea Horse down the Mississippi. However, US Coastguards refused permission, so instead the tractor was driven across the great Lake Pontchartrain, near New Orleans. The Sea Horse was eventually sold by County dealers, M & L Tractors of Houma, Louisiana.

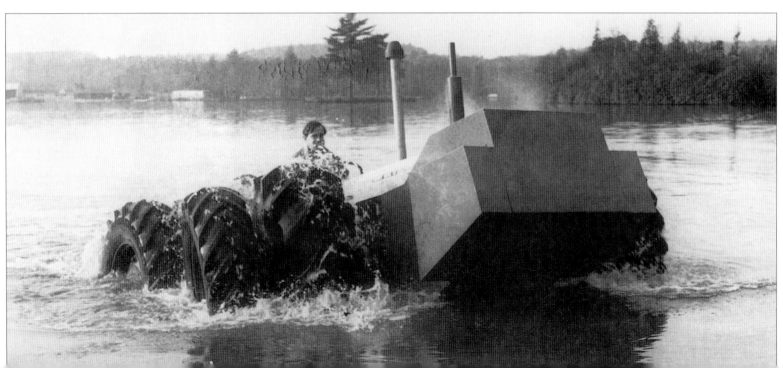

108. Another Sea horse was sent to the USSR for demonstration purposes and was exhibited at the 1964 Moscow Show. County's sales representative, Vernon Ponting, put the tractor through its paces on the ornamental lakes in Moscow in front of a crowd of sceptical Russians who expected it to sink.

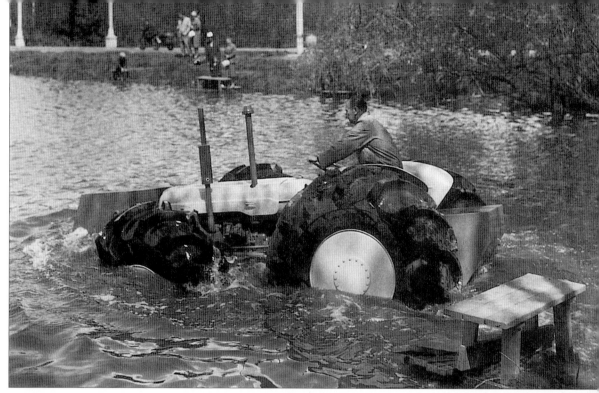

109. One of three Sea Horses sold to Holland for exploration and seismic survey work off the Dutch polders in 1963. The tractors, fitted with Winsam cabs and small covered pick-up bodies for carrying equipment, had the advantage of not needing ferries to move them from island to island.

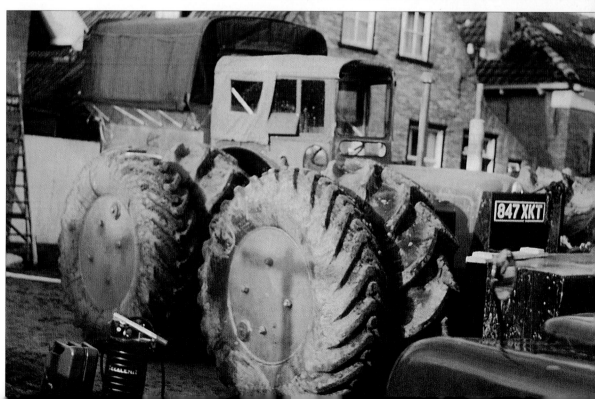

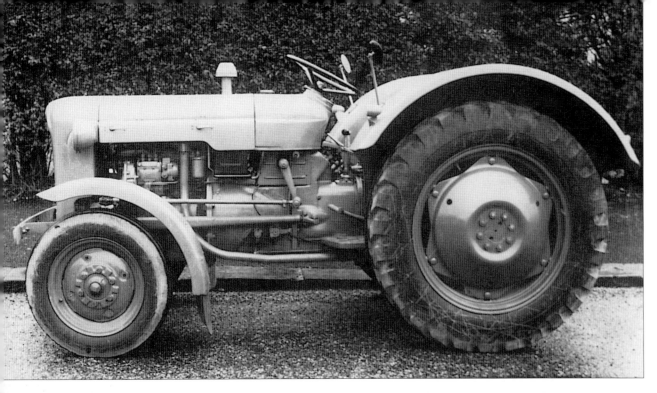

Dexta conversions

110. Although most of County's tractors had been based on the larger Major skid units, County did build one or two conversions on the smaller Fordson Dexta. The Highway Dexta was built from 1960 to meet the needs of local authorities who needed an agricultural tractor that complied with the UK Road Traffic Act.

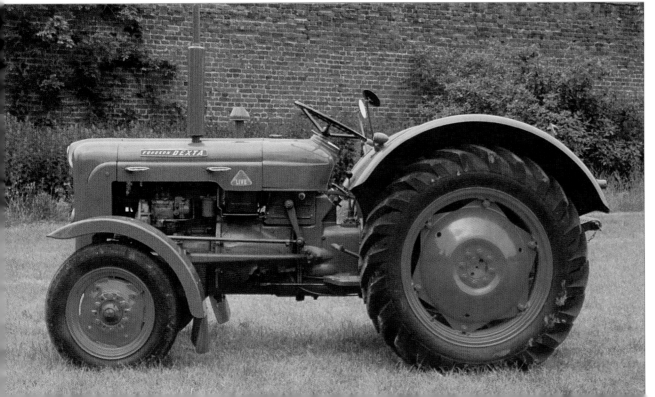

111. To comply with road regulations, the Highway Dexta was fitted with a dual braking system, accelerator pedal, large front and rear fenders, rear-view mirrors, speedometer, bumper and a towing hitch.

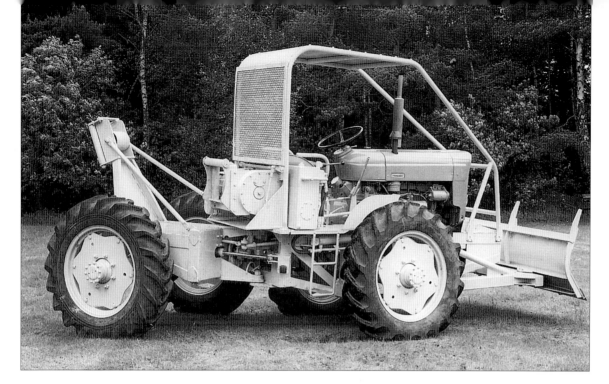

112. County's timber tractor, which was first exhibited at the 1964 Forestry Commission Exhibition, used the Super Dexta power unit. Designed for timber extraction, it was fitted with a winch and fair-leads for skidding and a front-mounted log-rolling blade. Built to the Forestry Commission's specifications using the pivot steer principle, it was found to be not heavy enough and was somewhat underpowered.

113. Three of the Dexta timber tractors were built. Two, including this example, were sold to the Forestry Commission in Northern Ireland. The third went to the Ford Motor Company for demonstration purposes, and is believed to have ended up in Scandinavia.

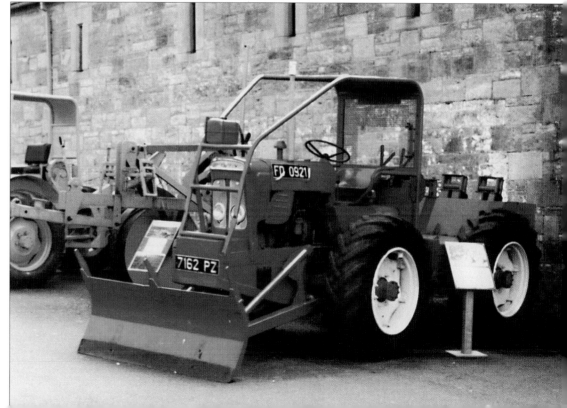

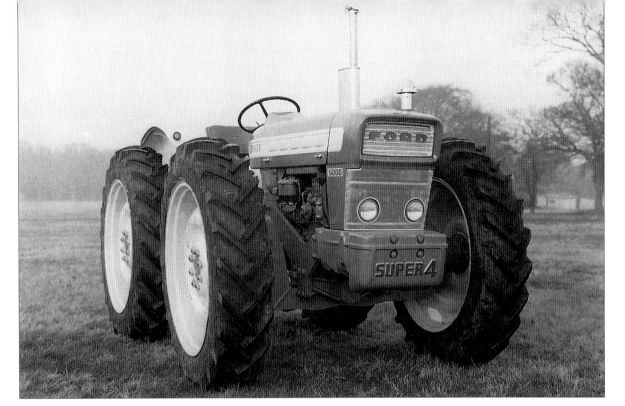

New models

114. *Following the launch of the new 6X Ford tractors from Basildon in late 1964, the County range was revised and new models were introduced. The first of these was the new four-cylinder Super-4, based on the 65 bhp Ford 5000. The prototype machine is seen in December 1964.*

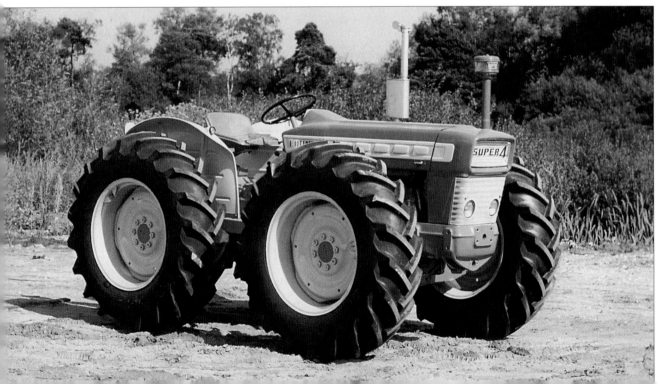

115. *The new Super-4 went into production as the 654 under County's new model numbering system. 65 denoted the horsepower and 4 stood for four-wheel drive. The drive for the twin propeller-shafts was now taken directly from the rear axle via bevel gears mounted on the differential output shafts.*

116. The replacement for the six-cylinder Super-6, the 954 fitted with the 95 bhp Ford 2703E engine, was not launched until the Royal Show in July 1965. In 1966, this model was awarded a gold medal from the USSR All Union Chamber of Commerce for design and performance.

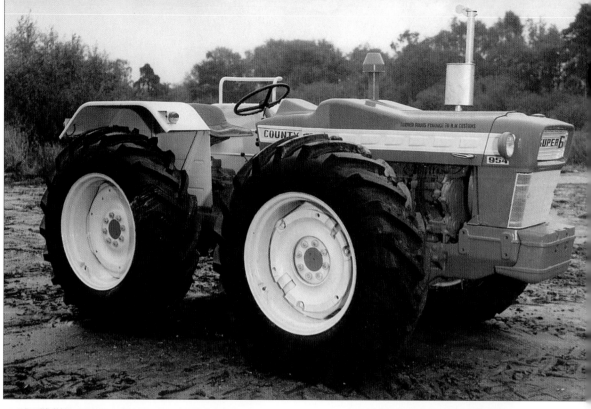

117. The 954 was only in production for just over a year before it was replaced by the uprated 1004 which had a strengthened rear axle. The engine revs of the Ford 2703E power unit were also increased to give an extra 5 hp. The first 1004 is seen coming off the production line in November 1966.

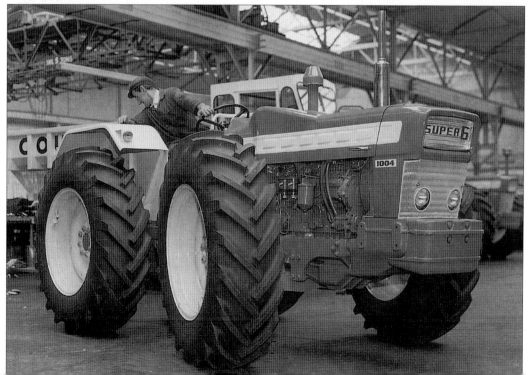

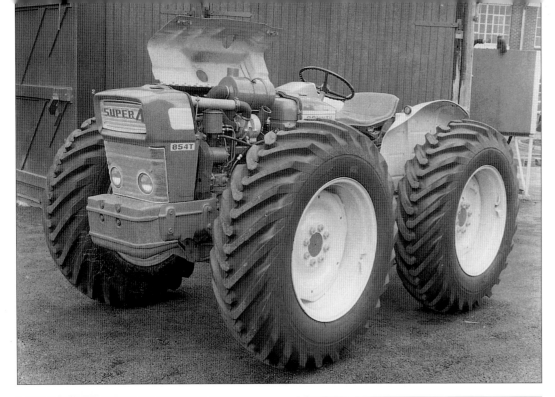

118. Introduced in 1966, the 854T was County's first turbocharged tractor. It used a CAV turbocharger and was fitted with an oil cooler, a tropical radiator and a six-blade fan. The injector pump and the injectors were recalibrated, and the power from the Ford 5000 engine was boosted to 85 bhp. Unfortunately, turbocharging was still a new concept and few were sold.

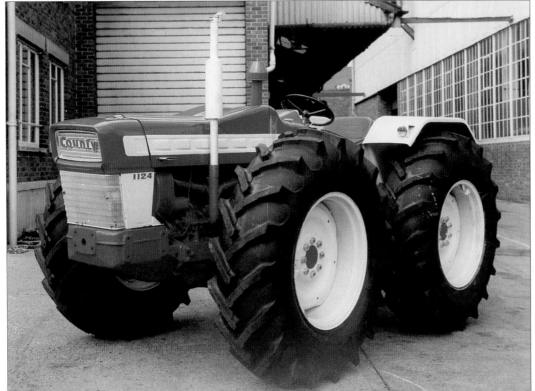

119. The first County 1124 shown outside the works in May 1967. This new model was unveiled to the public at the Royal Show in July. Distinguishable from the 1004 by the white panels on the side of the radiator shroud, it was powered by a 113 bhp Ford 2704E six-cylinder industrial engine and had a reinforced cast sump.

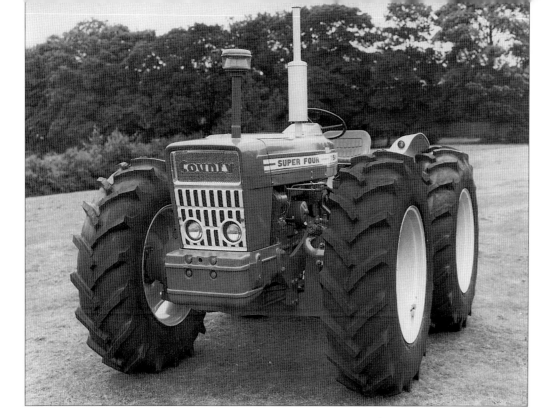

120. The revamped Ford Force 6Y range was introduced in June 1968. The County range received a similar facelift, and the 654 was replaced by the 75 bhp 754, taking advantage of the uprated Ford skid units.

121. The 944 was added to County's range in December 1971. Rated at 94 bhp, it was based on the new turbocharged Ford 7000 skid unit. The Duncan cab was a standard fitment for the UK market. The 1164, fitted with the de-rated Ford 8000 tractor engine, was also introduced in 1971 to replace the 1124.

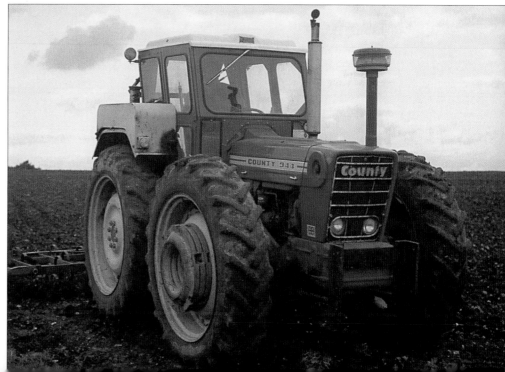

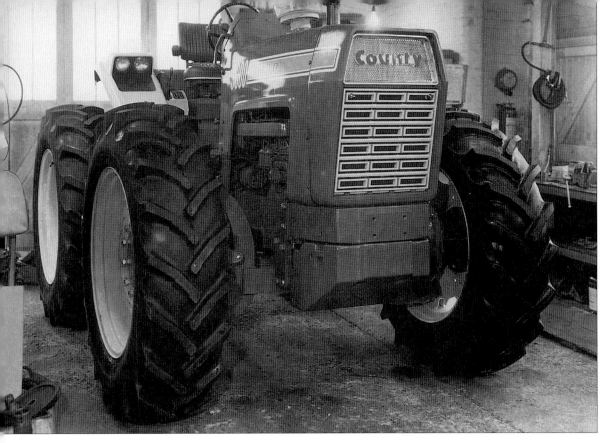

122. Seen in the development shop in February 1971, this prototype machine was based on the American Ford 9000 tractor, with a six-cylinder engine turbocharged to 145 bhp. The tractor was eventually put into production as the 1454.

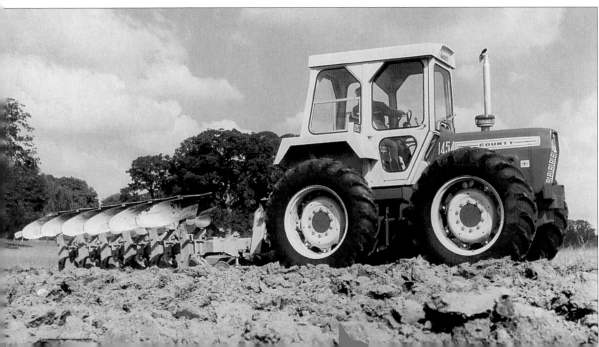

123. County moved into the league of high horsepower machines following the launch of the 1454 and its sister model, the 125 bhp 1254, at Elvetham Hall, Hartley Whitney, in June 1972. In the event, only one 1254 was built as there seemed to be little point in marketing a tractor with virtually the same horsepower as the existing 1164 which used the same engine. The 1454 shown is fitted with the improved County Hara Q-cab introduced in July 1974.

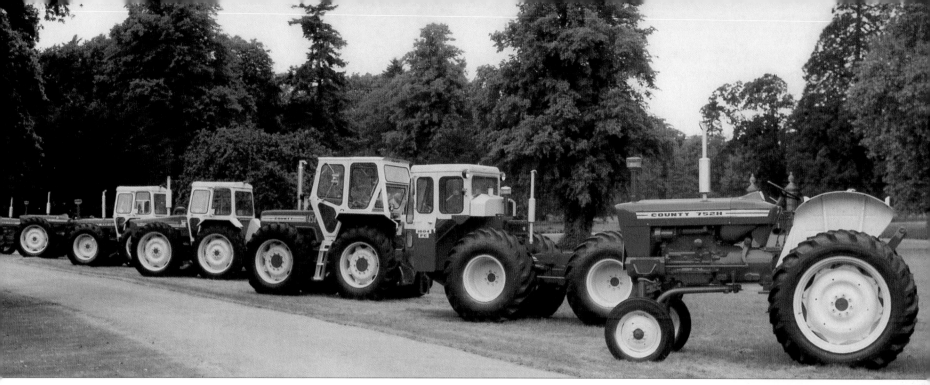

124. County's 1975 range lined up in the grounds of Elvetham Hall. Left to right are the 4000-Four, 754, 944, 1164, 1454, 1004 Forward Control and the 752H high-clearance tractors. Further model changes were announced at the 1975 Smithfield Show to bring the range in line with the new Ford 7A tractors.

Right

125. A County 1174 cultivating near Elvetham Hall. The 1174 , introduced in 1977, featured a flat-deck version of the Swedish Hara cab first seen on the previous 1164 model. Revised four-cylinder models, the 774 and 974, were also released in early 1978.

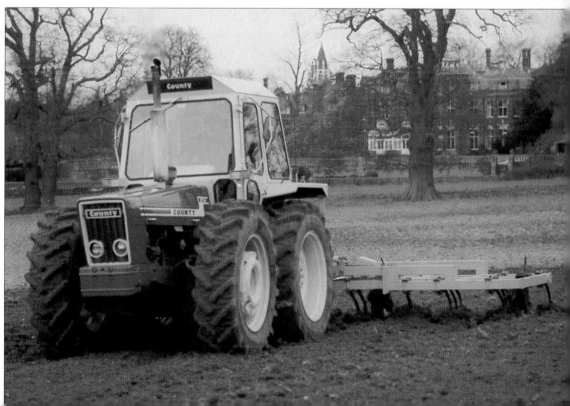

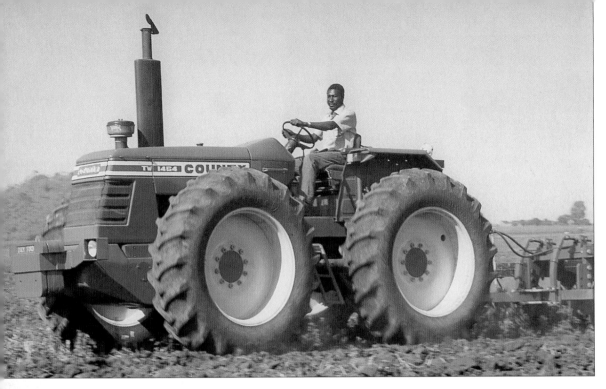

126. The replacement for the 1454, the 149 hp turbocharged 1474, was unveiled at the 1978 Smithfield Show. Originally based on the Ford 9700, it was uprated to the specification of the 153 hp Ford TW20 in 1979. The 1174 was superseded at the same time by the 120 hp 1184TW using the Ford TW10 engine. The export model 1464TW is shown here in Zimbabwe.

127. Export versions of the later County tractors were designated '64' instead of '74' at the end of the model number. Photographed in April 1982, these two 1464TW export versions of the 1474 were also destined for Zimbabwe to be used for towing railway trucks.

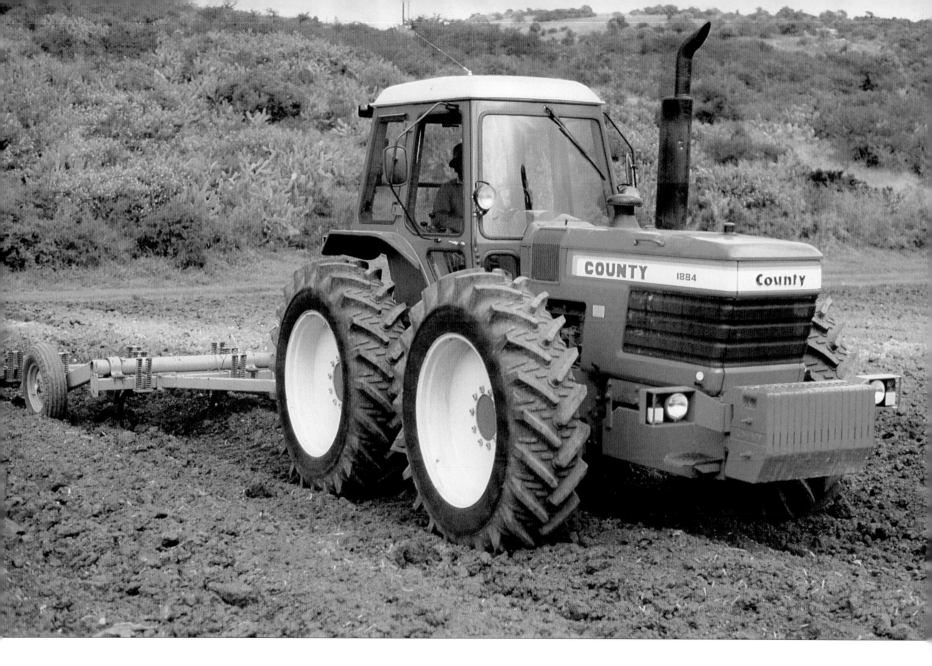

128. *County's flagship model, the 1884, was introduced at the 1980 Smithfield Show. Based on the Ford TW30, it boasted 188 hp from its turbocharged and intercooled engine.*

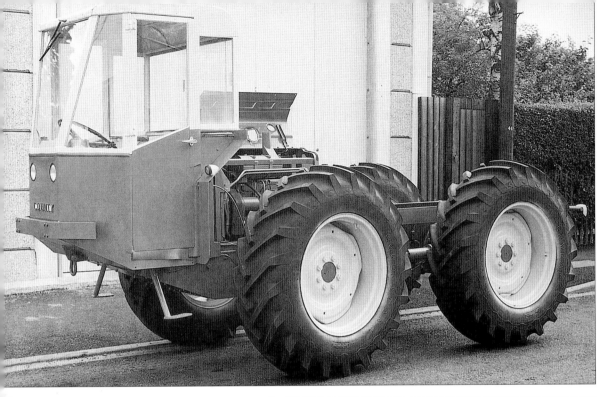

Forward Control tractors

129. The prototype FC 654 in July 1965. The thinking behind the forward control machines was to put the driver at the front and provide a platform vehicle that could be fitted with various bodies or equipment. The initial idea was jointly conceived by David Tapp and Joe Davey from plans chalked out on the workshop floor.

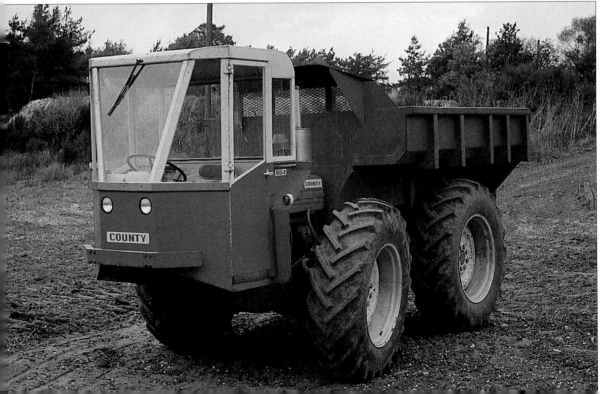

130. The prototype FC 654, fitted with a Select-o-speed gearbox and County's own 5 cu. yd dump body. The production model of the forward control tractor had a slightly different cab, and a six-cylinder version, the FC 1004, was introduced in February 1967.

131. An FC 1004 with a four-furrow Ransomes plough. The agricultural version of the forward control, fitted with a hydraulic lift and linkage, was launched in 1968. The tractor was first demonstrated at a special County press day held in February 1969 at Travers Farm, Crondall, Hampshire, where the machines had to cope with 8 to 9 in. of frozen soil.

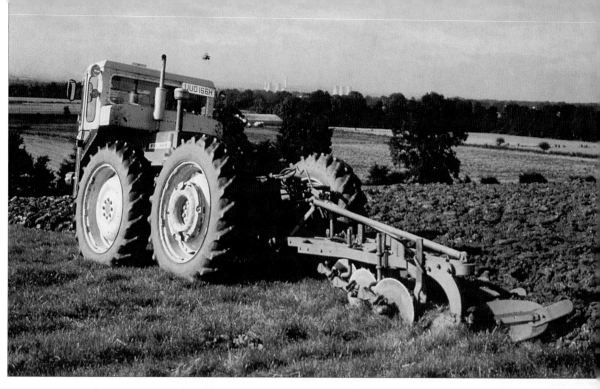

132. Among the types of equipment developed for the forward control were cranes, arc welding plant, drilling rigs, fifth-wheel coupling and gooseneck trailers, cement skips, tree planters, scrapers, spreaders, sprayers, and County even explored the possibilities of a clip-on combine harvester. This FC 1004 is fitted with an Atkinson lime spreader. Note the external tubular safety frame fitted from September 1970 to meet the new UK safety cab requirements.

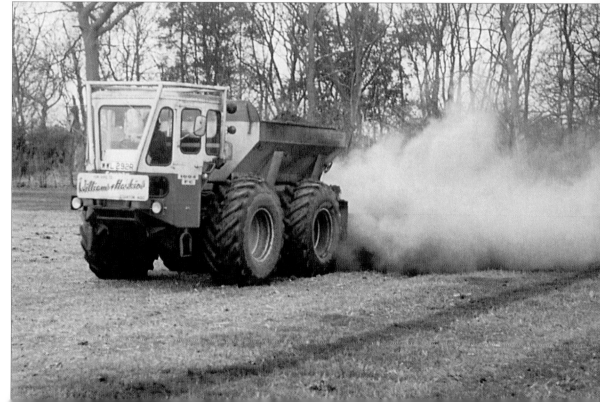

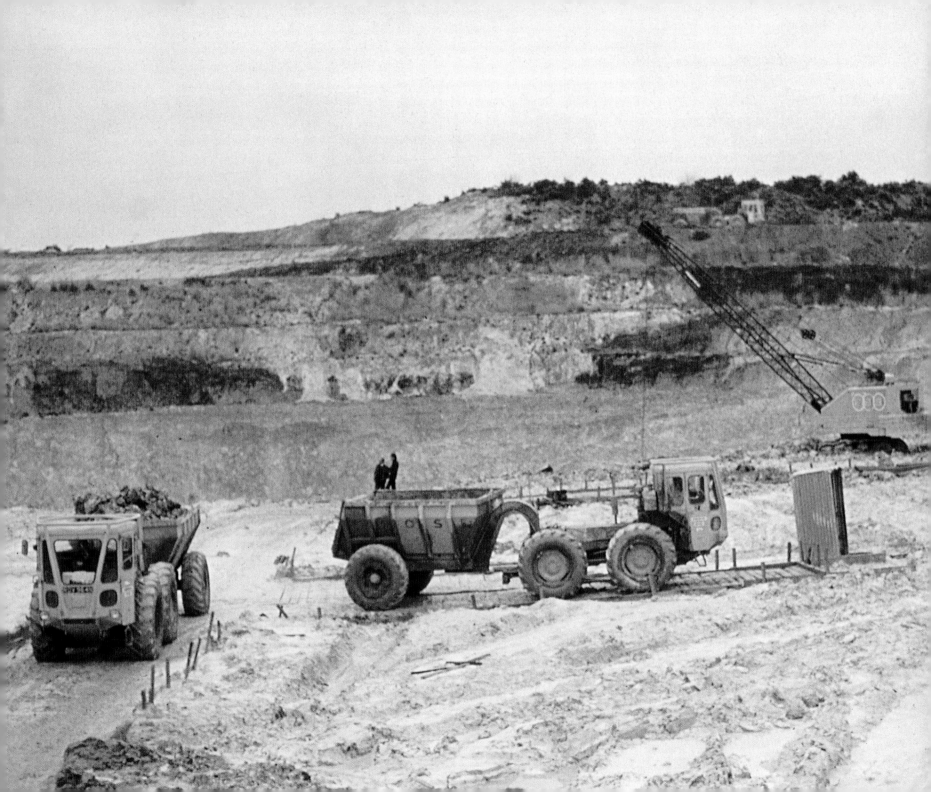

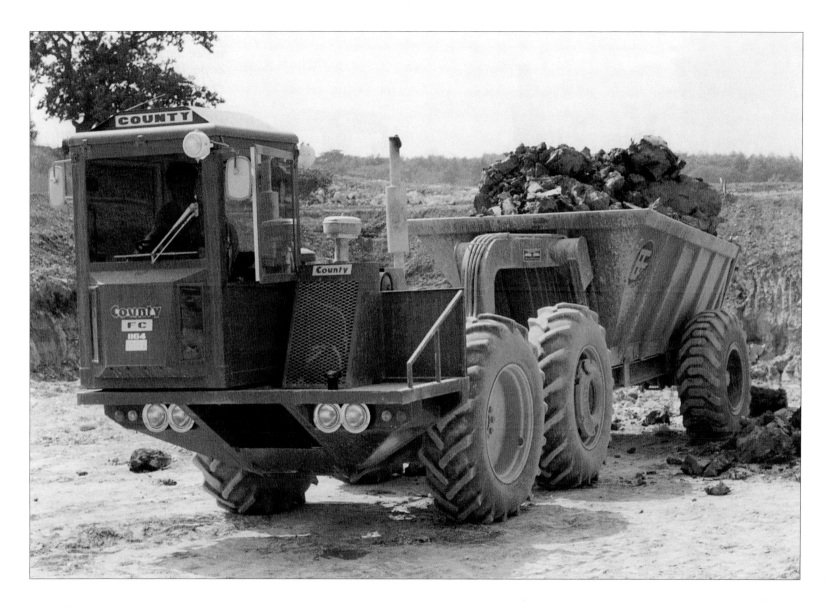

Previous page

133. Part of a fleet of 23 County tractors, including four FC 1004s, working with ten-ton Goose dump trailers at the Ball Clay quarries at Kingsteinton in Devon in 1975.

Above

134. The FC 1164, seen with a Thompson dumper, was a prototype for a new model forward control County, due to go into production in 1977.

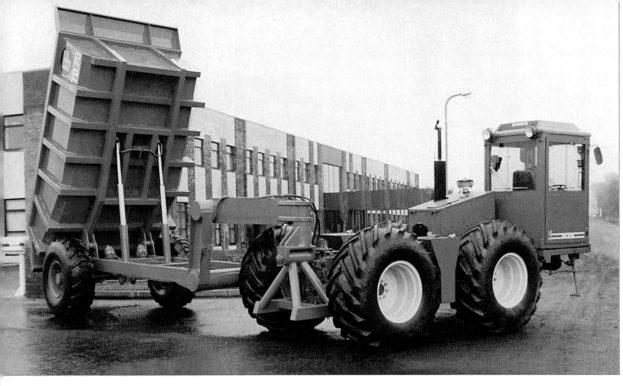

135. As County's drawing office was working at full capacity, the development of the new forward control was contracted out to an independent design consultant, Mike Bigland. Bigland, based in Bucknall in Shropshire, was responsible for the new design with the off-set modular cab incorporating plug-in electrical and hydraulic services, and controls operated by Bowden cables. He also prepared the jigs and fixtures for manufacture, and oversaw the testing of the prototype.

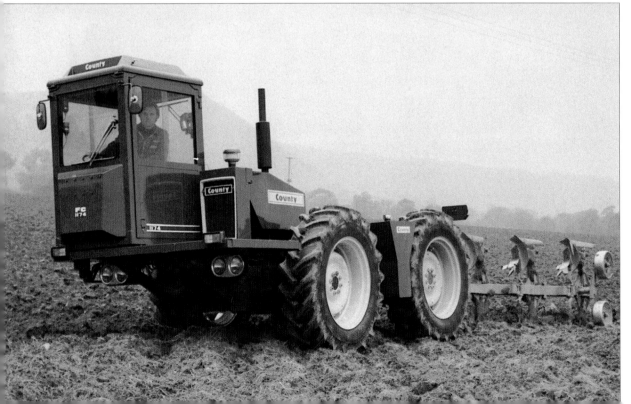

136. The new forward control tractor, based on the Ford 8700 skid unit, went into production from December 1977 as the FC 1174. An agricultural version with hydraulic lift and linkage is seen here ploughing. In February 1980, it was uprated to TW10 specification and re-badged as the FC 1184TW.

137. One of the new forward control tractors on evaluation trials with the British Army at Long Valley, near Aldershot. Under certain conditions, it even proved capable of outperforming the Army's own Alvis Stalwarts. During the Falklands conflict in 1982, a number of FC 1184TW tractors with fifth-wheel couplings were ordered by the Ministry of Defence for moving container trailers and supplies from the shore at Port Stanley.

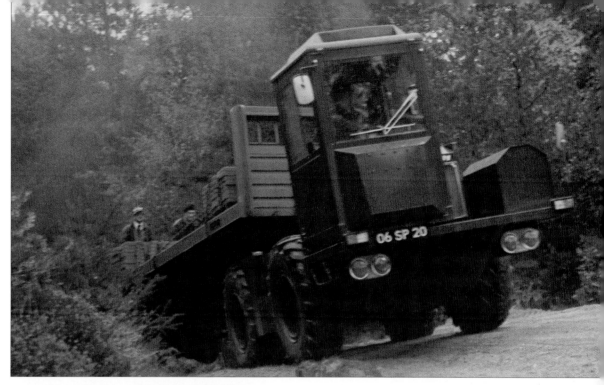

138. An FC 1174 used by Watts, Blake & Bearne Ltd for hauling a Thompson dump trailer at Ball Clay quarry in Devon. The driver rode in comfort on a Bostrom seat, and had the luxury of power steering, tinted glass, a clock, radio and a stereo tape deck. The driver's instructions were also supplied on a cassette tape.

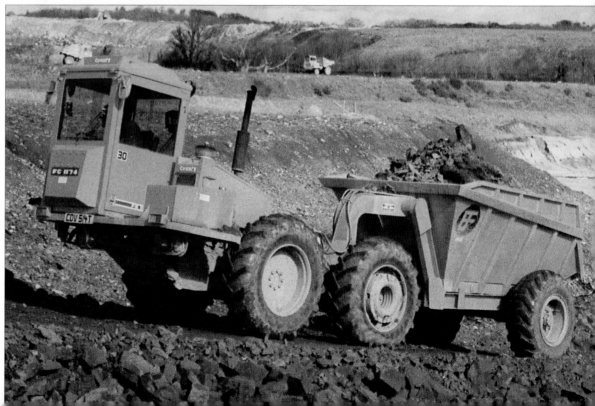

139. A County FC 1174 used for lime spreading by a Sussex contractor. A whole range of agricultural and industrial equipment was developed for the new forward control which was capable of carrying over seven tons depending on conditions and tyres.

Below

140. An Evrard high-capacity sprayer unit with 100 ft booms mounted on a County FC 1174.

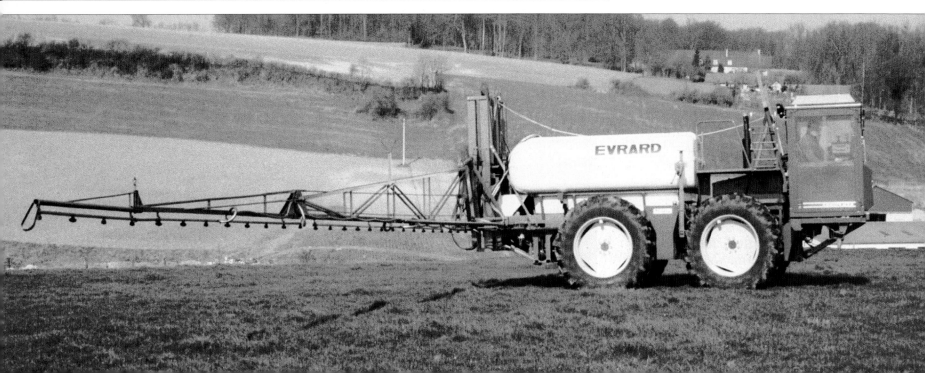

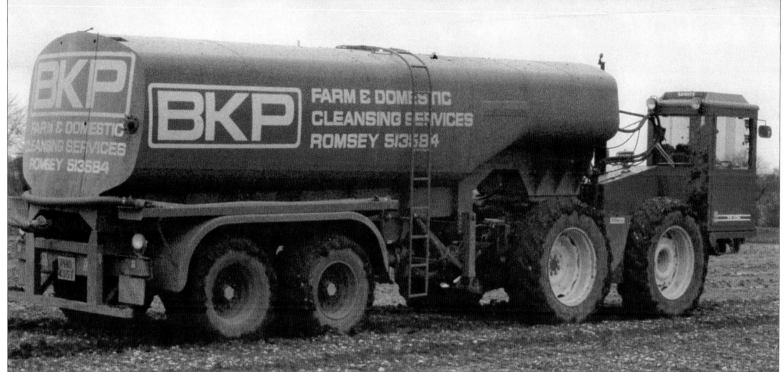

Above

141. This road-going tanker was used for spreading slurry on the land behind a County FC 1174 fitted with a fifth-wheel coupling.

Right

142. A slurry tanker mounted directly on to a County FC 1174. The conversion was carried out by T H White Engineers of Frome. Side- and rear-mounted muck-spreader bodies were also available for the forward control which was a popular choice for agricultural contractors.

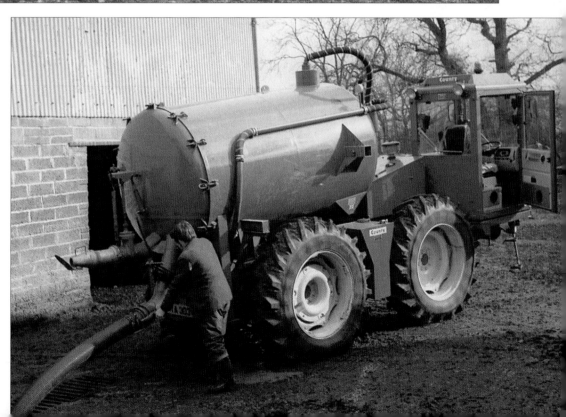

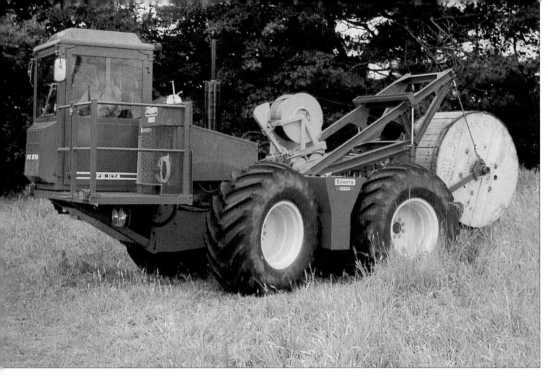

Left
143. A County FC 1174 equipped for overhead power line construction by TH White. The rear-mounted cradle was used to deliver the three-ton cable drums on-site, then the lines were strung out with the mid-mounted winch.

Below
144. A County FC 1174 in service with contractors, Johnson Brothers, towing a 19-ton road impactor used to burn off the old road surface ready for resurfacing.

Facing page
145. The prototype FC 1164 undergoing evaluation trials at Ball Clay quarry in Devon.

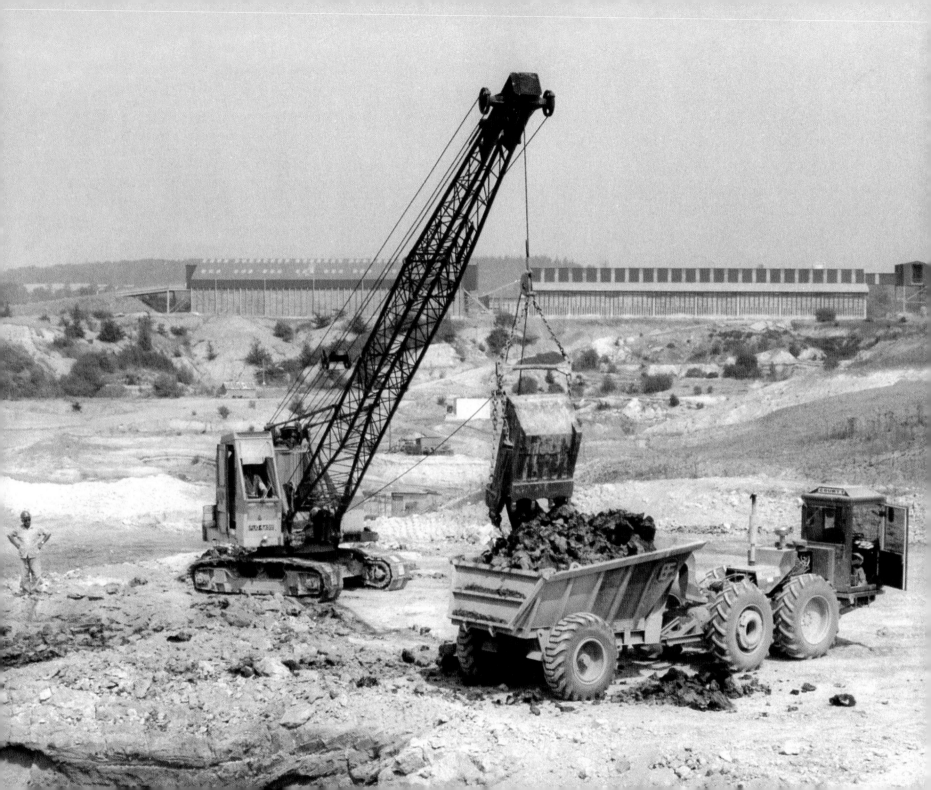

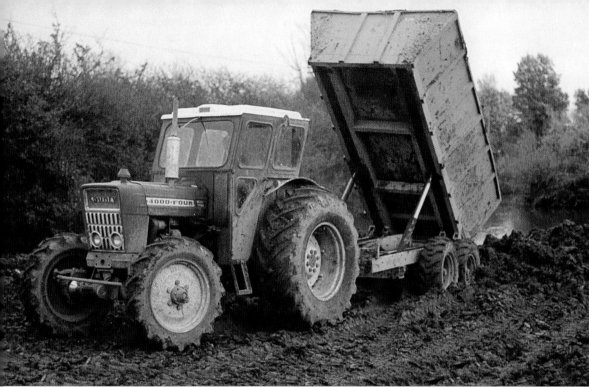

Unequal-size four-wheel drive tractors

146. Based on the 62 hp Ford 4000, County's first unequal-size four-wheel drive tractor, the 4000-Four, was introduced in 1968. Drive to the front axle, which incorporated a Ford 3000 differential, was taken from the output shaft of the main gearbox by a train of spur gears. The conversion was also available as a kit.

Below
147. A County 6600-Four in South Africa. This four-cylinder model was introduced with the 7600-Four in 1975.

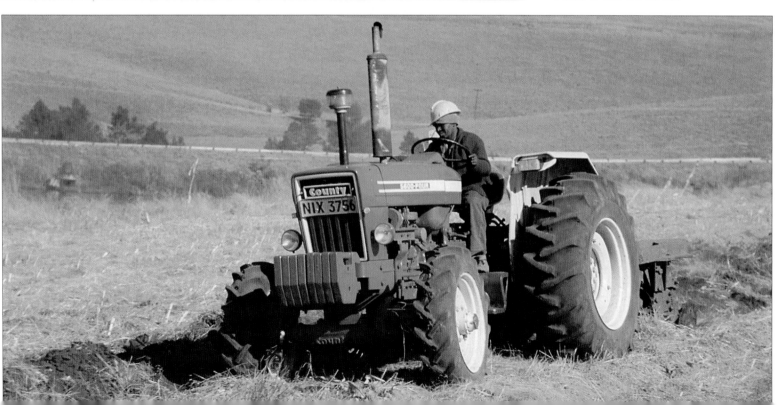

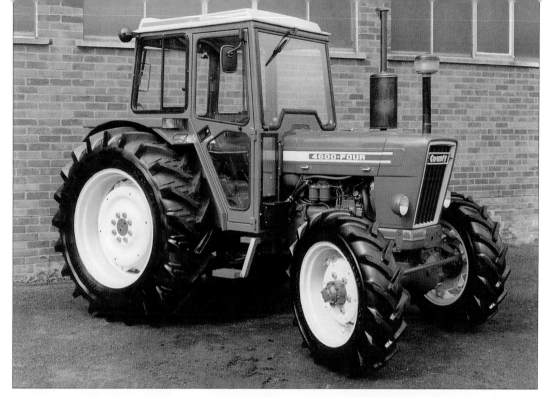

148. The 4000-Four was superseded by the 4600-Four in 1975. This tractor is fitted with a low-line Duncan cab, introduced in 1979.

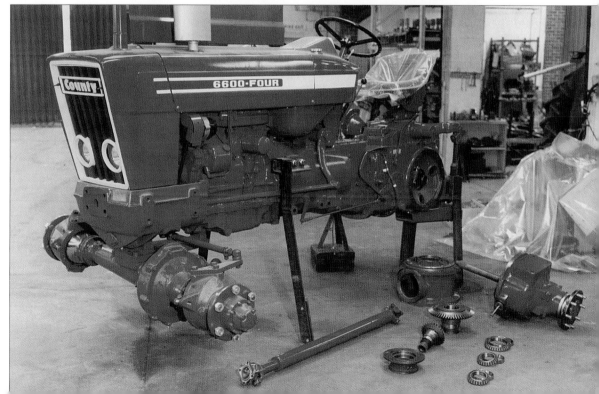

149. A County 6600-Four in the works at Fleet. The transfer box incorporated into the rear axle can be clearly seen. Unlike the 4000-Four and the 4600-Four, on the four-cylinder models the single propeller-shaft drive was taken off the crown wheel carrier. This allowed full use of the Ford Load Monitor draft sensing system on both axles.

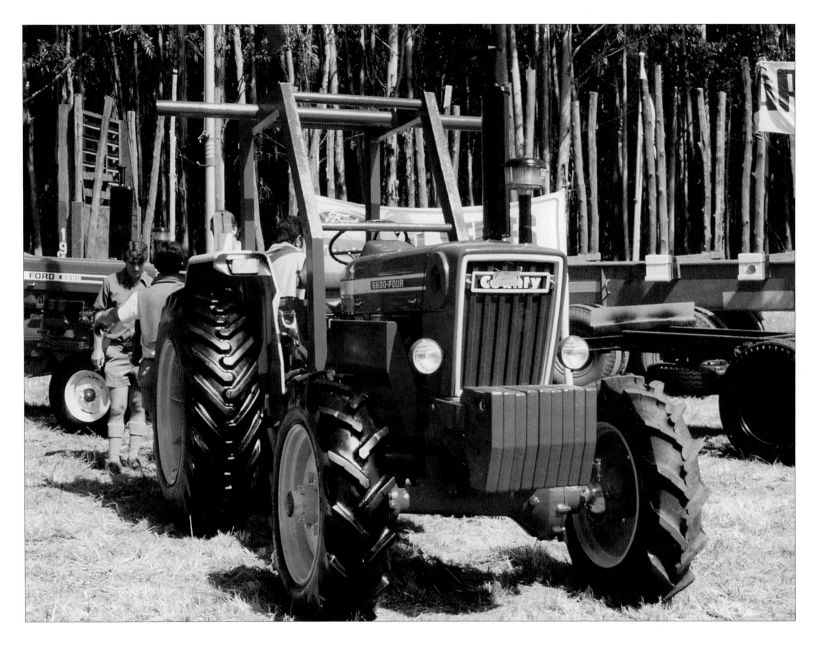

150. A County 6600-Four displayed in South Africa by the Pietermaritzberg Ford dealers, Armstrong Motors.

151. *The 97 hp Ford 7600-Four at work. The 6600-Four and the 7600-Four tractors for the UK market were fitted with the normal Ford straddle Q-cab from late 1977 onwards.*

152. *An export model County 6700-Four. This type of Ford styling was not used on the equivalent County 6700-Four and 7700-Four models for the home market. Introduced in 1978 and fitted with flat-deck County/Hara cabs, these tractors used similar bonnets and grilles to the 6600-Four and the 7600-Four.*

Two-wheel drive tractors

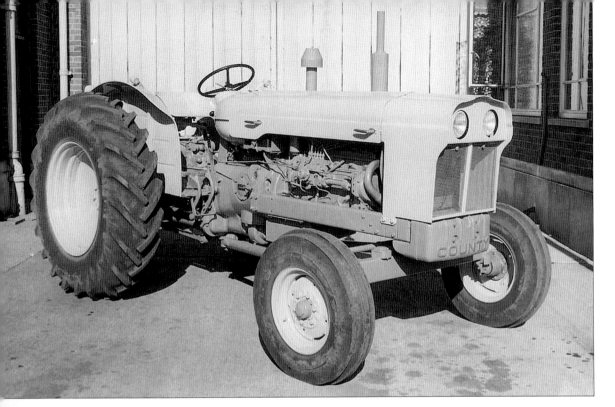

153. It is not commonly known that County produced a number of two-wheel drive tractors, apart from the high-clearance machines, as most of these models were built for export and few were ever seen in the UK. Three examples of this two-wheel drive version of the early Super-6 were built in 1964. One is known to have been sold to the agricultural contractors House brothers of Dorset, and the others are believed to have been exported either to Australia, New Zealand or Mexico.

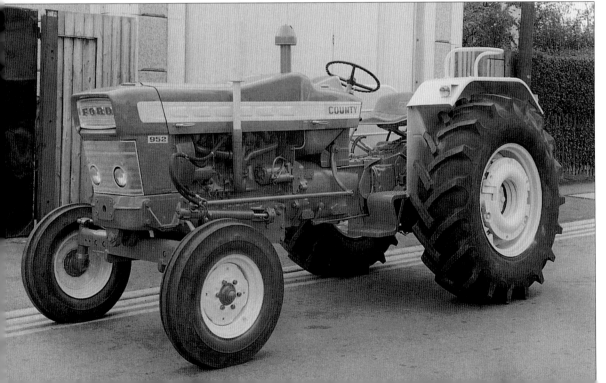

154. The 952 was a two-wheel drive version of the 954, powered by the six-cylinder Ford 2703E engine. Only one was built, in September 1966, as an engineering exercise, and for field evaluation trials by Ford in Australia, who required a tractor to compete against the six-cylinder Chamberlain. Unfortunately, it was dropped pending Ford's development of the four-cylinder turbocharged 7000.

155. *Following the introduction of the 854T in 1966, County also marketed a turbocharging kit for the two-wheel-drive Ford 5000. The kit cost £217 and included a CAV turbocharger, a six-bladed cooling fan, an oil cooler, a new exhaust pipe, a dry-element air cleaner and a special bonnet. The conversion was not approved by the Ford Motor Company who claimed it invalidated their warranty.*

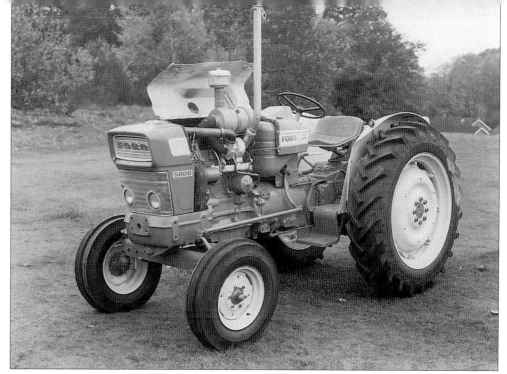

156. *Launched in 1980 to match a growing demand in certain countries for an inexpensive and uncomplicated high-horsepower tractor for field cultivations and general haulage, the 1162TW was a 'no-frills' two-wheel drive version of the 1184TW. Power came from a 120 hp Ford TW10 unit driving an eight-speed gearbox through a County 14 in. clutch.*

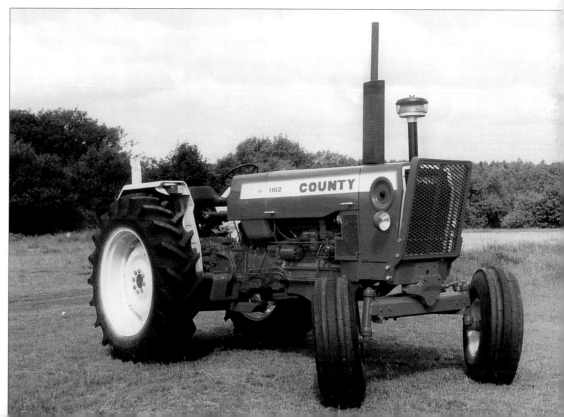

High-clearance tractors

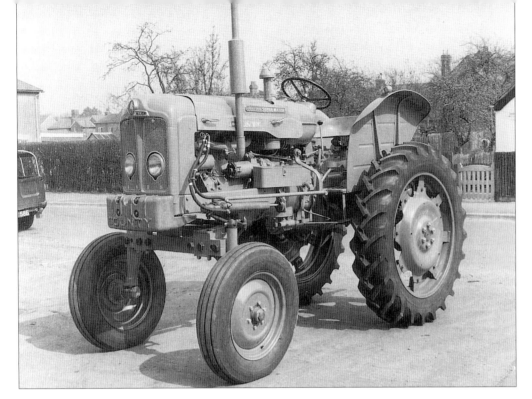

157. A 1963 County Hi-Drive version of the Fordson Super Major. The first high-clearance Hi-Drive, based on the Fordson Major, was built by County in 1958 for sugar-cane work in the West Indies. Although most were exported, a few were sold in the UK, including one to a celery grower in Lincolnshire. In the USA, it was marketed by M&L Tractors as the Blue Ox.

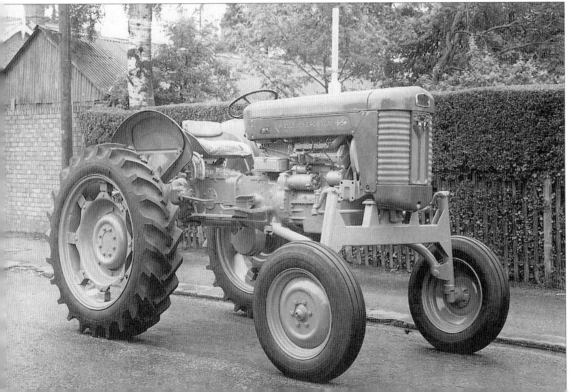

158. A County conversion of the Massey Ferguson 65. About 200 high-clearance versions of the 65 and later 165 were built at Fleet under contract for Massey Ferguson between 1964 and 1971. Designed mainly for sugar-cane work in the Tropics, the conversions were marketed by Massey Ferguson as Hi-Hi clearance tractors.

159. An early Hi-Drive conversion of the Ford 5000 built in 1965. The Hi-Drive name was eventually dropped in favour of the 652H designation. The tractor's rear axle was raised by a vertical train of three gears replacing the standard epicyclic reduction and the front axle was designed to give 30 in. ground clearance.

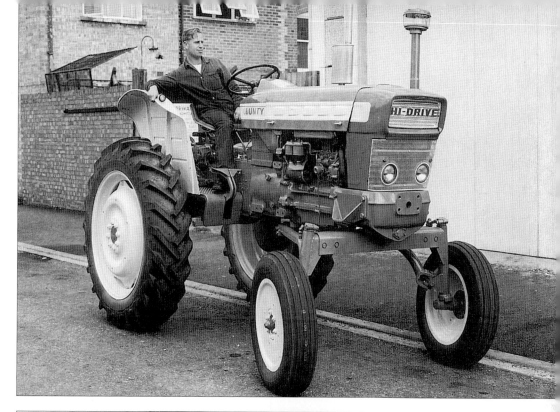

160. A 1968 County 652H. With the introduction of the Ford Force 5000 in June 1968, the County high-clearance tractor was re-badged 752H. Most were now exported, and the tractor sold well in Israel and America.

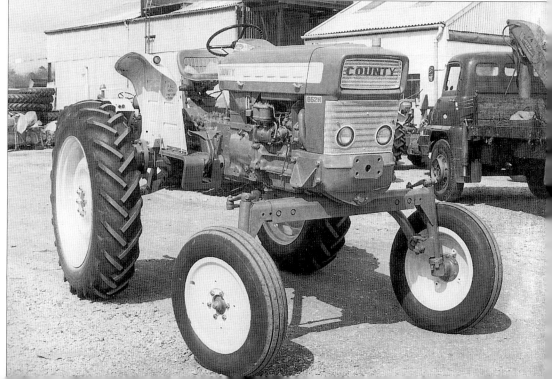

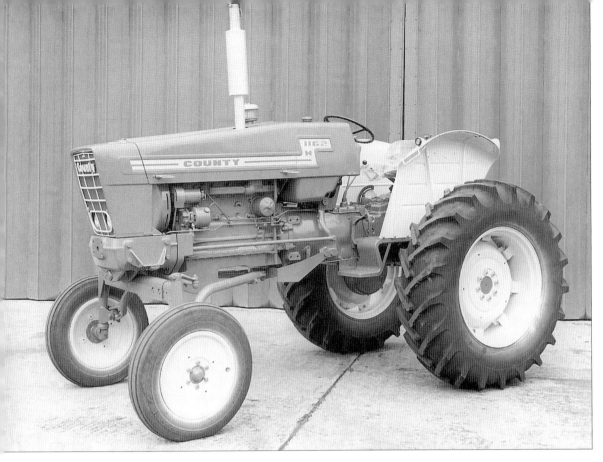

161. The 1162H was built in 1972 following a request from M&L Tractors for a more powerful machine for sugar-cane work in Louisiana. The tractor was based on the 1164 and was fitted with the de-rated Ford 8000 engine developing 116 bhp.

162. County's high-clearance tractors remained available only for export until 1976 when the 762H was relaunched on the UK market. Based on the Ford 6600, it was fitted with new front and rear axles which gave a ground clearance of 31 in. Suitable for rowcrop and tramline work, the 762H was an ideal spraying tractor.

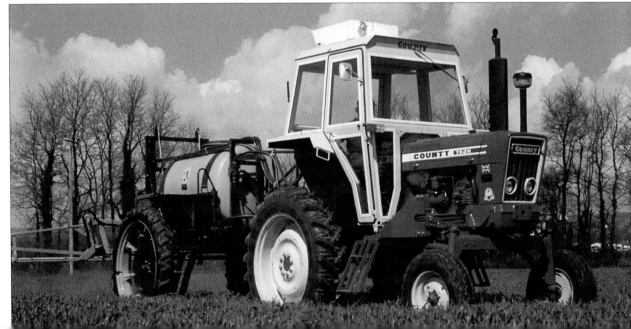

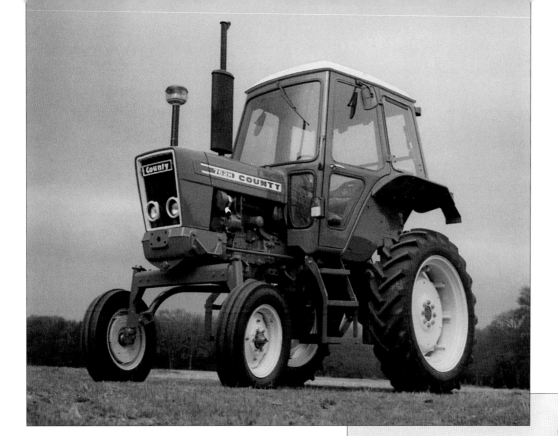

163. A County 762H fitted with a Ford straddle cab. The rear drop-boxes were also supplied to Roadless for use in a high-clearance version of its 115 tractor for sugar-cane work in Puerto Rico, and to Chafer for its high-clearance, self-propelled sprayer.

164. Export model 762H Highlander on Viking flexible half-tracks for working in raised sugar-cane beds in Barbados. County high-clearance tractors were used extensively in the Caribbean and South America for the inter-row cultivation of sugar cane and cotton, and pest control in melons and vegetables.

International conversions

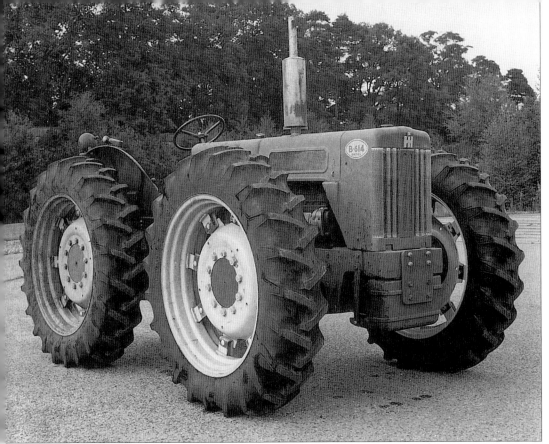

Left

165. County designed and built equal-size four-wheel-drive tractors for International Harvester of Doncaster between 1969 and 1972. This prototype machine was based on the International B-614 skid unit for evaluation purposes.

Below

166. The production model used the later 634 skid unit and was known as the International 634 All-Wheel Drive. Drive was taken off the bull-pinion reduction through the steering brake aperture. A batch of fifty were built.

Facing page

167. Blue tractors are in the minority in this unique shot of the County finishing shop in 1971. Several four-wheel drive International 634s are prepared for dispatch and in the foreground is a Hi-Hi clearance Massey Ferguson 165.

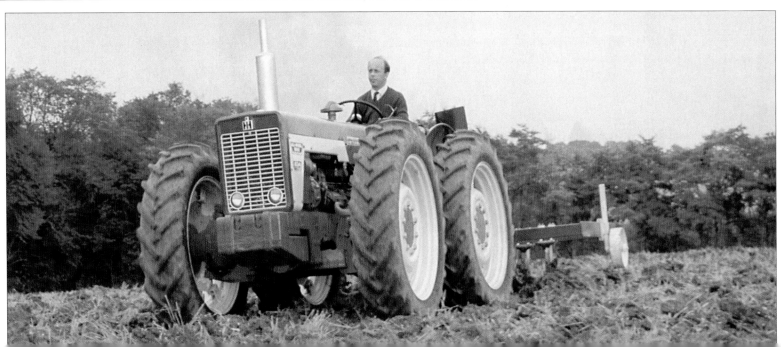

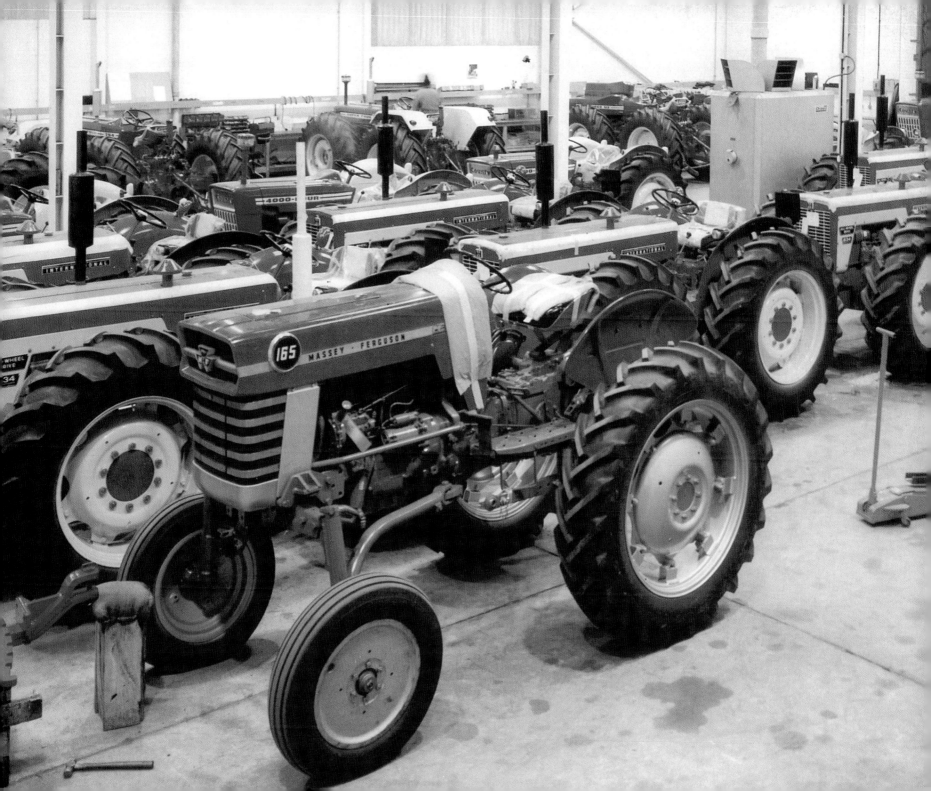

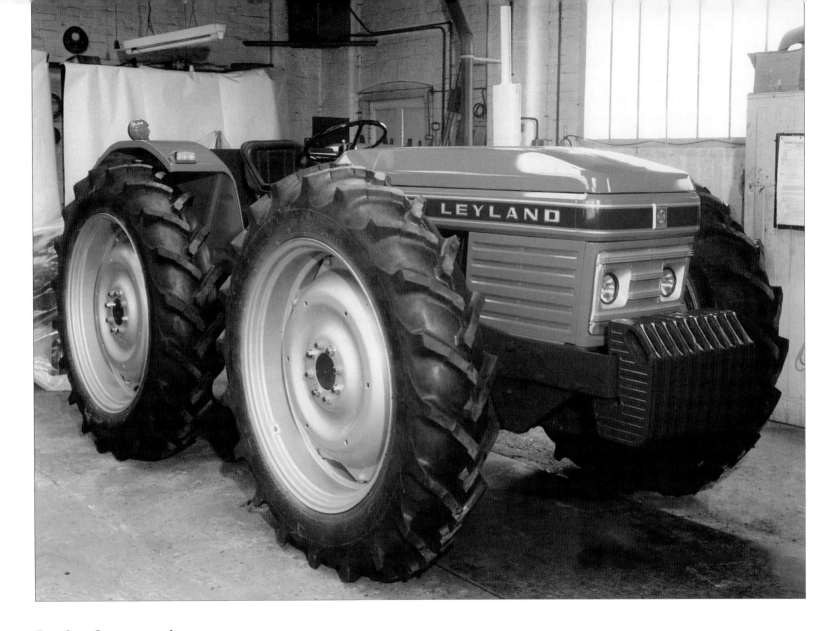

Leyland conversions

168. During the 1970s, County also developed a four-wheel-drive tractor for the tractor operations division of British Leyland, based in Bathgate in Scotland. The prototype County conversion of the Leyland is seen in the development shop in Fleet.

169. The four-wheel-drive
Leylands were assembled at
Fleet. Two models were
available, both using the six-
cylinder Leyland 6/98 series
engine. The 485 (shown) was
rated at 85 bhp, while the 4100
developed 100 bhp. Only about
100 are thought to have been
made. County also manu-
factured rear-axle housings
and transmission parts for
the equivalent two-wheel
drive models, the Leyland 285
and 2100, which were built at
Bathgate.

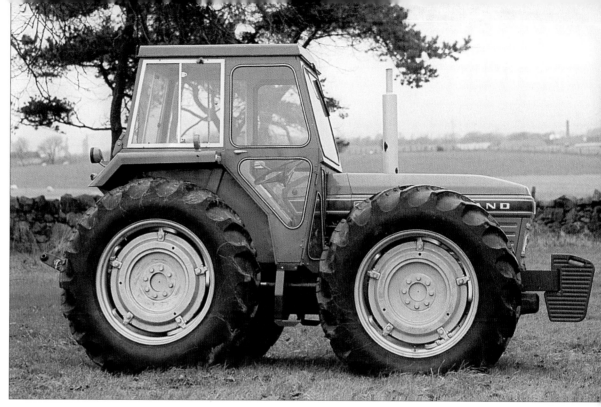

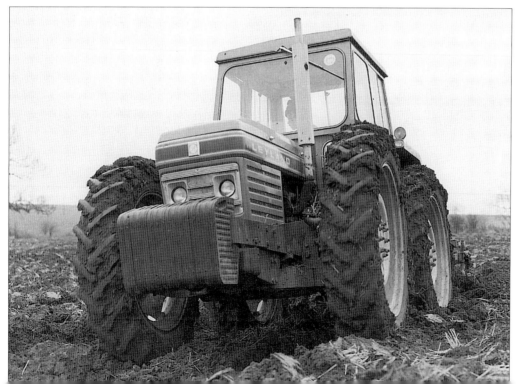

170. The Leyland 485 in action.
The tried and tested twin propeller-
shaft design was used, with the
drive taken by bevel gears off the
differential output shafts in the rear
axle. County four-wheel drive
versions of a David Brown 1200 and
several Massey Ferguson models
were also considered but never built.

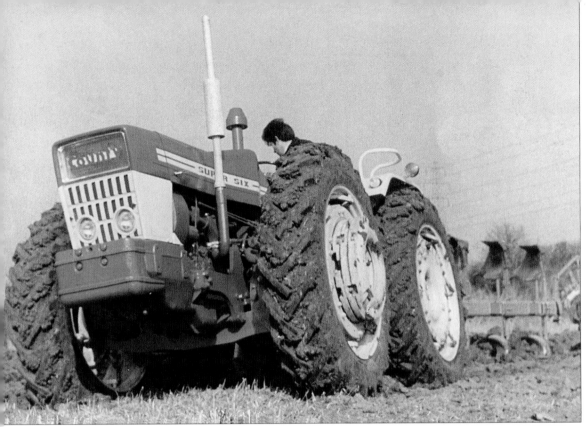

County in agriculture

171. A County 1124 ploughing in 1968. County tractors were primarily designed for agriculture, and very many went to work on farms both in the UK and across the world.

Below
172. Harvesting potatoes with County tractors in 1975 in Hampshire. A 4000-Four powers the Whitsed Pacemaker electronic harvester while an FC 1004 catches the crop.

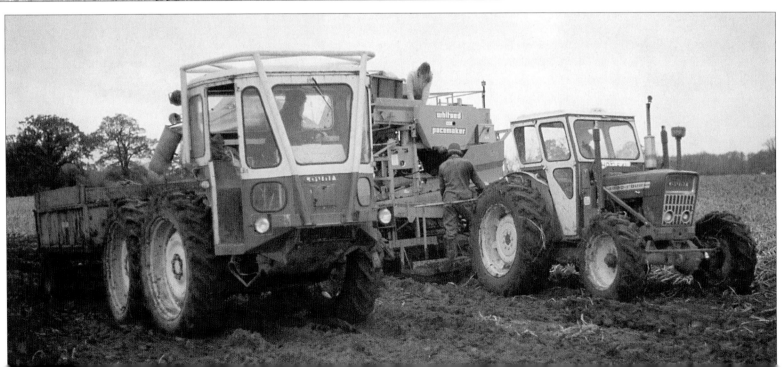

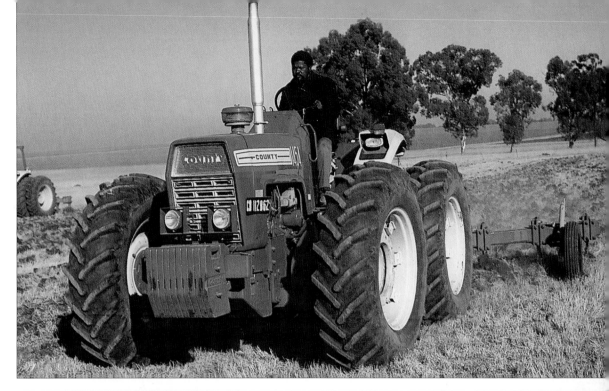

173. A County 1454 cultivating in South Africa in 1979. South Africa became one of County's largest markets and over 5,000 tractors were sold there.

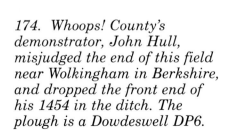

174. Whoops! County's demonstrator, John Hull, misjudged the end of this field near Wolkingham in Berkshire, and dropped the front end of his 1454 in the ditch. The plough is a Dowdeswell DP6.

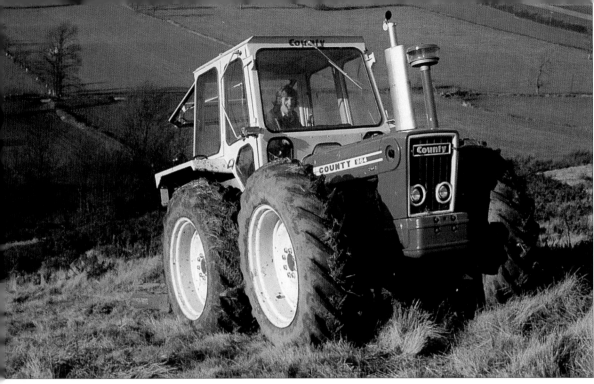

175. Topping gorse with a Bush-Hog behind a County 964 in the Mendip hills in Shropshire. County tractors were ideally suited to hillside work and could cope with 1 in 1 slopes.

Below
176. Eight furrows behind a County 1174. This tractor has been fitted with air-conditioning with the cooler unit mounted on the cab roof. The plough is a semi-mounted Dowdeswell.

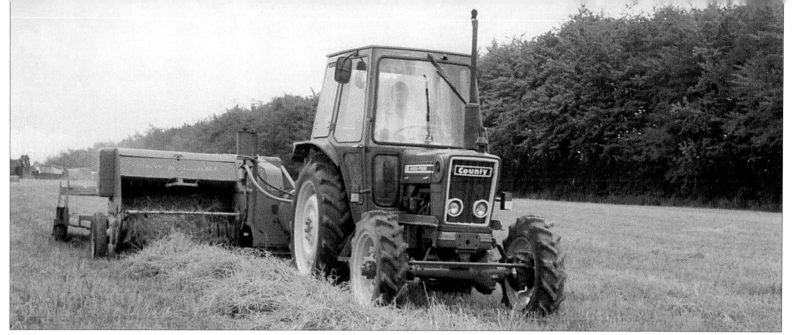

Above
177. Baling with a County 4600-Four and a New Holland baler.

Right
178. This 1164, seen with a Mather and Platt pea-viner in 1976, was one of a fleet of County tractors used by a large pea-growing cooperative in Lincolnshire.

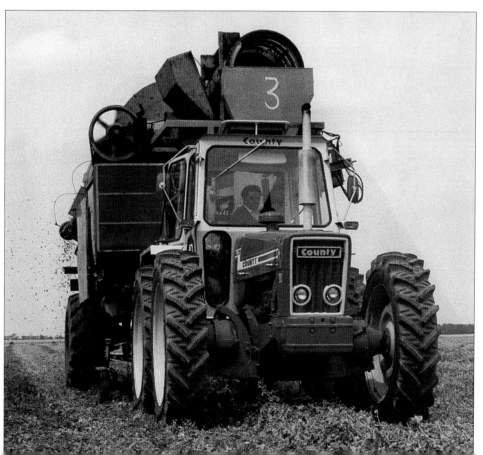

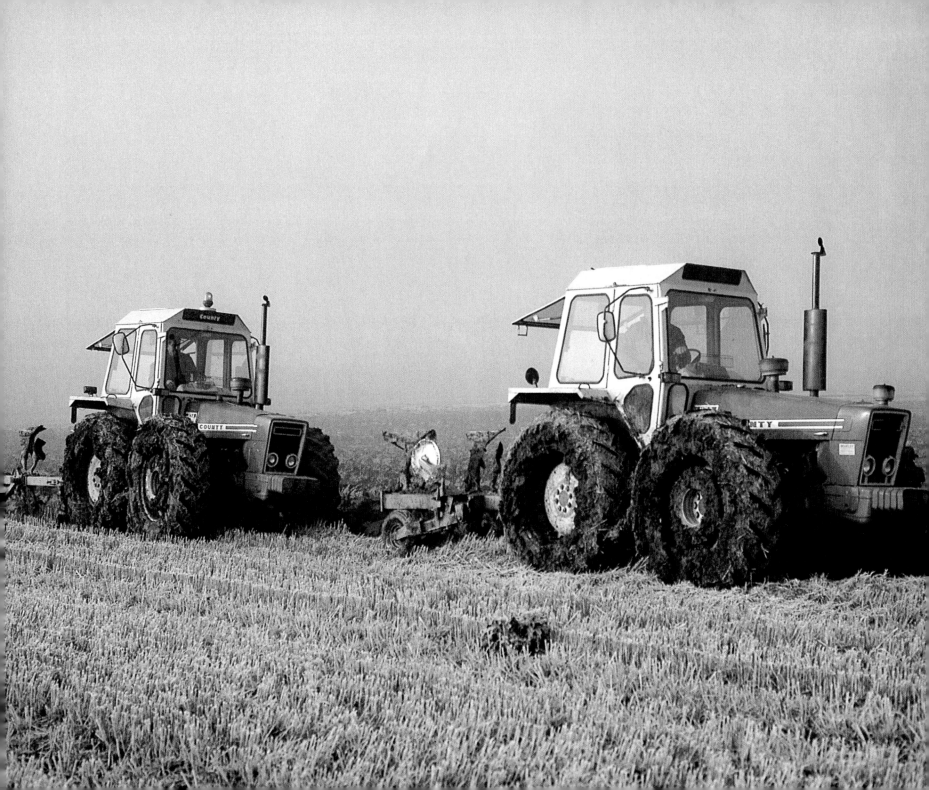

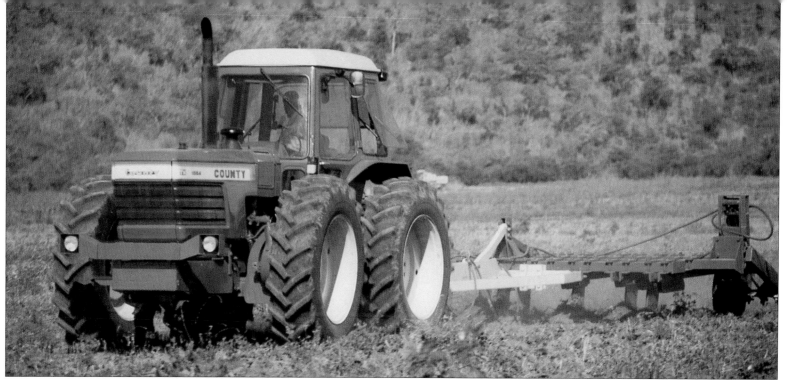

Previous page

179. Winter ploughing — two County 1174s belonging to farmer Jim Russell, cope with frozen land near Rugby in Warwickshire. These tractors were delivered new on the same day and are still in regular use on the same farm.

Above

180. A County 1884 in Zimbabwe, with a ripper panbusting land in preparation either for sugar cane, which was grown for ethanol, or cotton.

Right

181. A County 1464 ploughing in old sugar cane in the Hippo Valley in Zimbabwe. The tractor was supplied in 1981 by County distributors, Duly & Company.

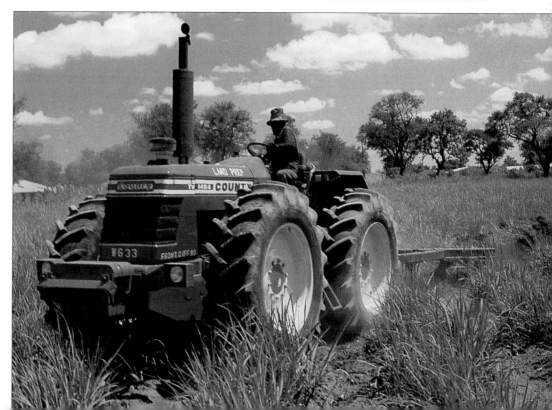

County in forestry

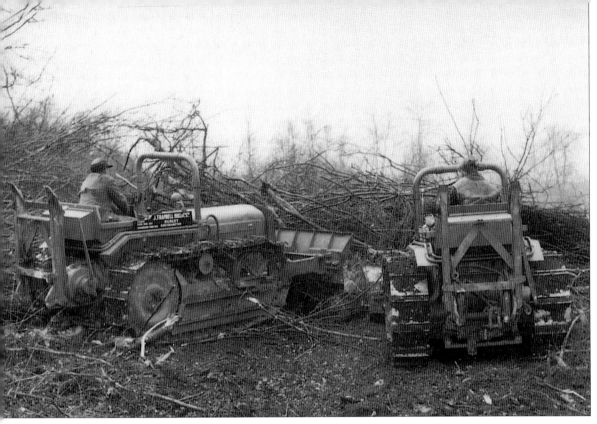

182. The County was ideally suited to forestry work and made an excellent timber tractor. Two County Mark III crawlers, fitted with Bray angledozers and Boughton winches, are seen clearing scrub and woodland near Southampton in the 1950s.

Below
183. A Highland County forestry tractor working in South Africa. Built by James Jones, the Highland was fitted with a special dozer blade for high-stacking timber, reinforced wheels, a radiator guard and undershield, a roll-over cab and a multi-drum rear winch.

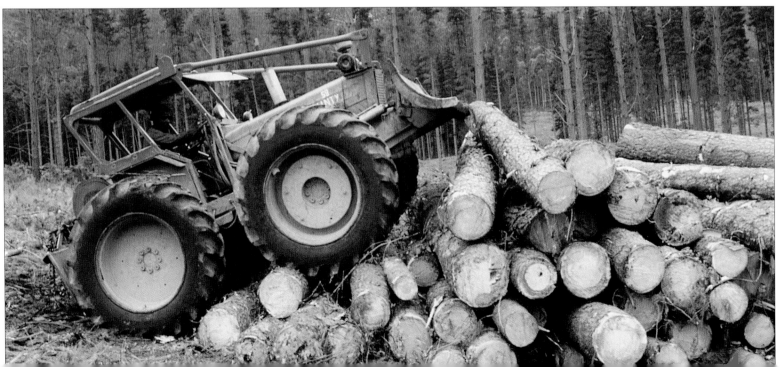

184. A County 1164 Highlander timber forwarder fitted with a Highland Bear crane and a double-drum winch. James Jones of Larbert, Stirlingshire, Scotland, built a range of County-based timber tractors, many of which are still in use today.

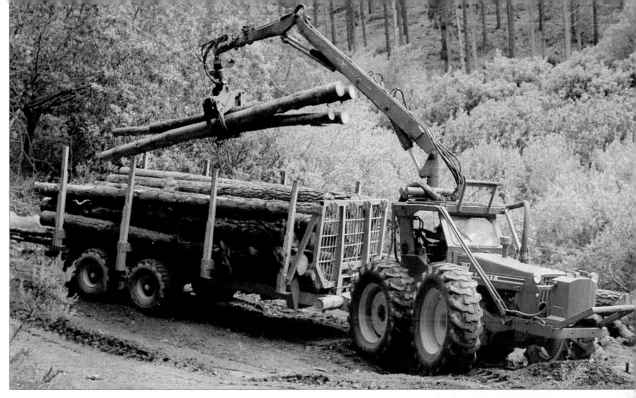

185. A County 764 with a Highland Bear crane overdoes it a bit with the weight of timber in the grab. This was one of a fleet of about 80 County timber tractors operated by the Natal Tanning Extract company in South Africa.

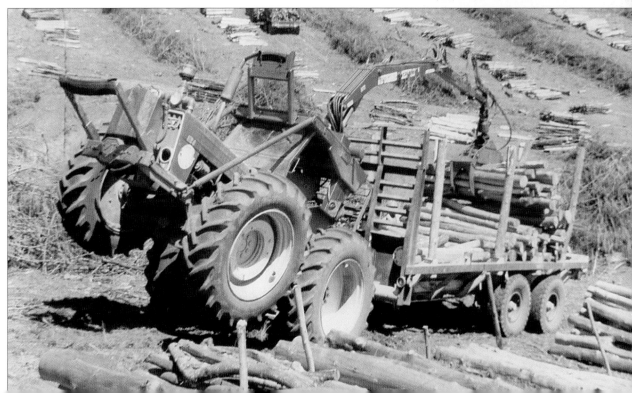

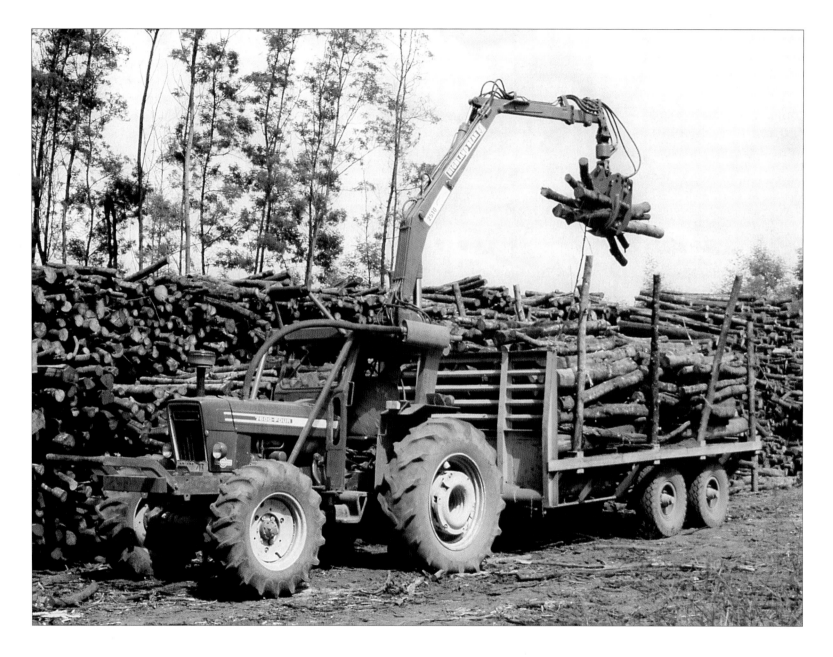

186. *A County 7600-Four with a Highland Bear crane used by Natal Tanning Extract in South Africa.*

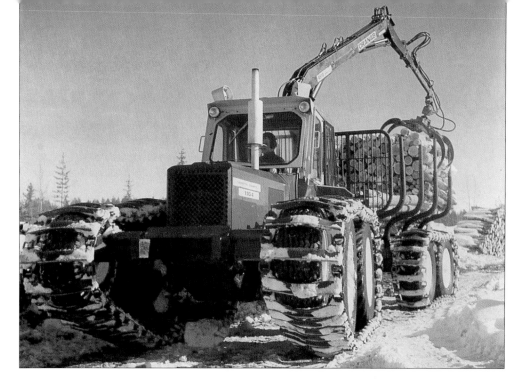

187. *A Savotta County 1164 timber tractor fitted with Finn-Tracks and a Cranab crane. Built in Finland, this was one of several different types of County timber tractors working across Scandinavia.*

188. *A Savotta County 754 timber tractor in Finland. Fitted with Finn-Tracks, the tractor was tail-steered by two hydraulic rams connected to the trailer which often featured powered wheels. County timber tractors were also built by Rottnë and Teg in Sweden, and Eik & Hausken in Norway.*

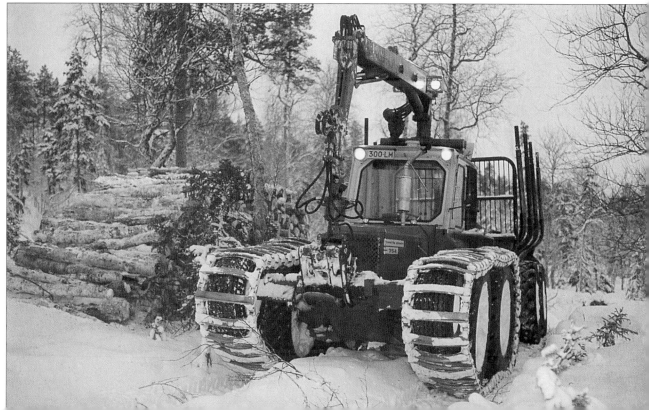

County in sugar cane

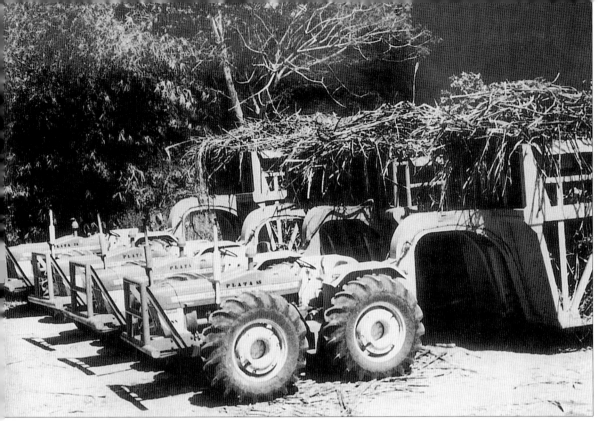

189. The sugar-cane growing areas of the world were probably County's most important export markets. Puerto Rico, in particular, had a long association with County whose tractors had been in use there since the 1950s. Four 1124s with cane trailers, part of a fleet of County tractors used on the island by the La Plata Sugar Estate near San Sebastian, are seen lined up in July 1970.

Below
190. An 1164 hauling two sugar-cane trailers is loaded by a cane harvester in the West Indies. County tractors were used for both sugar-cane haulage and cultivation.

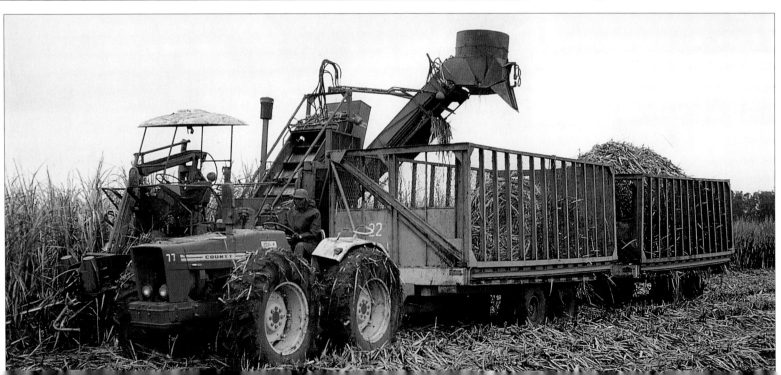

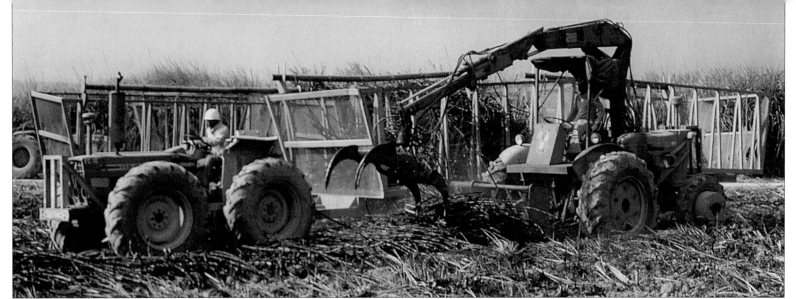

191. Hand-cut sugar cane is loaded by a cane loader into trailers hauled by a County 764 in the West Indies in 1979. The cane loader is also based on a Ford derivative, possibly a reverse-drive County or Roadless skid unit.

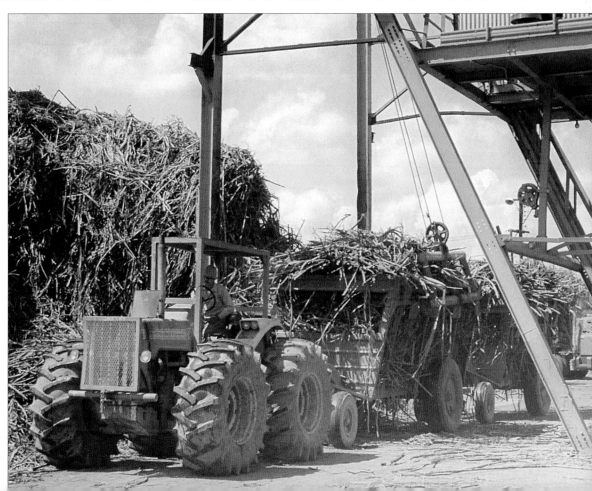

192. A County 1454 waiting to be unloaded at the refinery depot in Puerto Rico in 1975. The bodies of the cane trailers were tipped sideways for unloading by the overhead gantry hoist.

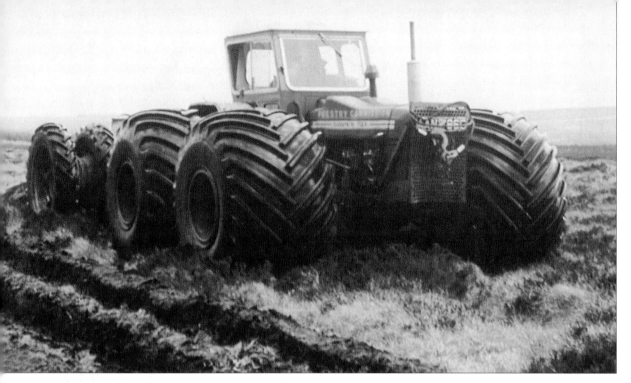

Swamp tractors

193. Having developed the swamp crawlers through the 1950s and early 1960s, it was a natural progression for County to also adapt its four-wheel-drive tractors for low ground-pressure work on soft conditions. This 1004, fitted with a reduction box and 42 in. Goodyear Terra-tyres, was used by the Forestry Commission with a Clark plough for reclamation work during an afforestation project in 1968.

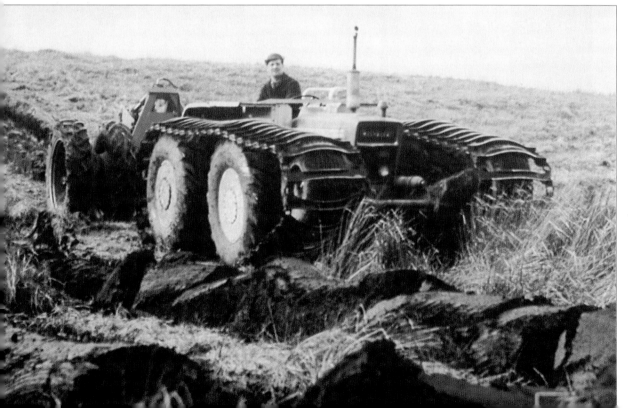

194. An experimental County 754 fitted with Finn-Tracks for swamp work and deep ploughing with the Forestry Commission in 1974. The tractor was skid-steered by means of an air-braking system.

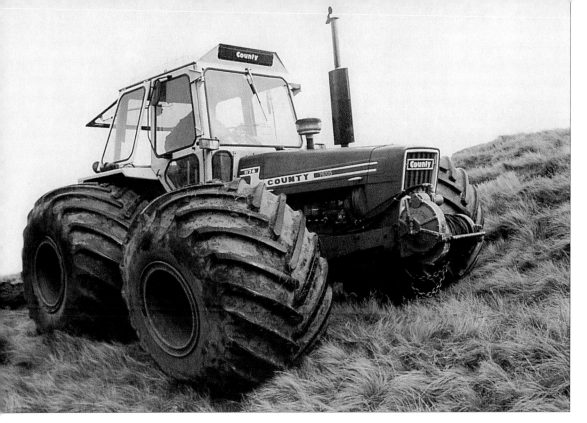

195. A County 1174 fitted with flotation Terra-tyres and a front-mounted Boughton hydraulic winch for hillside reclamation work. The Terra-tyres reduced ground pressure to 2.5 psi.

196. John Hull in Papua, New Guinea, with a County 1164. The tractor, fitted with dual wheels on the front and triples on the rear, was being used with a rotary drainage plough for reclamation work in the Waghi swamp.

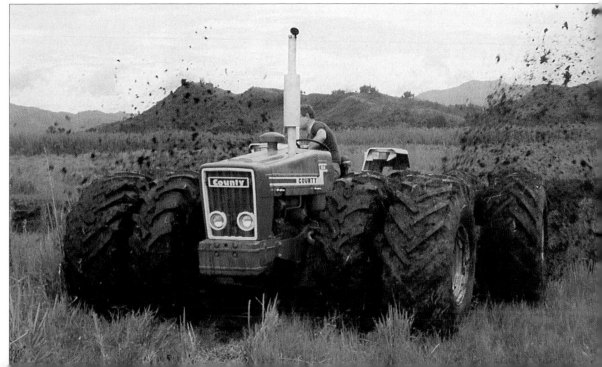

Drainage machines

197. A Howard Mark IV Trench Digger based on a County 654. The Mark IV was the last version of a range of rotary trenchers produced since the 1940s by Rotary Hoes of Horndon in Essex. Introduced in 1967, it was available either on a Ford 5000 on Rotaped tracks or on the County, both fitted with Howard 24:1 reduction boxes. The manufacturing rights for the Howard reduction boxes were taken over by County in 1969.

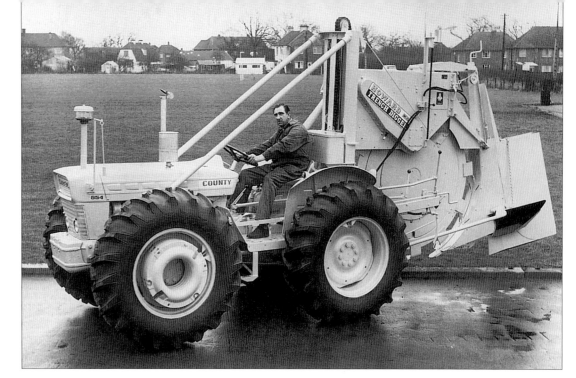

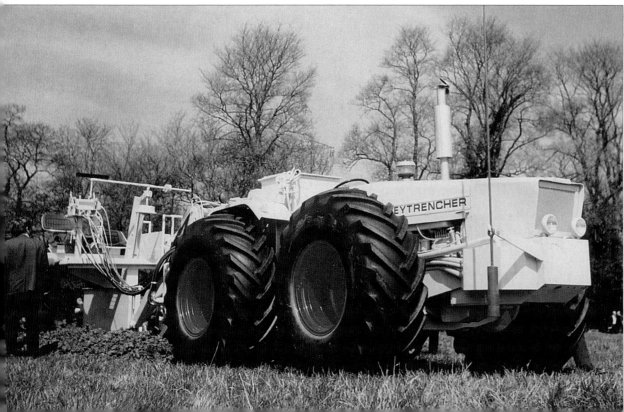

198. A Caley trencher based on the County 1164 in 1973.

199. *A County 1164 provides the motive power for this 1978 Barth trencher laying tile drains. Barth, based in Mablethorpe in Lincolnshire, started using County skid units as the basis for its drainage equipment in 1969.*

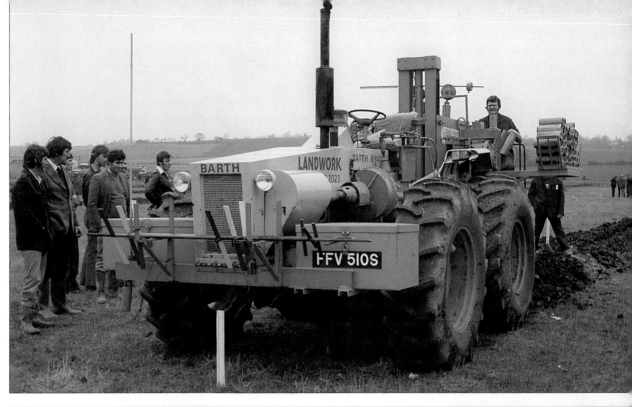

200. *By 1979, Barth were producing an average of 25 to 30 County-based drainage machines a year, using 764, 964 and 1184TW skid units. This K150 machine, being used to drain a woodland in Sussex, was built around a 964 tractor.*

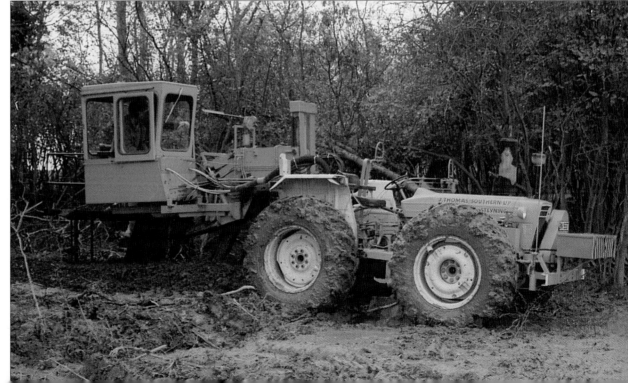

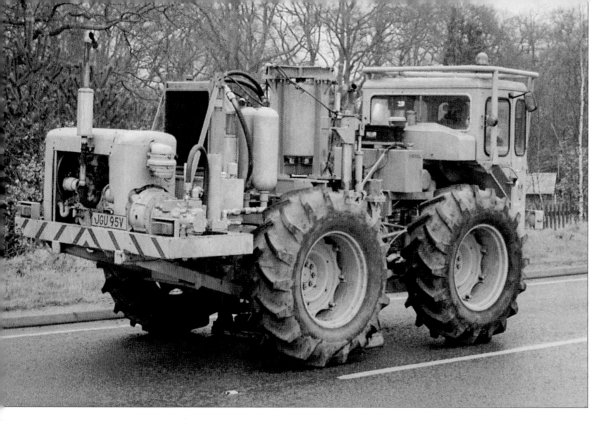

Drilling and exploration

201. One of a number of
Vibracice seismic testing
machines based on County FC
1004 tractors. Large single rams,
mounted under the machines
and operated by compressed
air, thumped the ground to set
off shock waves which were
recorded by microphones taking
underground soundings for oil
exploration.

Below

202. A fleet of six Hydreq
Gryphon drilling rigs, based
on County 1164TW tractors,
operating in Israel for water-well
drilling and exploration surveys.
The rigs were built by Hydraulic
Drilling Equipment of Horley in
Surrey.

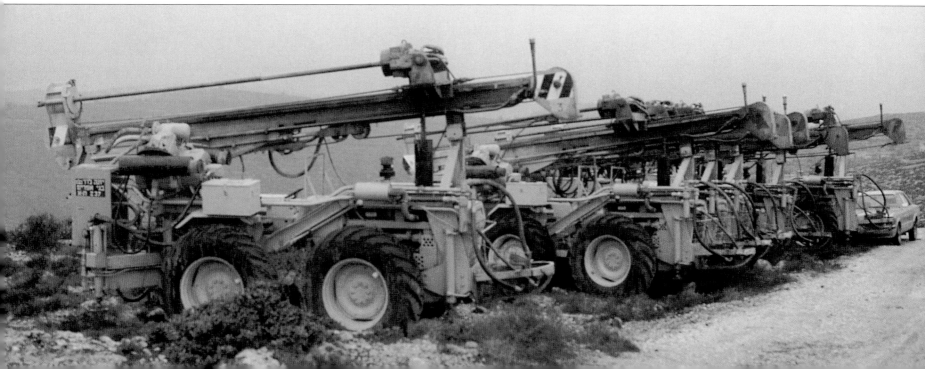

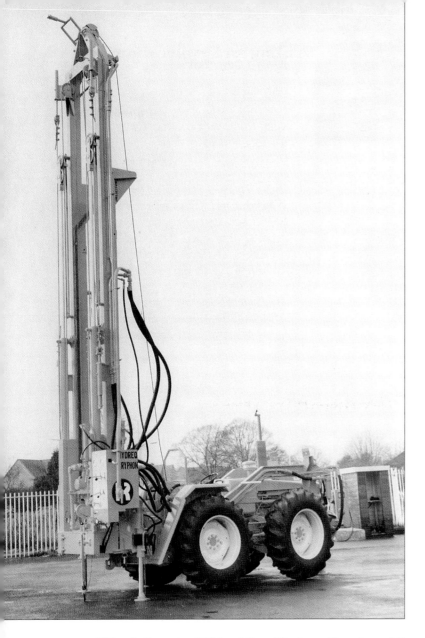

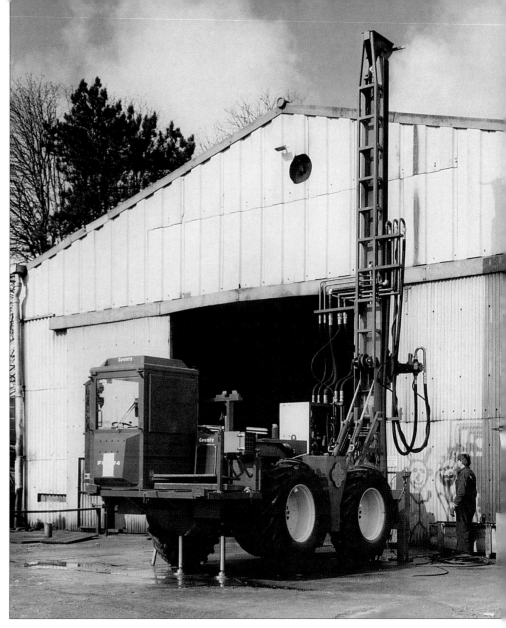

203. A County 1164 with a Hydreq Gryphon 10 drilling rig in the working position. The rig, mounted on a special sub-chassis, was powered by two engine-driven hydraulic pumps.

204. A County FC 1174 fitted with a Dando 250 drilling rig made by Duke & Ockenden of Arundel in Sussex in 1979. The rig was capable of working to a depth of over 600 ft.

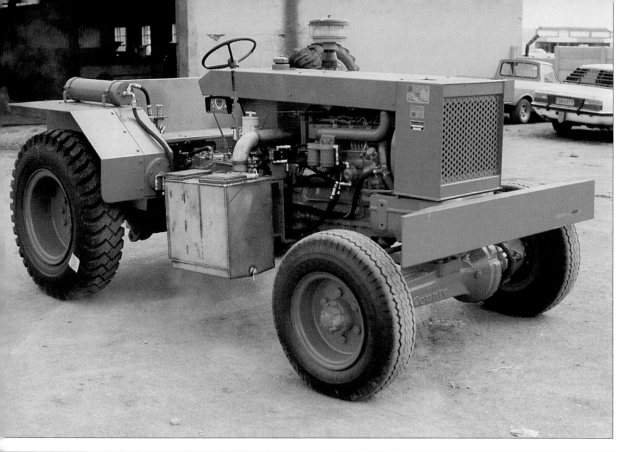

Mine tractors

205. A number of County tractors have been adapted over the years for use in underground mines, including a CD50 with a bulldozer used from 1960 in an anhydrite mine in Whitehaven. This tractor is a 7600-Four converted for mining use, and fitted with an exhaust-flash eliminator for working in explosive conditions in a mine near Johannesburg in South Africa. The owners, SASOL, were mining coal for fuel oil.

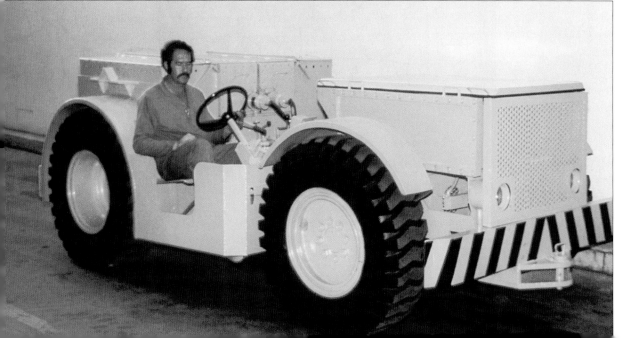

Left
206. Around 80 County tractors were adapted for mining work in South Africa and were used in coal, lead and diamond mines. This electric mine-tractor, based on a 764, was built by Ford dealers Erikson, and proved to be very successful.

Facing page
207. A County 764 adapted by Erikson for underground maintenance work in a colliery in South Africa.

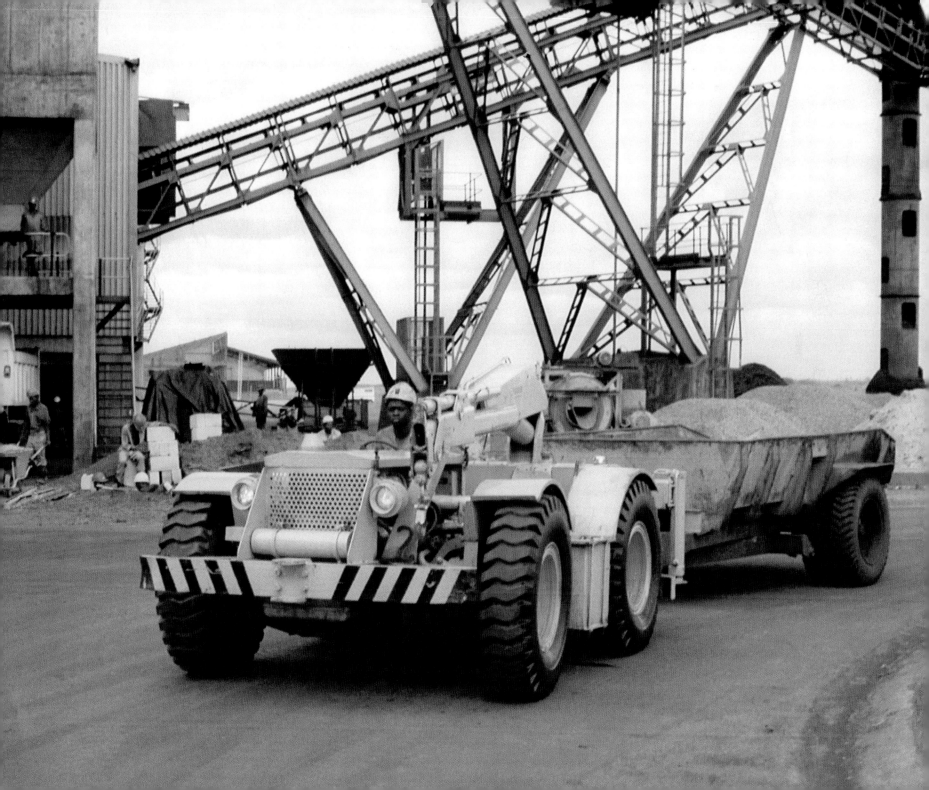

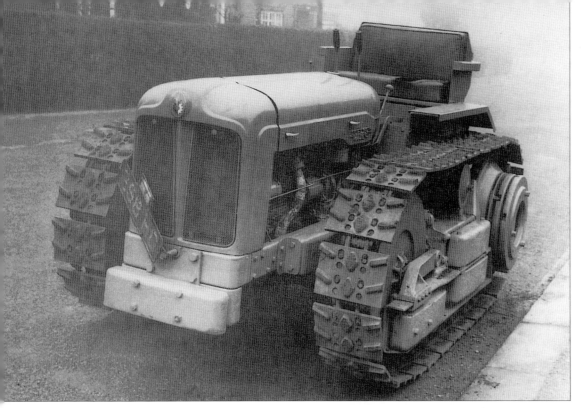

Aircraft-towing tractors

208. *County's first aircraft-towing tractor, based on the Mark III industrial crawler, dates back to the 1950s. Fitted with special rubber track-plates, and a solid cast front idler and rear-wheel weights for added traction, it was capable of towing 100 tons. John Heathers demonstrated it at Heathrow, and at RAF Marham where it was used to tow Vulcan bombers. Unfortunately, it proved to be too slow and none were sold.*

209. *The next County aircraft tug did not appear until 1967. Built in conjunction with the Royal Aircraft Establishment in Bedfordshire, this machine was based on a 1004 with 14x30 Firestone industrial tyres. Optional extras included a Brockhouse 33F torque converter transmission, outboard disc brakes and a ten-ton winch. An 1124 model appeared in 1970.*

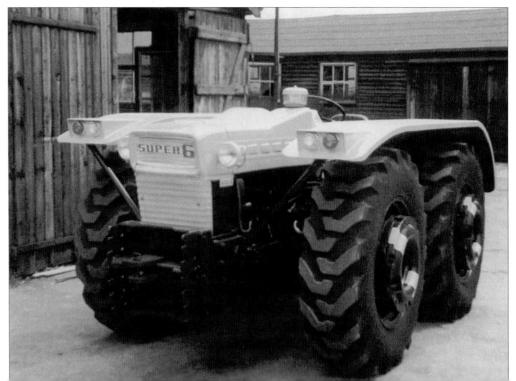

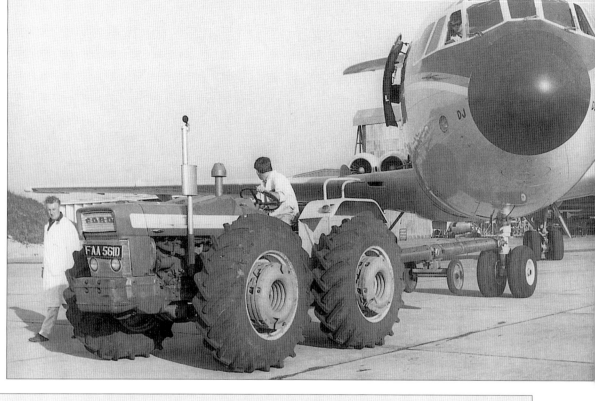

210. A County 954 undergoing evaluation trials for its aircraft-towing ability moving a Vickers VC-10 in 1966. Two County aircraft-towing tractors eventually saw service on the Australian aircraft carrier, Melbourne.

211. The forward control County was also evaluated by the Royal Aircraft Establishment for use as an aircraft tug. The aircraft is a Blackburn Beverley transport plane.

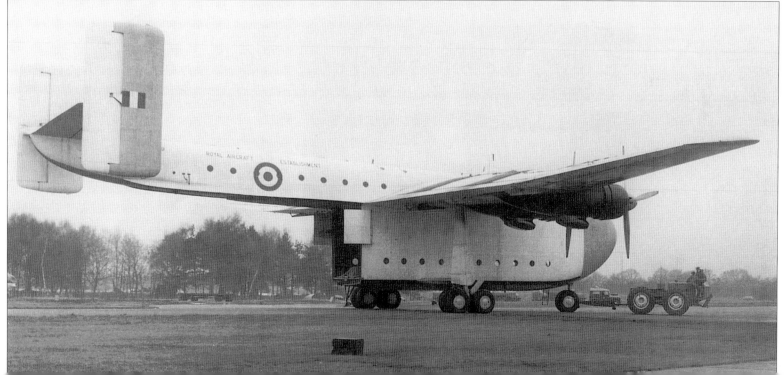

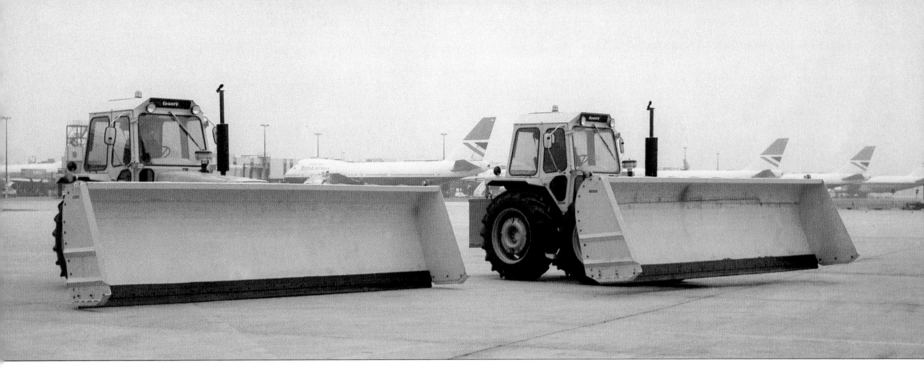

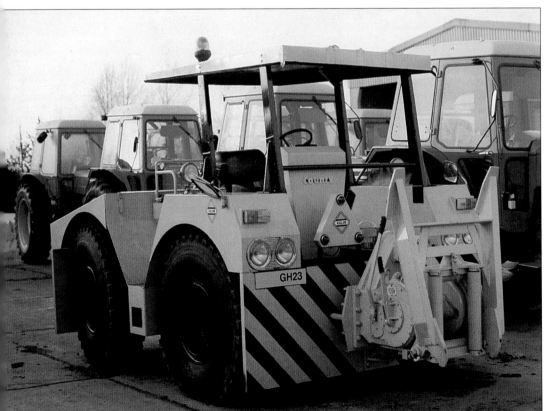

Above

212. A pair of County 1174 tractors fitted with Bunce snowplough blades used at Heathrow airport for keeping the runways and aircraft standing areas clear of snow. Thirty-three similarly equipped 1184TW tractors were supplied to the British Airports Authority in 1980 for use around the country.

Left

213. Developed by EC Hallam Engineering of Leicester, the Bulldog industrial and aircraft-towing tug was introduced in 1980, based on the County 764. Featuring rear-wheel steering and a Brockhouse 11F torque converter transmission, it is shown fitted with an optional 12-ton recovery winch.

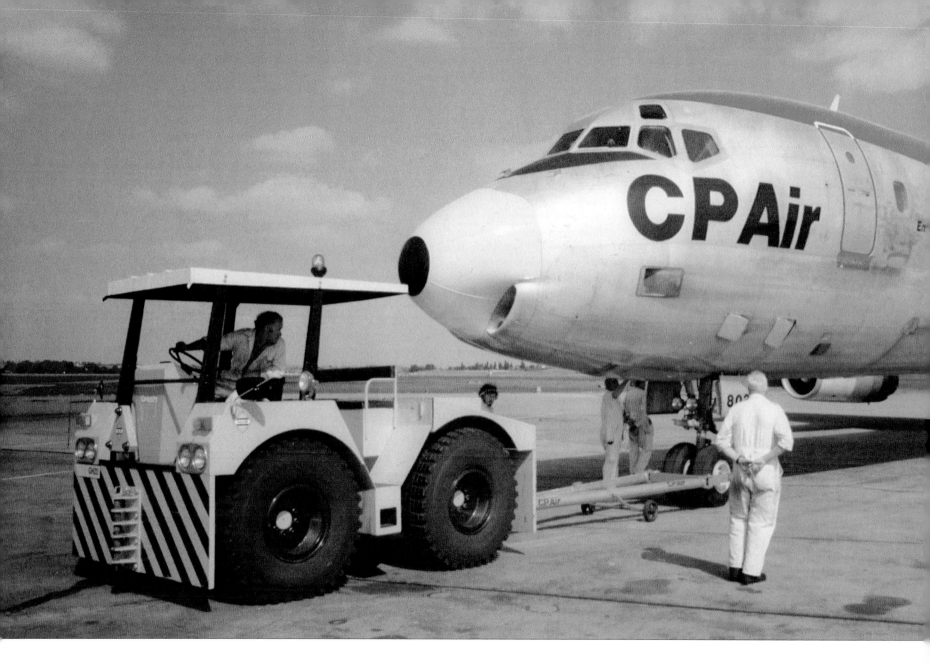

214. *A County Hallam Bulldog tug moving a Douglas DC-8 weighing over 140 tons. More powerful versions, based on County 964 and 1164TW skid units with Brockhouse 33F transmissions, became available in 1981.*

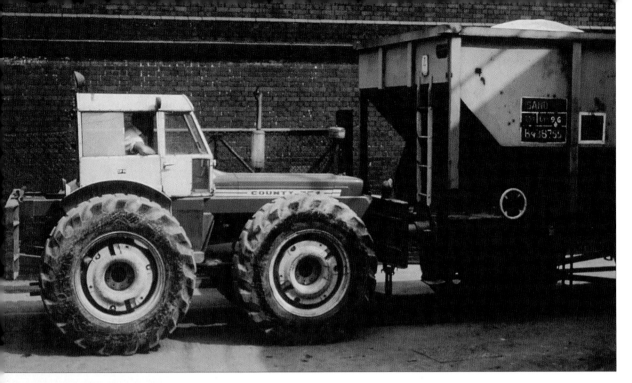

Shunting and haulage

215. A County 754 adapted for shunting railway wagons. Most of the County-based shunters were built by Cheshire County dealers, Warrington Tractors, and were marketed as the Mersey Shunter. Customers included British Rail, Kelloggs, British Shipbuilders and British Nuclear Fuels.

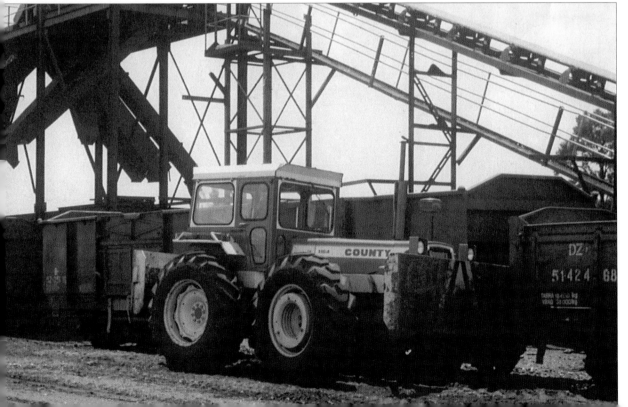

216. A Mersey Shunter, based on an 1164TW, used for shunting duties in Africa. Eight similar units were supplied to Mozambique in 1987 for use in the dockyards of Maputo, Beira and Nacala.

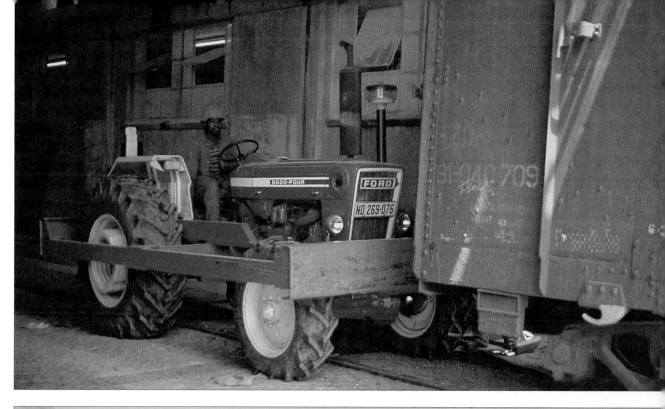

217. A County 6600-Four adapted for shunting duties in South Africa.

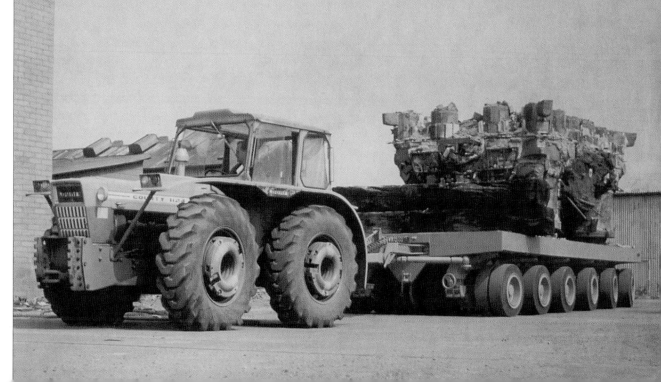

218. A County aircraft-towing tractor supplied to Hawker Siddely for general haulage work. Based on the 1124, it was fitted with a Brockhouse 11F torque converter transmission and had a maximum tractive effort rated at 16,920 lb.

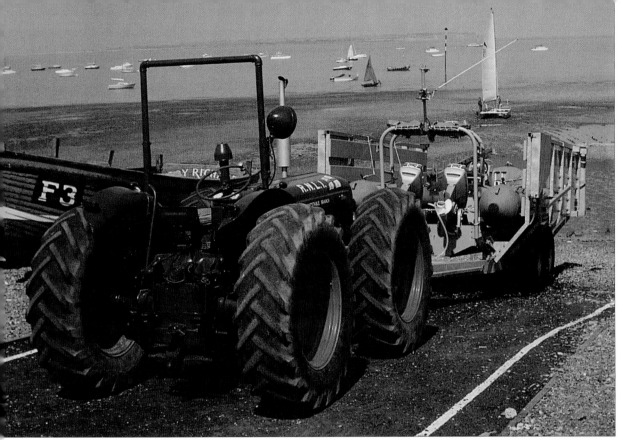

Lifeboat-launching tractors

219. The Royal National Lifeboat Institution's first County tractor, a Super-4 bought secondhand by the coxwain at Whitstable in Kent for launching the inshore lifeboat.

Below
220. A County 754 acquired by the RNLI in 1974 for launching an Atlantic inshore lifeboat at New Brighton. Following further trials another 754 was equipped with Finn-Tracks for use at Minehead with a Zodiac inshore rescue boat.

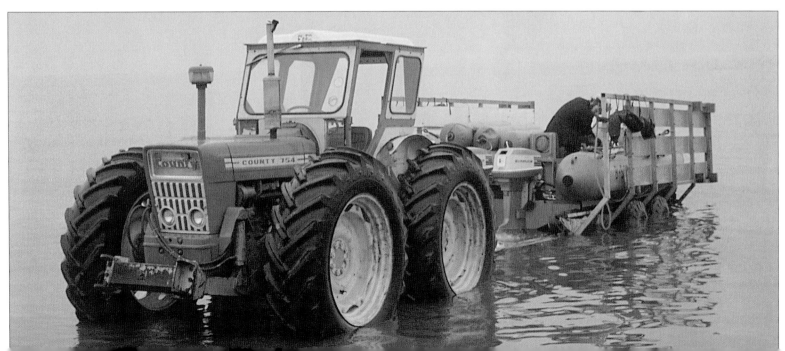

221. In 1974, Mike Bigland was approached by the RNLI to design and build a four-wheel-drive semi-submersible wading tractor to launch and recover Atlantic 21 inshore rescue craft. A prototype (shown) was built on a County 754 and was successfully tested at Blackpool in 1975. The bulk of the tractor was enclosed in a watertight compartment which also protected the driver from the elements. The design of the hull also gave the machine progressive buoyancy and allowed it work to a depth of 5 ft.

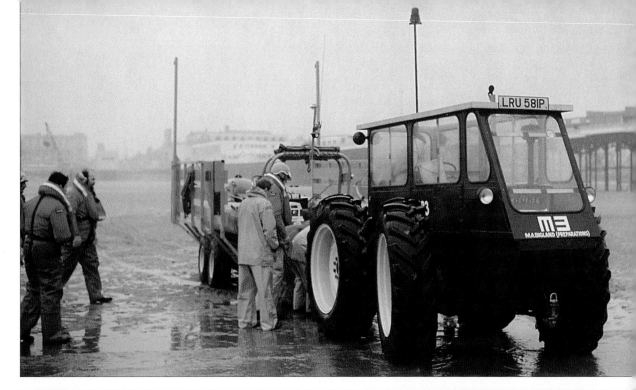

222. Mike Bigland put his lifeboat tractor into production on the County 764 skid unit as the Talus MB764. Several were commissioned by the RNLI, including this example seen in service with Newbiggin Lifeboat Station in Northumberland. The machine is still in production at MA Bigland Preparations, now based in Knighton, and is built from completely refurbished County tractors.

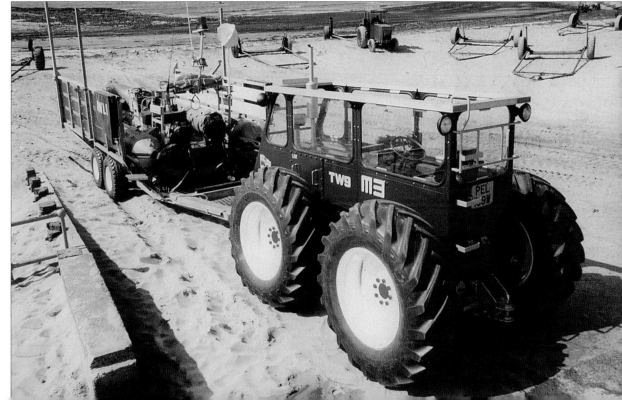

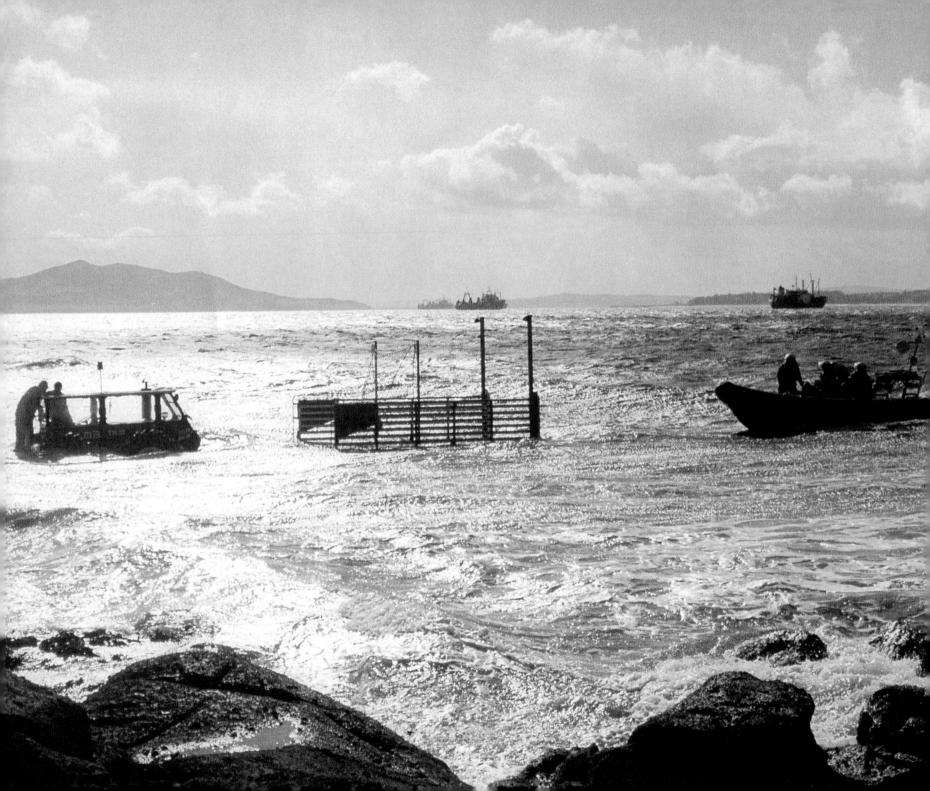

Previous page
223. A Talus MB764 in a dramatic recovery at Buncrana in Eire in 1996. Up to January 1997, 26 Talus MB764 tractors had been supplied to numerous sites throughout the UK and Eire.

Right
224. The Talus MB764-MOD was a derivative of the RNLI tractor developed for use by the Ministry of Defence in the Outer Hebrides. The vehicle went into service in 1978 and was used to launch and recover inshore rescue craft.

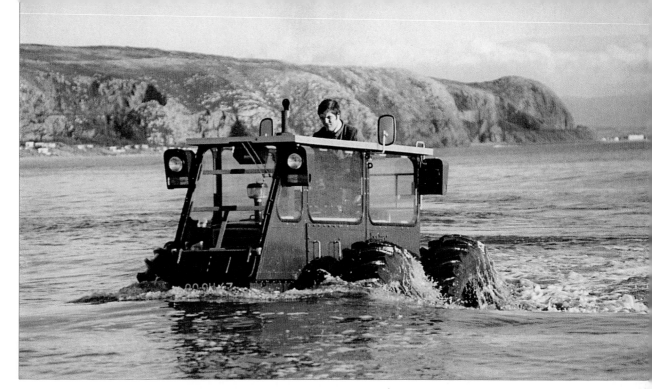

225. A second County-based Talus MB764-MOD completed by M A Bigland in May 1997, again for the Ministry of Defence for use in the Outer Hebrides. The company also manu-factures lifeboat-launching carriages and trolleys for both Mersey Class lifeboats and inshore rescue craft.

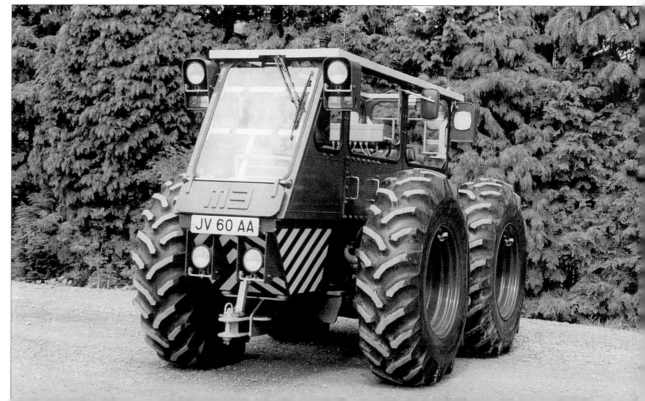

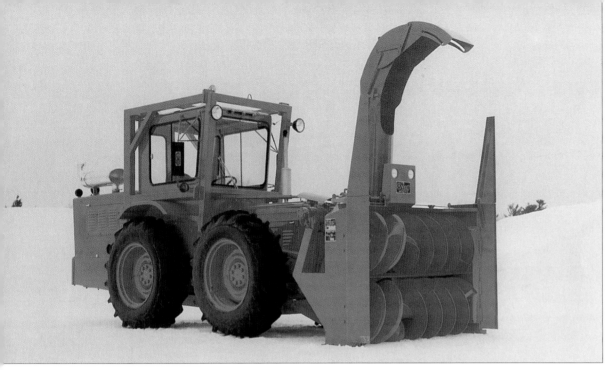

Snowblowers

226. *A number of County 754 tractors were fitted with snowblowers by Canadian dealers, Richard Piché of Quebec, from 1972. The snowblower attachment was made locally by Adrien Vohl et Fils and was powered by a 220 hp auxiliary engine mounted at the rear of the tractor.*

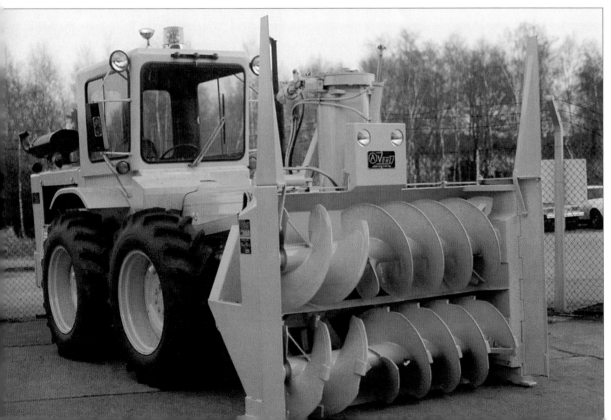

227. *Later Piché machines were based on the County 764 and were available with torque converter transmissions. The side paddles were controllable from the cab and used for steering in deep snow.*

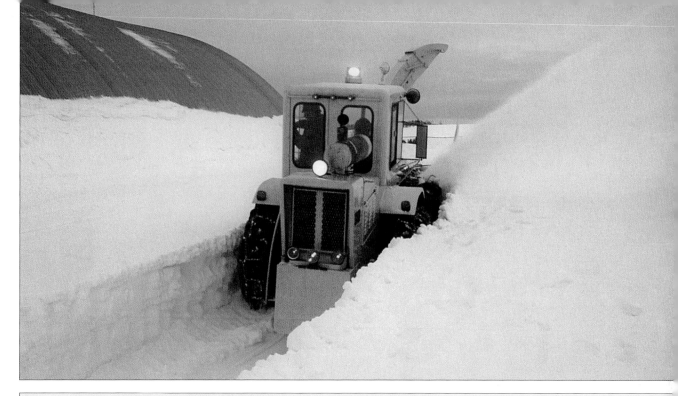

228. The twin 26 in. augers were capable of clearing a path 7 ft 6 in. wide through frozen snow up to 8 ft deep. The discharge chute could be angled hydraulically from the cab, which was fully insulated from the cold. Working at full capacity, the machine could move about 2,000 tons of snow per hour.

229. Richard Piché's yard in Quebec. About 400 machines were supplied, including several which were used at the 1988 Winter Olympics in Calgary, Alberta.

County loaders

230. Making its appearance in 1963, this loading shovel of County's own design was based on a reverse-drive Super-4 and Bray loader equipment. The machine never progressed beyond prototype stage, and changes to the skid unit following the introduction of the new Ford 6X range in 1964 led to the project being shelved.

231. A less elaborate loader, based on a County 654 fitted with a Bray-derived loading shovel, underwent trials in 1967. Plans to market it for 1968 as the County Loader were dropped when it was found to be too heavy. Bomford & Evershed were later given approval to manufacture what was felt to be a better and lighter design of loader to fit the County.

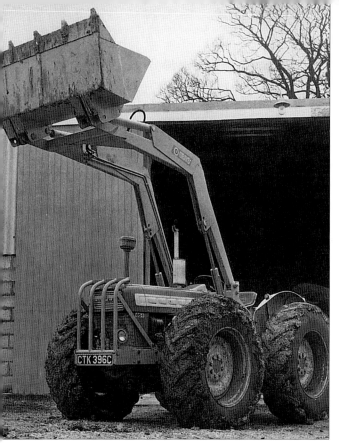

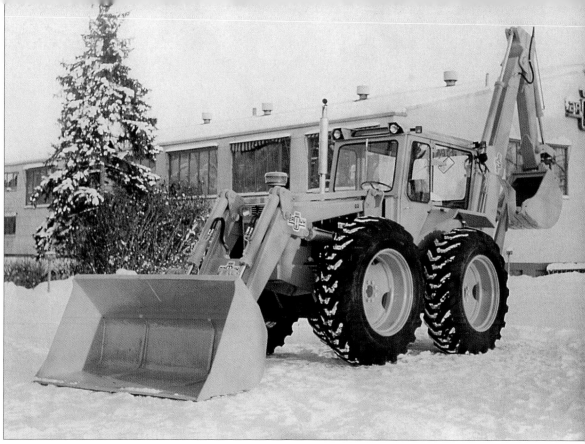

Above left
232. A 1965 County 654 fitted with a loader made by Grays of Fetterangus, Scotland.

Above right
233. The Hymas 72 backhoe loader manufactured in Norway from 1974 on a County 944 skid unit.

Right
234. A County 6600-Four, fitted with a Farmhand F12 loader, loads a grinder-mixer powered by a County 1454.

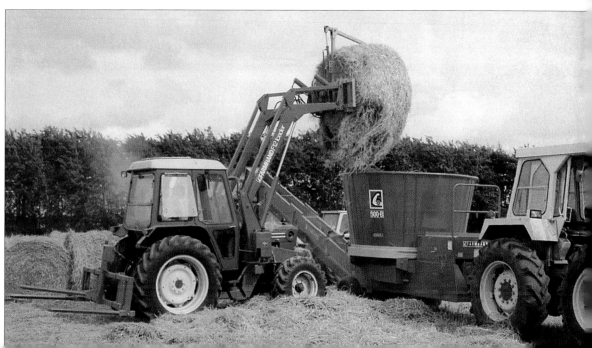

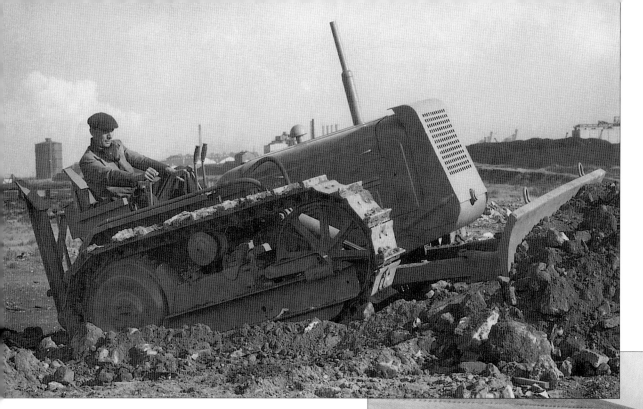

County dozers

235. *A County Mark III industrial crawler fitted with a Bray angledozer. Based in Feltham, Middlesex, Bray had a long association with County dating back to 1949 when the company introduced hydraulic dozer equipment to fit the Full Track. Bray dozers were manufactured for all the County crawlers, the Four-Drive and some later four-wheel-drive tractors.*

236. *John Heathers puts his own County crawler with Bray dozer equipment through its paces. This Mark IV was a transitional model and was used as the testbed for many of the CD50 components.*

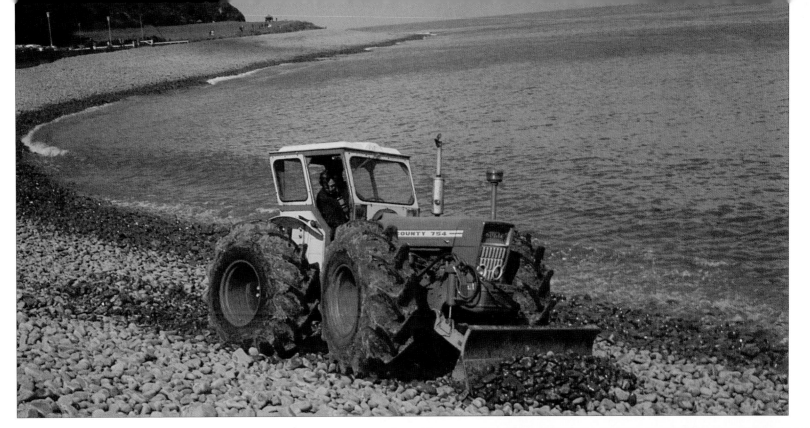

237. A County 754 fitted with a Sapper Powerdozer working on a beach in Kent. Manufactured by Bomford & Evershed, the 8 ft blade was operated by twin hydraulic rams. The company, based near Evesham, also made loaders, log grabs and snow-ploughs to suit County tractors.

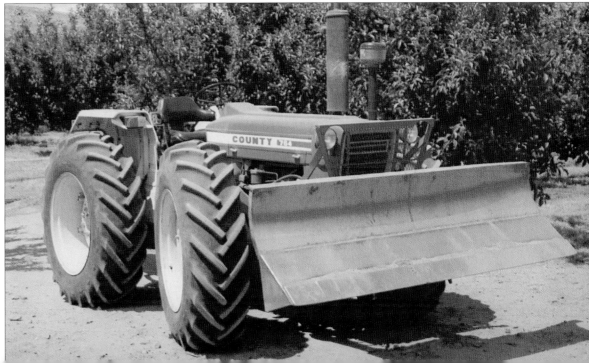

238. A Bomford Sapper Powerdozer fitted to an export-model County 764.

County cranes

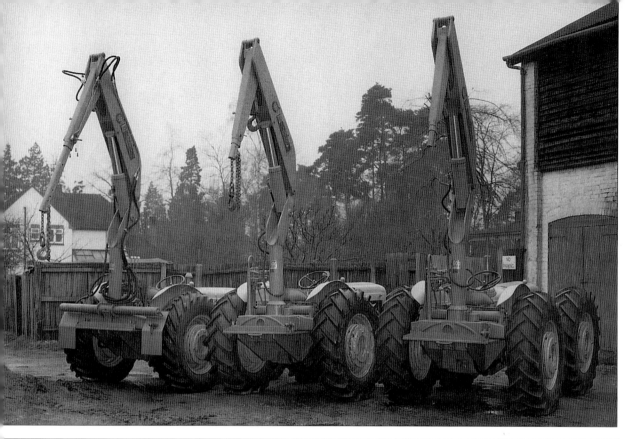

239. *A trio of County Super-4 tractors fitted with Hiab cranes in 1964. The tractor made an excellent mobile crane. Capable of lifting up to two tons it could work over all ground conditions and was ideally suited to forestry work. Note, the wheel weights mounted both inside and outside the wheel for stability.*

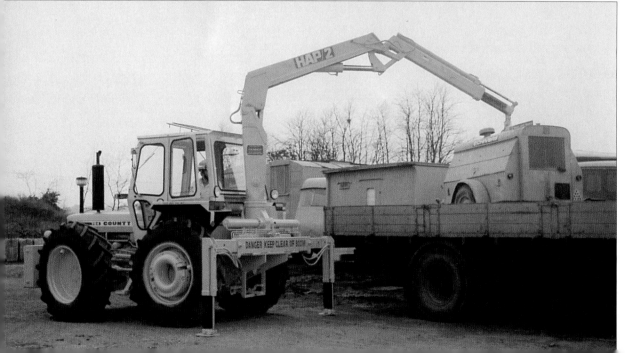

240. *A County 764 fitted with a HAP2 crane by TH White & Sons of Devizes in 1977.*

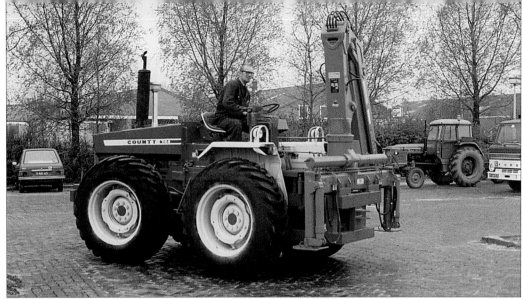

241. *A reverse drive County 764 fitted with an Atlas crane for work on the polders in Holland in 1978.*

Below
242. *A County FC 1174 fitted with a HAP1710 crane is used on a construction site to lay concrete drainage pipes in 1979.*

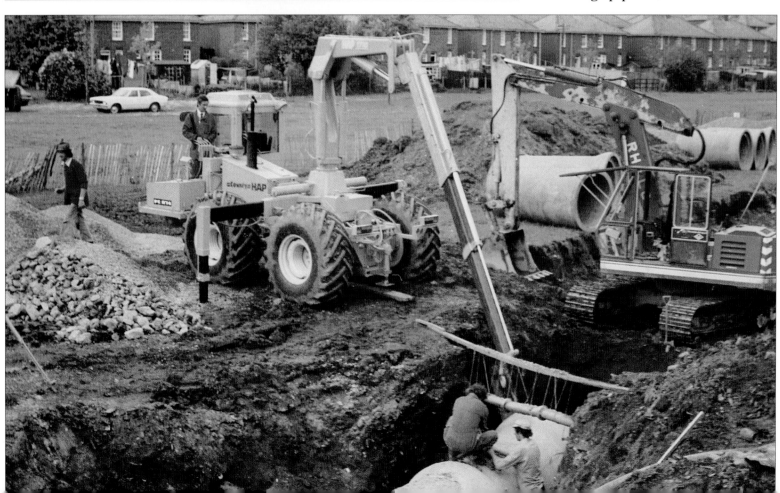

A County for all climates

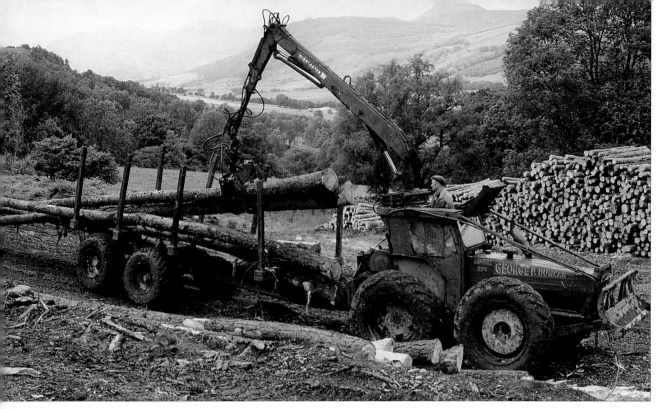

243. A Highlander timber forwarder, based on a County 1164, working near Perth in Scotland.

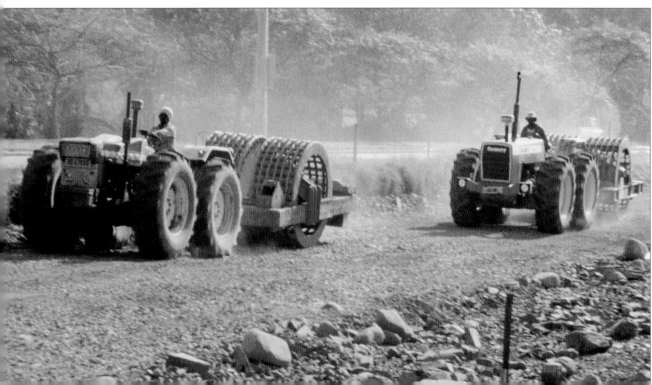

244. Road building near Durban in South Africa. A County 1004 and an 1164TW are used with grid-rolls.

Facing page
245. A County 1164 hauling sea salt off the salt pans near Walvis Bay, on the coast of Namibia in south-west Africa.

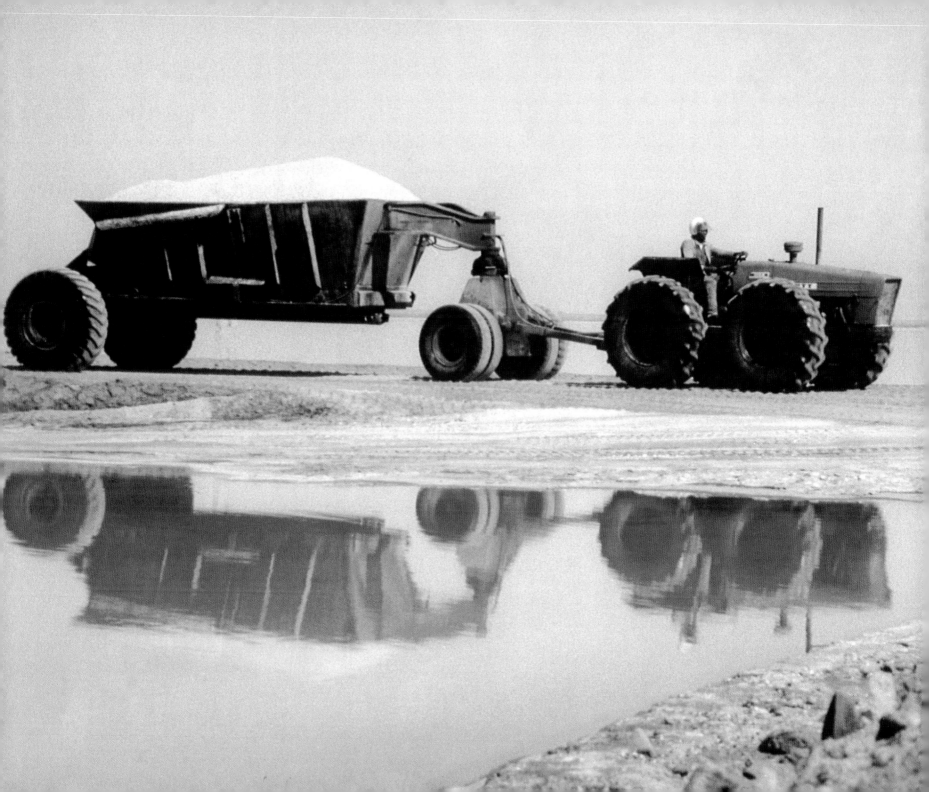

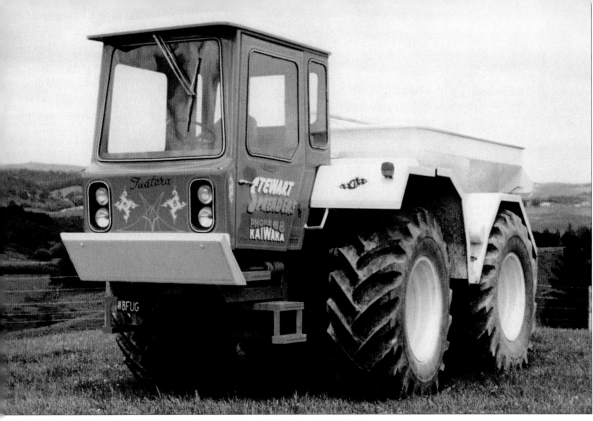

246. A County 1454 converted into a forward control tractor and adapted for lime spreading in New Zealand.

Below
247. Beach cleaning at Skegness with a County 774 and a Moreau trailed cleaner.

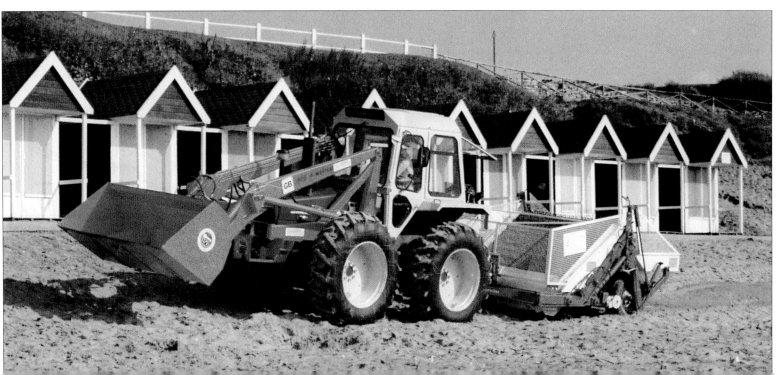

248. This tractor was built by a customer in the USA. Unable to obtain an 1884, he bought the necessary four-wheel drive parts from County and converted his own Ford TW30.

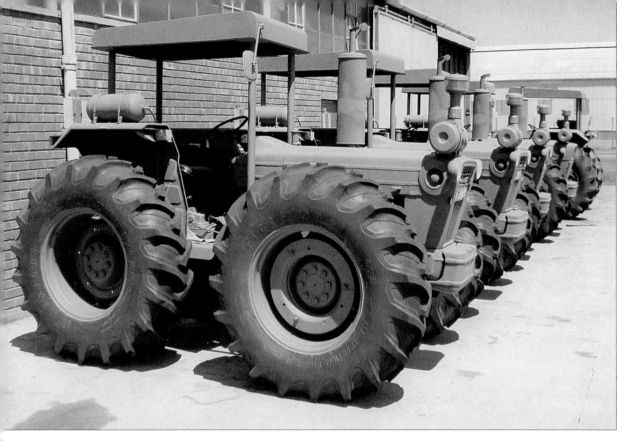

249. A fleet of five County 764 tractors used by the South African army in the Craprivi strip to tow tankers for emptying cesspools. The army politely called the tankers night-earth trailers; County's reps called them something else.

Below
250. This giant Oshkosh truck was used for County's demonstration tour of South Africa between June and October 1976. The tour covered over 17,000 miles, and visited more than 40 demonstration sites from the Transvaal to the coast.

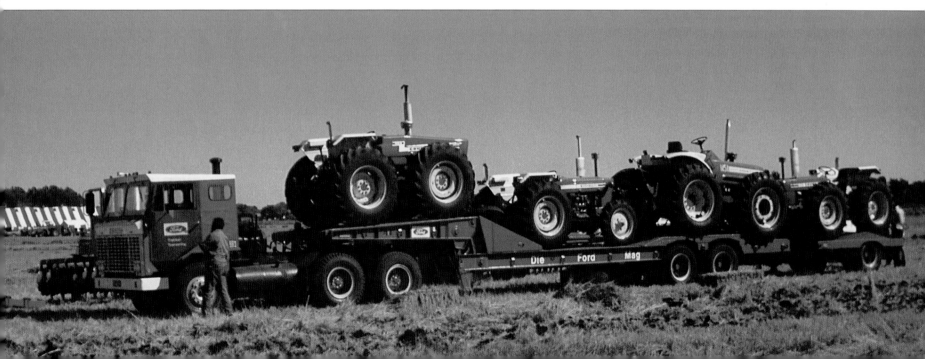

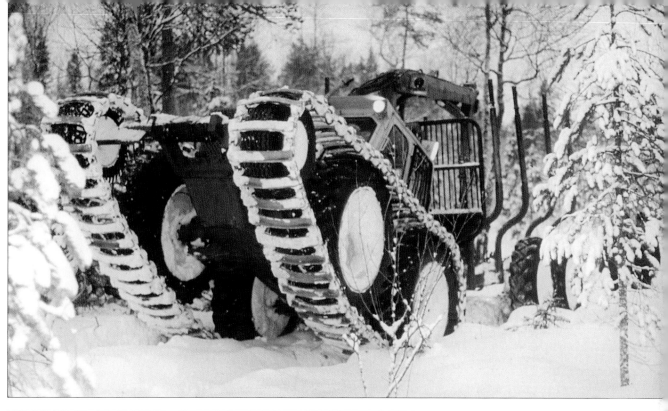

251. A County timber tractor coping with harsh winter conditions in a Finnish forest. County tractors were used extensively in Scandinavia, and by 1969, nearly 500 County units were operating in Norway alone.

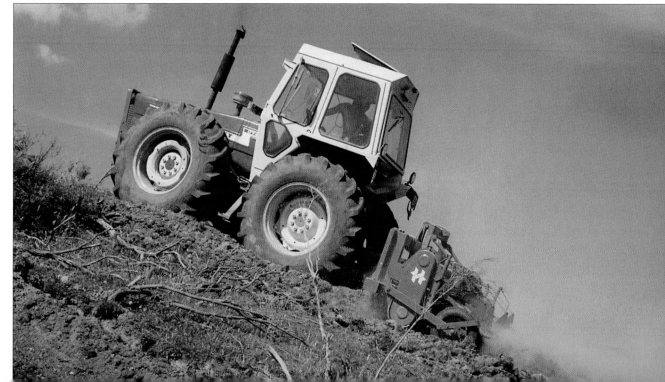

252. County's sales representative, Mike Gormley, puts an 1174 through its paces with a Howard rotavator on some difficult slopes on South Island, New Zealand in 1980.

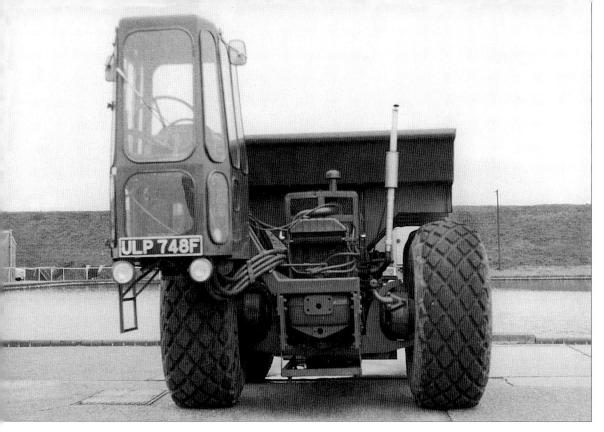

Special applications

253. This special forward control tractor was built in 1969 for the Metropolitan Water Board for use on filter beds at Uxbridge. Fitted with a front-mounted transverse auger, it was used to skim the top few inches of sand off the filter beds. The sand was then elevated by a conveyor to the rear-dump body, The vehicle was also equipped with a reduction box and sand tyres.

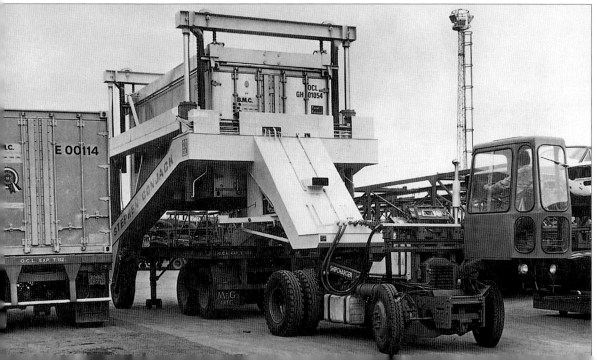

254. A forward control County skid unit, converted to two-wheel drive with dummy front hubs, was used as the basis of the Shipcharger. Designed in the early 1970s by consultants, Norris Brothers, for Alexander Stevens, this was one of the first vehicles developed for handling containerised loads at ports and shunting cargo trailers on and off the roll-on roll-off ferries.

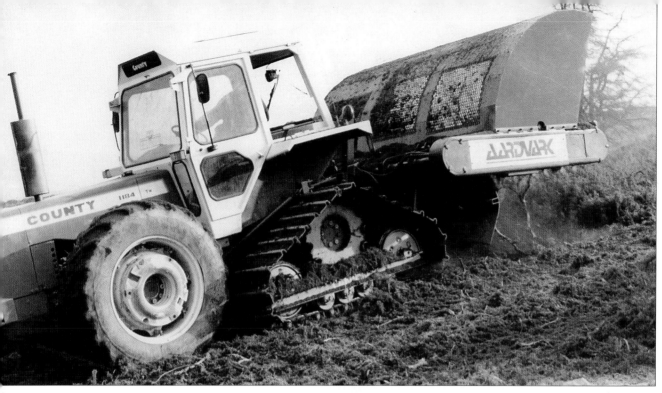

255. Based on a County 1184TW, the prototype Aardvark land-mine clearance vehicle appeared in 1985. Built in Scotland for military use, the machine used a revolving flail to clear a path through minefields. The Aardvark has since gone into production and several are in use across the world.

256. A Dutch loading shovel based on a reverse drive County 754. Seen exhibited at the Utrecht Show in Holland, the machine was equipped with special rear wheels with solid tyres and sprung centres for construction and maintenance work on the polders.

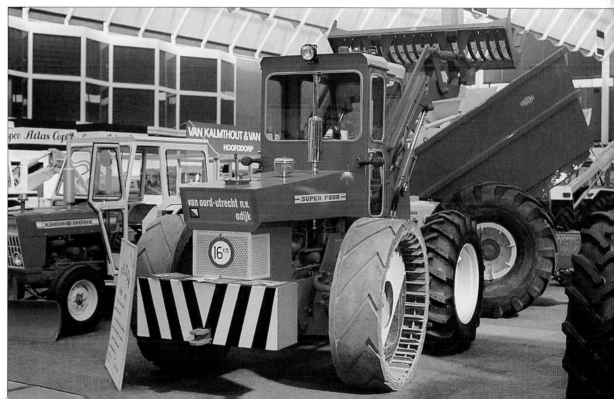

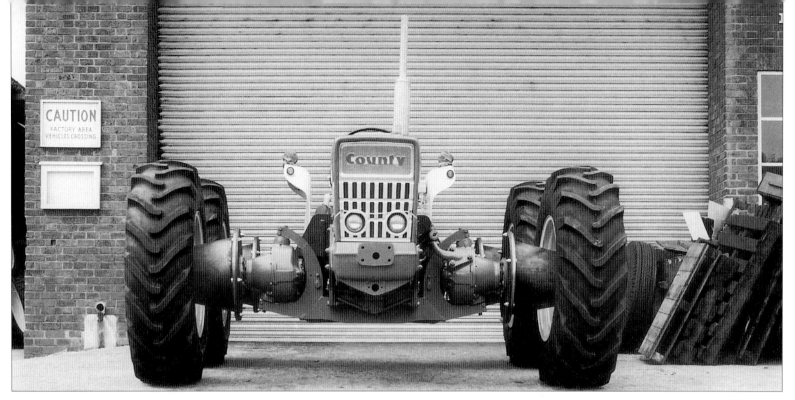

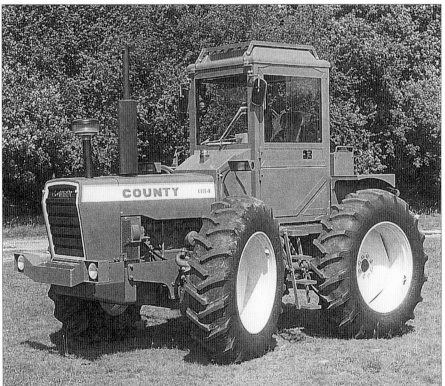

Special tractors

Above

257. This special, wide County 754, with a 109 in. track, was built in July 1970 by the South African Ford dealers, Perry of Stanger, based on the coast near Durban, for planting sugar cane. The cone-shaped hub extensions were made from County's dual-wheel adaptors.

Left

258. A design concept mid-mount tractor developed for County in 1980 by Mike Bigland, based on the 1184 fitted with the forward control modular cab. With the cab centrally mounted, space was left over the rear axle for equipment such as cranes, winches or couplings for goose-necked trailers. A 764 version was also built and both machines went to the Forestry Commission.

259. A County 764P working near Port Elizabeth in South Africa. The 764P and its sister model, the 1164P, were supplied as knock-down kits to the Ford plant in South Africa where they were fitted with Perkins engines made locally under licence by Atlantis Diesel Engines. County also considered marketing the Perkins-engined tractors in a proposed red and green colour scheme to sensitive markets where there was an embargo on Ford products. One 764 with an MWM engine was also built for Brazil.

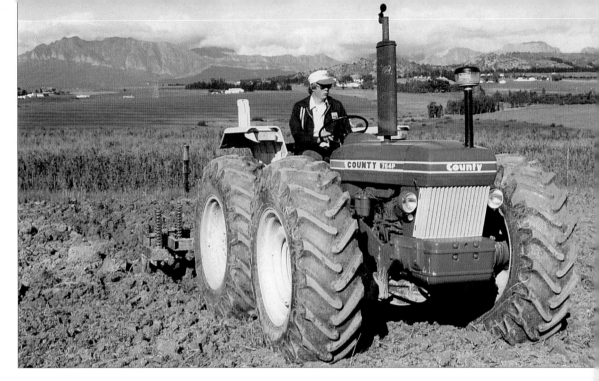

260. Ford 8100 tractors for the UK and France were assembled from 1979 by County at Fleet. The six-cylinder 2714E industrial engine was mated to the 7600 transmission with fitting kits supplied from Belgium by EVA. During the course of production, County adapted the design to take the de-rated 8700 tractor engine using conversion kits from its own 1174 model. Launched in 1980, this new model was known as the 8200 (shown) and was fitted with a Schindler four-wheel-drive axle. Production continued at Fleet until Ford took the design back 'in-house' with the introduction of the 8210 in 1981.

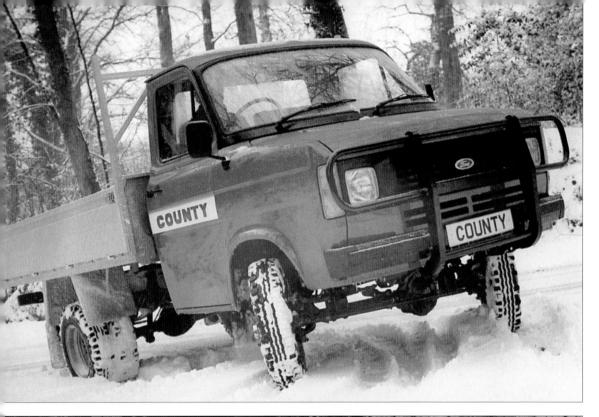

County Transit

261. County's four-wheel drive version of the ubiquitous Ford Transit first appeared at the 1981 Royal Show, following two years of development and testing. The conversion, which used American Dana axles, was available in van or pick-up form. The transfer box allowed two- or four-wheel drive to be selected, as well as a low-ratio gear range. Free-wheel front hubs and larger wheels and brakes were also fitted.

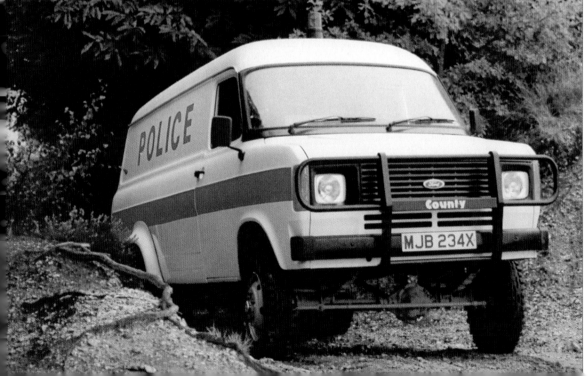

262. The County Transit became popular with the emergency services needing to operate in poor conditions or on difficult terrain. Vehicles were sold to the Police, the Ambulance Service and mountain rescue teams, as well as the military, public utilities, gas, electricity and water boards. The conversion added £3,500 to the cost of the basic Transit in 1982.

263. County's Transit demonstrator in 1983. Under David Gittins and Benson Group's ownership, sales increased and vehicles were exported to Pakistan and the Falklands. An improved version, based on the new model Transit, was launched at the 1986 Motor Show.

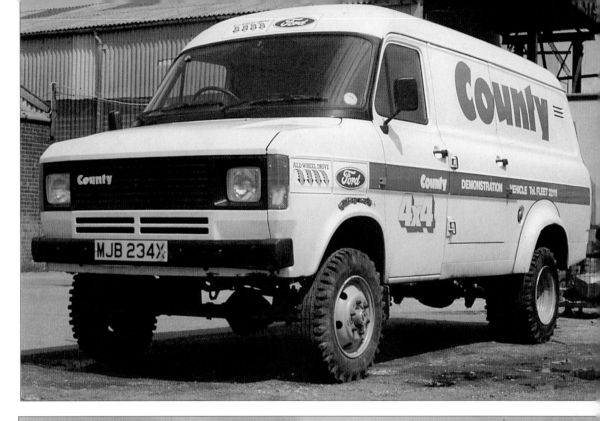

264. This four-wheel drive Transit truck was supplied to the Ministry of Defence by CountyYork Ltd of Knighton in the mid-1990s. In 2000, the production of the County Transit was taken over by Countytrac and moved to Ashford in Kent. None were produced after 2001 but the firm began working with the Ford Motor Company to develop the All-Wheel Drive Transit, which was launched to great acclaim in September 2006.

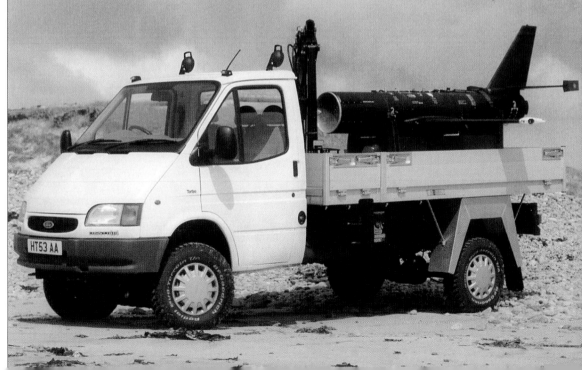

Special vehicles

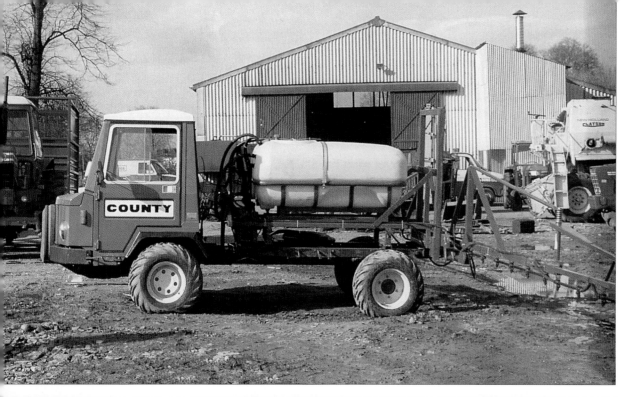

265. *Two low ground-pressure vehicles, the Muli-50 and the Metrac-3000, were marketed by County from 1981. Both machines were built in Austria by the Reform company. The Muli, seen fitted with a sprayer, was powered by a 46 hp three-cylinder Perkins diesel engine.*

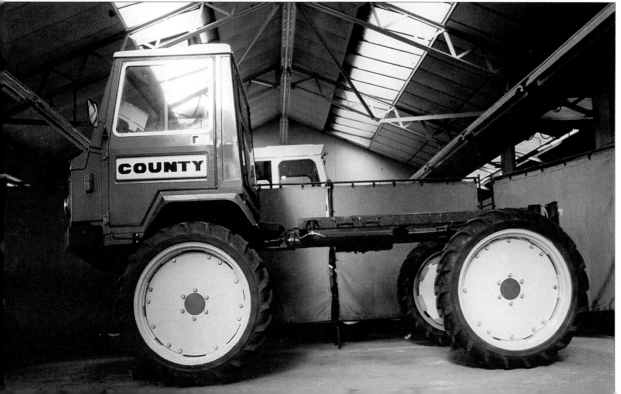

266. *A kit was developed to adapt the Muli for high-clearance work. Drop-axle boxes were fitted to give the vehicle a ground clearance of 33 in. After County Commercial Cars went into liquidation, the agency for the Muli was taken over by John Wilder Engineering.*

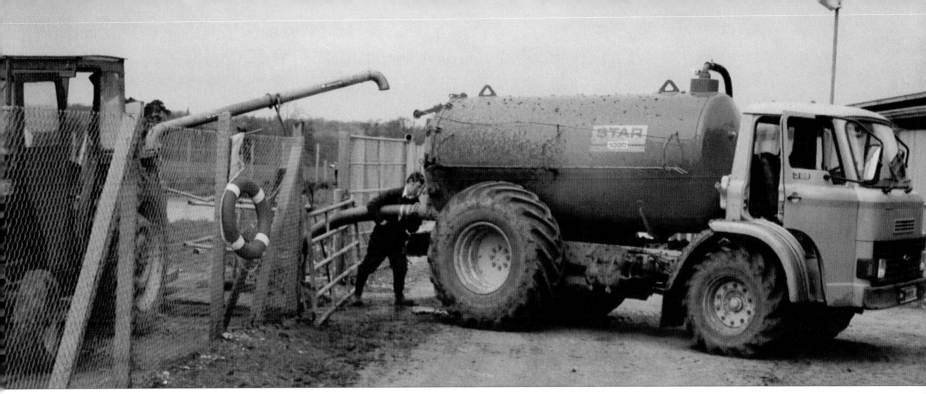

267. Developed in 1981, the Tracktruk combined
cross-country capabilities with the advantages,
comfort and 40 mph top speed of a road vehicle.
Designed for County by Mike Bigland, the prototype
was based on a Ford D-Series chassis fitted with
County tractor rear axle with road-legal outboard
disc brakes, and a bulk spreader body for handling
slurry.

268. This concept utility vehicle, designed for
cross-country work in third-world countries, was
also developed for County by Mike Bigland.
Nicknamed the Tonka, it was powered by a
transverse-mounted 1300cc Ford engine mated to
a Fiesta gearbox. With front-wheel drive through
reduction hubs, a clean underbelly and 14 in.
ground clearance, it could outperform a Land Rover.
David Tapp just about manages to hold on to the
steering wheel during trials.

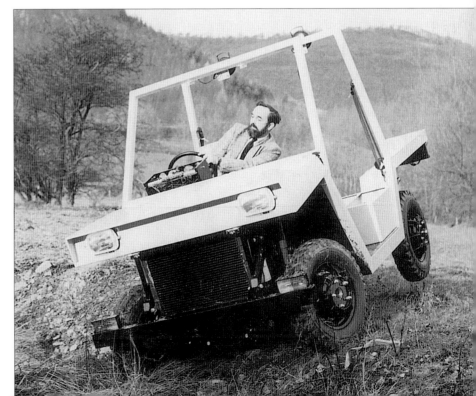

Epilogue

269. About 150 tractors were built by County Tractors Ltd at Knighton under the ownership of the Benson Group. Production finally came to an end in early 1990 following problems in sourcing suitable cabs to meet with UK legislation. A number of the last tractors built, including this 1184, were finished in Benson's red colour scheme.

270. One more batch of ten County tractors was completed at Knighton in July 1995. Based on the Ford 40 Series skid units, the new tractors were built for orders from the Falklands, St Helena and Canada. Both cabbed and uncabbed versions were supplied. Shown is the 135 hp 1164-40, based on the Ford 8340, destined for St Helena. The present Countytrac business developed a high-clearance County model for CNH in early 2007 and has plans for a new four-wheel drive machine.

INDEX

Other Books and DVDs from Old Pond Publishing

County Tractors

County tractors are vividly portrayed in action all over the world including the paddy fields of the Philippines and a unique crossing of the English Channel. Postwar crawlers, pioneering 4-wheel drive designs of the 1950s and 60s and high-horsepower tractors of the 1970s and 80s are among the main models featured in archive and new footage. Compiled and scripted by Stuart Gibbard. DVD.

County Tractor Working Days

The machines featured range from early conversions based on the Fordson Major through to the massive Muir-Hill 171 and County 1884. Well-known machines of the 1960s and 70s, including the County 1124, Roadless 120 and Northrop 5004, are seen at work. Although the programme focuses on County tractors, machines from Bray, Doe, Matbro and other manufacturers are in action with a range of ploughs and other cultivation equipment. Script by Stuart Gibbard. DVD.

Roadless Tractors

With full access to the Roadless archive, Stuart Gibbard has compiled a spectacular film of the company's products from the tracked machines of the 1920s to the forestry machines of the 1980s. He has focused in particular on the famous 4-wheel drive tractors produced during the 1960s and 70s, and he has also uncovered some lesser-known developments. DVD.

Roadless: from tracks to tractors

From tank track design and pioneering work with agricultural crawlers and half-tracks, Roadless went on to develop its celebrated range of 4-wheel drive and high-horsepower tractors. Stuart Gibbard covers the whole story from 1919 to 1983, including many lesser-known aspects of the company and prototypes. Hardback book.

The Doe Tractor Story

With its two engines, 4-wheel drive and 90-degree articulation, the Doe Triple D was one of the most unorthodox of tractors. This book by Stuart Gibbard is a detailed account of Triple D and the associated tractors and machinery from Ernest Doe & Sons, written with full access to the Doe archives and illustrated with many previously unpublished photographs. Hardback book.

Ford Tractor Conversions

Stuart Gibbard gives details of all the main models and machines by the manufacturers who were linked by their extensive use of the Ford tractor skid unit. He shows the development of the 4WD agricultural tractor in Britain and deals with earthmoving and construction equipment. Hardback book.

The Ford Tractor Story Part One

This award-winning, meticulous and highly illustrated account starts with the Model F at Dearborn, carries on through the Model N and the E27N to the Diesel Major and the Dexta. Covering both Cork and Dagenham, Stuart Gibbard's comprehensive research unearthed photographs of little-known prototypes and a wealth of new information. Hardback book.

The Ford Tractor Story Part Two

Stuart Gibbard's award-winning account starts in 1964 with the launch of the 'worldwide' 6X range. The next thirty years saw a host of new models and features as the line evolved towards today's sophisticated machines. The book takes the story right up to the Fiatagri merger and the New Holland line, concluding in 1999. Hardback book.

Fordson Farming

Stuart Gibbard has selected over 30 excellent examples of Fordson tractors from the 1945 launch of the E27N Major to the New Performance models of the 1960s. His detailed script covers the key developments of the E1A series, Diesel Major and Dexta as well as conversions. Stuart shows the machines in action with authentic implements. DVD.

Farm Machinery

A key text for agricultural students and an outstanding resource book for all those concerned with machinery on the farm. There are chapters on tractors, cultivation and drilling machinery, crop treatment, harvest machinery, farmyard and estate maintenance machinery, mechanical handlers, dairy equipment, irrigation, farm power and the farm workshop. Safety is stressed throughout. Fully revised 2004. Hardback book by Brian Bell.

Free complete catalogue:

Old Pond Publishing Ltd
Dencora Business Centre, 36 White House Road, Ipswich IP1 5LT
United Kingdom

Secure online ordering: www.oldpond.com

Tel: 01473 238200 Fax: 01473 238201
Email: enquiries@oldpond.com